SHOOTING for STOCK

SHOOTING for STOCK

George Schaub

AMPHOTO
An Imprint of Watson-Guptill Publications/New York

GEORGE SCHAUB was born in New York City in 1946, and now lives with his wife, Grace, in Sea Cliff, Long Island. A graduate of Columbia University, he has operated a custom black-and-white photo lab, served as Technical Editor at PTN Publications, had freelance articles and photos published in numerous books and magazines, wrote a regular series of columns on photography for the *Sunday New York Times*, and is currently Senior Editor at *Popular Photography* magazine as well as a teacher of photography at the New School/Parsons School of Design in New York. He and his wife have travelled extensively, and they're both actively engaged in the making and marketing of their own stock photography.

Editorial Concept by Marisa Bulzone
Edited by Robin Simmen
Designed by Areta Buk
Graphic Production by Ellen Greene

First published 1986 in New York by AMPHOTO,
an imprint of Watson-Guptill Publications,
a division of Billboard Publications, Inc.,
1515 Broadway, New York, NY 10036

Library of Congress Cataloging-in-Publication Data
Schaub, George.
 Shooting for stock.

 Includes index.
 1. Photography, Commercial. 2. Photography—Business
methods. I. Title.
TR690.S337 1987 770'.68 86-28821
ISBN 0-8174-5870-0
ISBN 0-8174-5871-9 (pbk.)

Manufactured in Hong Kong.

1 2 3 4 5 6 7 8 9/91 90 89 88 87 86 85

To Grace, in whose love I grow

Many people have contributed their energy and experiences to this book, and the writing of it is a result of touching lives through photography and love. Special thanks goes to Dennis Simonetti, who cared enough to give encouragement to my work; Rick Sammon, Dave Fox, Fred Rosen, and Barry Tanenbaum, all of whom helped me early on; to Rudy Maschke, who gave me much encouragement and opportunity; and to all the photographers and friends who've shared their souls and visions with me on the road. Love and thanks to my father, who I miss, and my mother, whose continued caring and strength I cherish and admire. Thanks especially to Grace, my wife, lover, friend, and fellow traveller.

CONTENTS

PREFACE

THE APPETITE FOR PHOTOGRAPHY IN TO-day's marketplace can only be described as voracious. Every day, thousands of pictures are sold and published in all printed media— in books, magazines, greeting cards, posters, calendars, advertisements, public relations brochures, annual reports, trade journals, and newspapers. Additional markets for pictures include audiovisual presentations, film strips, trade show displays, and still shots on television and in product packaging. When you're on the outside looking in, the pictures seem to pour forth from some huge image-generating machine, produced by unknown, faceless photographers who travel to fascinating places and "bring 'em back alive" or by in-house photographers who toil on the publishing companies' time.

The fact of the matter is that a good many of the pictures you see are produced by independent photographers, people just like you, working part-time, full-time, freelance, or through an agency that represents their work. The market for freelance pictures has been growing steadily over the last decade, with the last few years being truly "boom" times in this field.

Why has this market seen such a recent surge? As usual, economics provides the key. Let's say a travel magazine needs pictures of a café scene in Amsterdam. Sending a photographer overseas for that one shot and paying for the airfare, day fees, and hotels involved might cost the magazine a few thousand dollars. That magazine, like most other buyers of stock pictures, has discovered that someone can pick up a phone, call a few picture sources, and get the exact shot required for less than one-tenth the cost of paying an assignment photographer.

The same holds true for the advertising market that formerly bought pictures on an assignment-only basis. Escalating day-rates and miraculous, new computer methods for making montages from separate images have created an entirely new market for freelance work. Pay rates for this market are higher than the traditional avenues of sales trod by freelancers. In short, the demand for pictures made by independent photographers is greater than ever, and with the right approach there's no reason why you can't share in this bonanza.

The law of supply and demand is as valid in the photography marketplace as it is in other markets. Although stock photographs could be considered a commodity as much as potatoes or wheat, many things make pictures special. First, while a picture is, in a sense, consumed by the buyer, its usefulness to its maker doesn't end after a usage takes place. In fact, success in this business is often determined by making multiple sales of the same image. That's because a stock photograph is *leased* rather than sold outright. As a photographer, you should look at your inventory of pictures more as rental property than as consumable goods.

The second major difference is that all photographs are unique—they are not mass-produced like, for instance, the cameras that make them. Their uniqueness always bears the mark of the craftsperson who composes, shoots, and owns the picture. For example, if all pictures of the Empire State Building were the same, all that buyers would need is one

depiction of it, which would fill all their needs for pictures of this scene. While it's true that almost everything under the sun that can be photographed has been photographed, it's also true that a unique vision, a personal interpretation, and a fresh outlook are continually sought by photo buyers. That's why so many photographers still find success, and why there's always room for one more—you.

Stock photography shares with other businesses the need for marketing, promotion, and getting the product into the hands of buyers. Even if you have the greatest pictures in the world, until you have a way of circulating them to buyers, you'll never see them published, and you'll never make a dime from your work.

The method of selling photographs described in this book is one that encourages you to address the task with enthusiasm tempered with organization. The enthusiasm comes from being published, having your work appear on the printed page, and getting paid for it. It recognizes the fact that your photography is a very personal matter—it's a part of yourself that you want to share with the rest of the world, the fruition of many years of picture taking. It's your art—your self-expression. The organization provides the mechanism to make this happen. It involves hard, often tedious, work, tempered with patience and a thick skin against the pain of rejection. Organization demands that you set up a filing and retrieval system and do vigorous editing and captioning of your work. It means establishing and maintaining contacts among picture buyers. The paper work can seem overwhelming, and the phone and delivery bills can be astronomical. And it will take lots of your precious time. Building an ongoing photo sales business may take up to a year, including nights and weekends, and you may not begin to see the true results of your labors until two or three years after you've begun.

When viewed over the long term, however, your efforts can pay off. Your pictures can become an annuity, a type of stock or bond that pays dividends for years to come. Perhaps most important, you'll begin to see your work published, reinforcing your vision and your love of photography. You'll become a better photographer, as well as have the financial backing to continue making pictures. Eventually, you discover that you have a way to fund and then write off your travel and photography expenses.

The purpose of this book is not to peddle illusions, to fill your eyes with stars about a free ticket to becoming a self-sustaining, globe-trotting photographer. It might happen down the road, but only after years of diligent work. This book is more a guide to getting started, and it offers a technique for building and maintaining momentum. It is a blow-by-blow description of the photography market based on years of building a business, doing research, writing articles, and having conversations with hundreds of successful, often part-time, sellers of their own photography. My wife, Grace, who is also a photographer, and I file our work together and market it through our own stock business under the name G & G Schaub; hence the reference to "we," which you will see throughout the book.

The tools presented here are for you to use—ultimately, you must be the one to pick them up and get to work. Your success will depend upon a dedication to your photography coupled with long, hard work at administrative tasks.

This guide is also intended for those who want to make selling their photography a part-time job, who don't see that as a full-time career. Necessarily, a part-time approach will cut you out of certain markets where constant readiness and availability are essential, but that doesn't mean that you can't successfully tap into a good number of markets. Although the initial groundwork is the same for both full-time and part-time selling, a more casual approach can be taken for making some part-time money and getting an occasional picture published. What you put into it is what you'll get out of it.

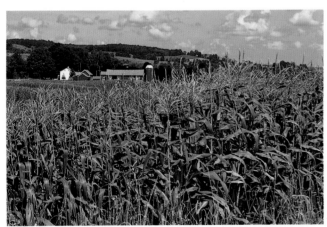

Some of the most successful stock photos are straightforward illustrations of people, places, and events. The "everyday" quality of what sells might surprise you. Another key to making pictures that sell is "universality," where one photo can serve many needs, thus many markets. This shot of farmland in upstate New York incorporates crops, architecture, and landscape in one frame, and could be used to pinpoint locale, show the coming harvest, illustrate a rural calendar, or simply say "Farmland."

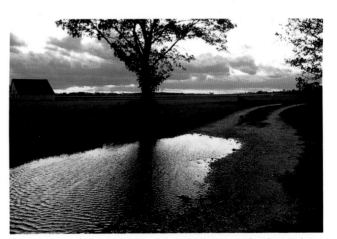

However, not every shot for the stock photo market has to be made in bright light with straight, or purely descriptive, elements. Your creative eye, your special style, and your use of technique will serve to separate you from other photographers in this highly competitive field. This shot, made in the farmlands of Eastern Long Island, is meant to describe the feelings of a place. It is more than a straight photo-illustration, but both types of pictures have a place in the market. Try to keep this balance in mind when shooting.

INTRODUCTION

YEARS AGO, THE STOCK PHOTO MARKET was viewed by professional photographers as a dumping ground for seconds, a place to get some pocket money from the culls of a shoot. Rates were low and so was the quality of the photography and the energy working photographers put into it. All that has changed—as the price for pictures sold went up, so did the competition and buyers' expectations. Aside from pictures with a particular point of view or specific subject matter, the first priority in the market now is technical excellence. There's no room for poorly composed, out-of-focus, or badly exposed pictures in today's photo market. Art directors have become fussier, and any hint of sloppiness or poor execution brings immediate rejection of the work. That's why editing is given such prominence in this discussion.

Another point to consider when honing in on the market is the increasing preference for graphically composed pictures. A case in point is the greeting card market. Twenty years ago, the more bland the photo, the more saleable it became; clichés abounded, and gaudiness seemed to be the main criterion for a sale. Nowadays, individual expression coupled with excellent technical execution of a concept is the rule. "Filling the order," or making rote pictures with little personal initiative and a special effects filter, is much less in demand. Everyone makes those shots and, frankly, most buyers are sick of them.

This is not to say that clichés won't sell. The art of meeting the demands of the market lies in making a cliché seem fresh. For example, if a greeting card company says it wants "nature scenics," it doesn't necessarily mean a sunset on a beach with palm trees framing the scene. The buyers may like such a scene, but one taken with your own personal point of view, not in a way that's been done for the last forty years. The travel market, rife with clichés, is also undergoing a visual renaissance, and although the upscale couple drinking coconut cocktails by a pool might still sell, this up-to-now stodgy market is getting more personal and "abstract" in its needs.

Textbook markets tend to be fairly conservative, but even there the "current" photography is making inroads. These markets are often "straight-illustrative," and a straightforward shot of a place or object is still better than a more personalized approach. Magazines, on the other hand, *must* keep up with the times, and editorial work (features, not hard news) is where experimentation is encouraged, depending on the art director's or editor's point of view. Advertising is probably the most demanding area for stock photography, requiring you to think *ahead* of the times. In short, don't feel that you merely have to duplicate what you already see published in order to make it in this field. Your personal style, your point of view, and your technically perfect execution will be your best selling points.

Not every subject you photograph and sell in the stock market has to be spectacular. Most of your sales will be images of day-to-day subject matter. Perhaps the greatest shock to new entrants in this field is just how mundane the picture needs of the market can be. I've kicked myself more than once when receiving a picture call-list from a buyer and realizing that I had passed up the requested shot a dozen times the previous year.

Let's take a look at a call-list issued by a textbook company for a fifth-grade civics textbook. About fifty shots were listed, including: children seated in an airplane . . . a campsite in a national park . . . a school bus, with children climbing aboard, at dawn . . . a street fair, with various races and ethnic groups . . . a food stand at a carnival . . . a ferris wheel at night . . . pies cooling on a windowsill . . . a Fourth of July parade . . . a marching band on a football field . . . a family camping.

Here's a list for a junior high school mathematics book: the Pyramids . . . a trapezoidal tent . . . people making purchases in a supermarket . . . a farmer on a tractor . . . Wall Street in New York City . . . a greenhouse filled with plants . . . the interior of an airline terminal with a view out to the tarmac . . . sailboats in a race showing a series of triangular sails.

And for a high-school science book: a drop of water splashing on a surface . . . a medieval sculpture . . . a nature trail in Everglades National Park . . . a jet airplane taking off . . . the roots of a tree . . . the destruction after a hurricane . . . gypsy moths . . . a praying mantis . . . the interior of a telephone.

As you can see, picture calls from buyers represent a wide subject mix, and subjects include specific places, generalized events, and people engaged in day-to-day activities. Don't be overly concerned if you don't have many of these pictures in your present files. Until exposed to the needs of the market, you probably wouldn't even think of taking those pictures, much less keeping them in your files. Being aware of what is needed in the market will make a difference in your

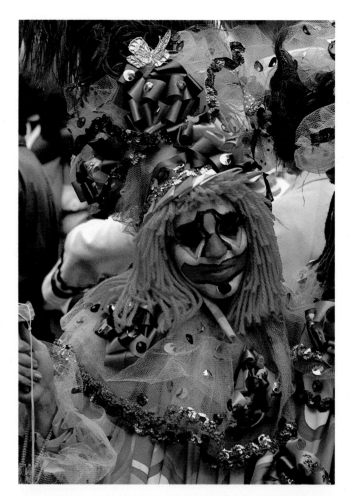

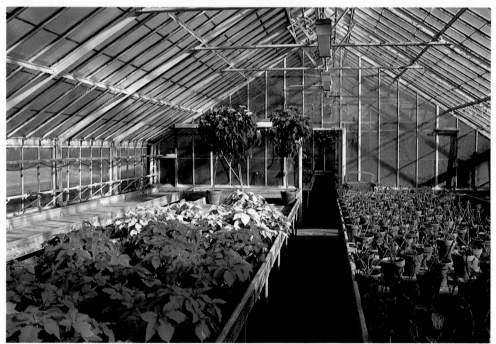

The diversity of subject matter that sells in the stock photo market is a constant source of surprise and fun. Taking pictures for your files can be as enjoyable as selling them—in this business, process is as meaningful as product. These photos were made (clockwise) on the streets at Mardi Gras, in St. Paul, Minnesota, at the Chartres Cathedral, and in a local greenhouse.

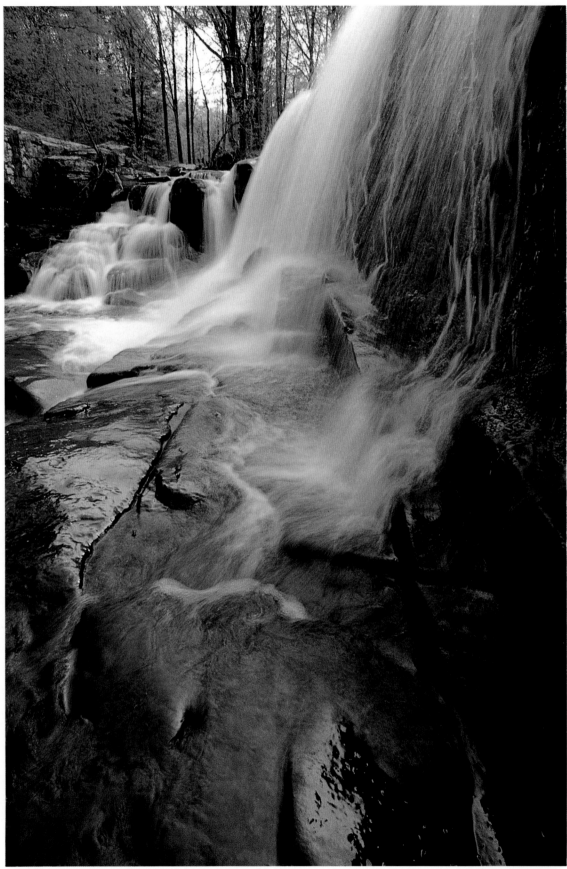

Originally taken on speculation for an ad agency stock call, this shot later served as part of a submission to a greeting card company and to a nature magazine, and as one part of an essay on the Catskill Mountains in New York. This is an example of parlaying a picture.

future picture selection, as well as convince you to always carry a camera around with you.

We aren't always given the luxury of such a specific list. General calls go out from travel markets, advertising firms, and various paper goods and editorial buyers. Whenever such a call comes in, it's time for you to play "art director." These calls may come in various shapes and sizes. For example, a number of years ago, a cigarette company was using the image of a waterfall to communicate the mentholated "coolness" that its product would give users. Every year or so, a call would go out for a new image of the waterfall, and

stock agencies and photographers would vie for the chance to score a sizable fee for a simple shot of cascading water. Another tobacco company also gets all its ad images from stock, but its "image logo" is that of rugged men of the sea tugging on its particular brand of weed. Studying each company's past use of pictures, and realizing that drop-in type would be part of the final picture-product, helped some photographers in the lottery to gain the winning edge. They also brought a fresh approach to the subject matter—mere copying of the last few winners was never enough. Sometimes, submitting a bold, new idea enables an in-

house art director to justify working with an entirely new concept and layout.

Travel magazines present the same sort of challenge, and finding the right pictures is often a matter of research and follow-through. Let's say you get a general call for pictures of Belgium. Though not an especially large country, it still has a diverse mix of languages, cultures, and landscapes. A call to the picture editor may reveal that the story is on the Ardenne Forest region, still a fairly wide topic. If it's possible, you should attempt to get a copy of the story. Or have the picture editor skim the text for you over the phone and supply you with call-outs for the vi-

sual references made by the author. The more details you get, the better off you'll be, and you won't be wasting anyone's time by sending unnecessary pictures.

Subject matter is important, but so is the way you render a scene, an event, or a locale. Here are some special elements that define pictures and can make or break a picture sale.

People

Whenever possible, include people interacting with each other and with the world around them. You may have the greatest location shots in the world, but without people they may lack interest and end up looking like just another postcard.

Whenever you have the cooperation of "found" models, pose them in a way that indicates a positive and strong interaction. Also, a signed model release will greatly add to potential markets and sales.

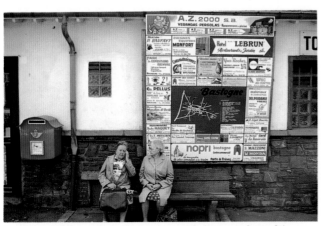

People candids with a strong sense of place, such as this travel stock shot made in Bastogne, are always good sellers in editorial markets.

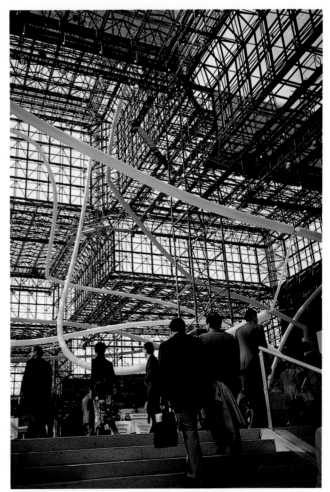

Include people in scenes to add scale, involvement, and "humanization" to your coverage. This shot of the recently opened Javits Center in New York includes some likely users of the great hall.

13

INTRODUCTION

We recently received a call for pictures of Great Smoky Mountain National Park, and filling that order highlights how important the human dimension is.

A travel magazine's editorial list included the park as a feature story in their future lineup, so we researched our files and came up with a series of spectacular scenics showing all the major attractions in the area. As part of our coverage, I just happened to snap a casual shot of some people walking along a nondescript trail. When editing, I even considered throwing the picture away because it didn't stand up and say "GREAT SMOKY MOUNTAIN NATIONAL PARK" to me. I was lucky I saved it. That shot was one of the few with people in it (as opposed to the pristine landscapes), and it was the shot that sold.

Another example of the importance of including people came from a travel assignment in the Ardenne. The Belgian town of Bastogne is filled with history and monuments, it being the site of the Battle of the Bulge in World War II. A very moving and memorable stone edifice marking the events is just outside the town; American and Belgian flags fly over this huge monument, and on a sunny day it's really an impressive sight. We spent most of our time there taking photographs of the monument, working from different angles with various lenses. After exposing six rolls of film, we decided to relax and go into Bastogne for a cup of coffee. Following the sometimes confusing street signs, we arrived in the main square where we found a collection of cafés and went into one. As we sat down to coffee, we noticed an old American tank, set up in the middle of the square, with children clambering in and out of its hatches. Our coffee half-finished, we moved into the square and began taking pictures of the scene, working quickly because the sun was moving behind a tall spire that was throwing the square into shadow.

As it turned out, the picture that said "Bastogne" was not from among the stately studies of the battle monument, but was of those kids playing around the tank. We didn't regret making the pictures that didn't sell (we're confident they'll fulfill future picture requests), but we learned more about always including people in the scene.

In general, any stock picture of any location or event benefits from the inclusion

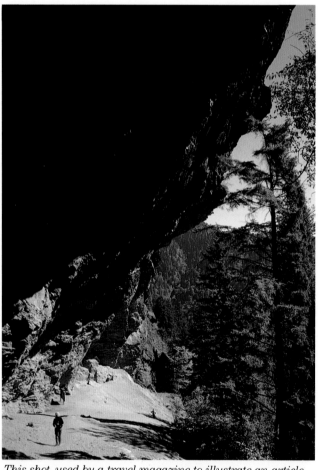

This shot, used by a travel magazine to illustrate an article on the Great Smoky Mountains National Park, was chosen over other more pristine (peopleless) landscapes. When asked why, the photo editor replied, "I always like people in location shots." In fact, we almost left this shot out of our initial submission.

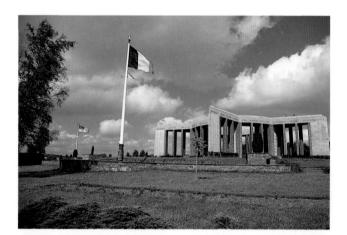

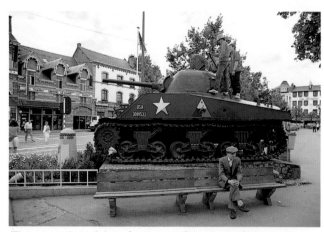

These two shots (above) were made as part of our coverage of Bastogne, in Belgium. Though the top picture is all you could want from a descriptive location shot (showing the Battle of the Bulge Monument), the shot of the people clambering over the tank was chosen for publication. This taught us another lesson about including active and involved people in our travel stock shots.

of people. We'd been eager to get down to the National Air and Space Museum in Washington, D.C., ever since it opened, both to satisfy our own interests and to fill our stock files with oft-requested shots. When an assignment brought us to the nation's capital, we kept an afternoon free for stock shooting. We found the museum jam-packed with children on field trips, and they were brimming with enthusiasm over the rockets, space capsules, and assorted gizmos. We did make a few overall shots, but having learned our lesson well, we put our main efforts into capturing the rapt involvement the children had with the place. Knowing that full-faced shots of children might give us a later problem with model releases (even though the museum is a public place), we made a conscious effort to compose the pictures so that a side view of the children pointing, or a long shot of them climbing on board a space vehicle, were the main shots. Our instincts paid off, and one shot of a group of boys contemplating the lunar lander has sold repeatedly to science books, and to children's and general interest magazines. Shots of the museum lacking this interaction just haven't had the same sales appeal.

So whenever possible and appropriate, include people in your locale shots. They add scale and compositional balance, and most important, they give the viewer a sense of empathy and involvement with your shots.

Jobs, Skills, Avocations

Though this section might come under our People heading, it constitutes a more "focused" type of shooting that has people interacting specifically with an applied task or in a prob-

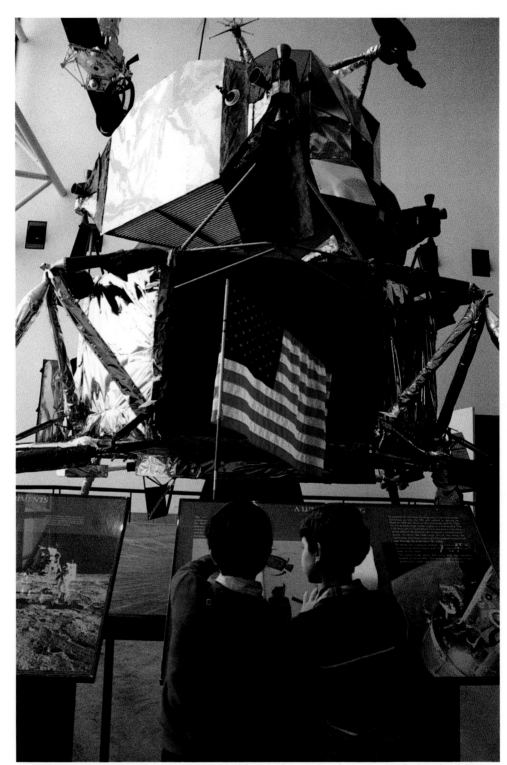

Part of your photo coverage of a place should include people who are actively involved in enjoying, contemplating, or working in a special environment. When making such pictures, your sense of design will dictate whether the people or the locale get the most attention. Many times, your best bet is to strike a balance between the two. Or, if you can, make both types of pictures. In this shot, made at the Air and Space Museum in Washington, D.C., we felt it was important to highlight the fascinating objects on display and to communicate the sense of wonder and excitement of the children who always seem to fill the museum's halls. We shot from a balcony above the Lunar Lander, and composed the picture so these two wonder-struck children were placed in the important lower-third of the frame. Of all the shots we made that day, including documentary ones of rockets and planes, we felt that this one communicated best what we wanted to say.

lem-solving environment. Textbooks, trade journals, and annual reports are especially fruitful markets for these occupational shots.

For the last few years, computer skills have been a number one topic and, in addition to numerous journals solely dedicated to hardware and software, general interest magazines, daily newspapers, and the scholastic presses have been continually filled with how-to articles and articles on computer-related activities. Providing illustrations for this market is keeping many photographers busy.

The photos used in these articles (except for hardware reviews) tend to focus on people using the ma-chines and on the environments in which they work. If the market called only for pictures of computer screens and keyboards there would be a lot less work than there is. On an assignment for a trade journal covering the annual Digital Corporation's trade fair in Boston, I arrived to find that the company had set up mini-environments to showcase the various applications of their machines, such as a school, a home, an office, and an art director's office. After completing my photo coverage for the magazine, I spent the rest of the afternoon wandering the floor and making pictures of people working in these environments. It was a ready-made set, complete with models, machines, and props.

In the past, other occupations that have been best-sellers were those allied with oil production, nuclear energy, automated auto-assembly, teaching, and farming. If you link up with a group of trade journals (every industry has at least three or four supplier and industry newsletters or magazines), then you can stay busy shooting skills and tasks for that particular group. To break into photographing a special industry, get a copy of a public relations or a publishers guide and star those industries that strike your fancy, then follow up with an introductory letter and samples of your work.

Aside from trade-oriented journals, occupational shots also sell well in textbooks, particularly in the areas of civics and social studies. For a number of years, nontraditional holders of jobs were a hot seller, with shots of female construction workers and male secretaries doing well in all markets.

As a general rule, whenever you're in a work environment or can photograph someone in the course of his or her working day, do so. You never know when you'll get a call for these shots. Often, you can make these pictures while on an assignment. A few years ago, I was given a photo assignment for an article on a computerized pag-

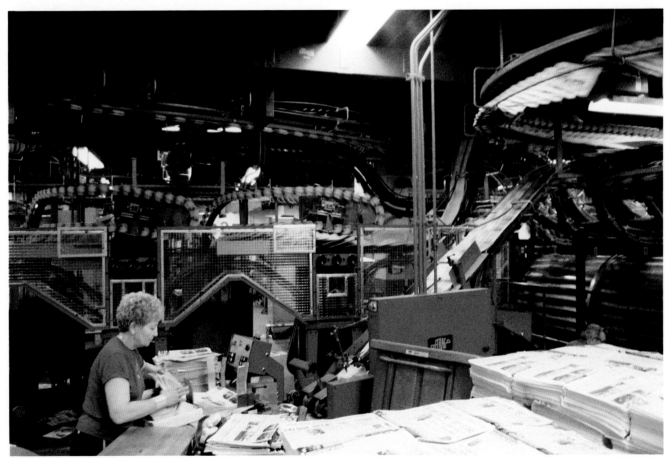

Whenever possible, make shots that give an insider's view, whether it be backstage at a theater, in a scientists' research lab, or, in this picture, showing the sorting room of a major metropolitan newspaper. Such rare glimpses not available to *the general public make your files unique and set you apart from your competitors. This photo is a likely candidate for sales in the textbook and trade markets. So whenever the opportunity arises, be prepared to shoot for stock.*

ination system that had just been installed in a mid-sized city's daily newspaper. Most of the shots for the piece were taken in the paper's composition area and laser scanning room. As I was winding down, I asked my contact at the paper how this system affected the rest of the plant—his response was to offer to give me a Cook's Tour of the facilities. After the assignment was wrapped, I loaded two cameras with high-speed slide film and went on the tour. I shot three or four rolls as we walked, knowing that I was getting picture opportunities not usually afforded an outsider. The assignment shots sold and paid well, but the stock shots I took afterward continue to sell to this day. So when you're given the opportunity to get an insider's look, load your camera and start shooting.

Trends

After working in and studying the photography market for the last ten years, I've noticed that picture sales tend to come in cycles—when a particular subject is hot, it stays hot for a few months, then fades away. Success often comes to photographers who pick up on a fad, trend, or fashion, depict it graphically, then move those shots quickly into the marketplace. My best advice is to keep your eyes and ears open, to read up on and follow trends in the media, and eventually to try to forecast which pictures will be in big demand.

Over the last few years, the heavy picture demands that have come and gone included alternate forms of energy (solar, windmills, all in response to the oil crunch), computers (still strong), women and minorities in nontraditional roles, aerobics and dancercize, yuppie life-style artifacts,

Pictures of computers have been and continue to be top sellers in the stock market. Anticipating a coming hot topic can mean strong sales for an enterprising photographer, and being aware of changes in fashion and technology is a real plus. A few years ago, alternative energy sources were in big demand, but when the oil "crunch" became a glut, picture needs seemed to vanish into thin air. Calls for trendy shots come and go quickly, so don't spend all your time filling your files with this type of picture. I'm sure some old shooter out there has a file folder full of hula-hoop shots that continues to gather dust.

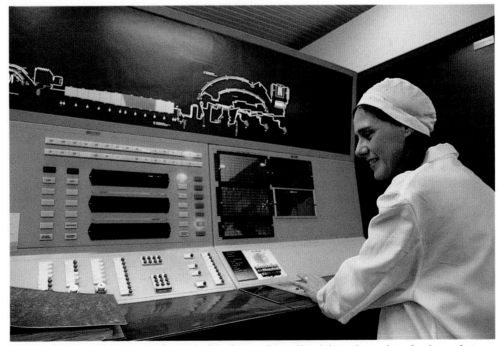

Photos of the workplace are always in big demand in editorial, trade, and textbook markets, with high-tech automation being the best seller today. This shot of a computerized control board was made during a press tour of a factory. Whenever I'm on assignment, I try to use the situation as an opportunity to build my files. Naturally, the client comes first, but I usually shoot two for them and one for the files whenever I can. In fact, this is the way that most professional photographers have built their files, especially those who retain all rights to their photographs.

and cats. Currently, patriotism and the old red, white, and blue are very strong—perhaps when you read this it will be trailers, space ships, spirit photography . . . who knows? The point is that "when it's hot it's hot." Being able to have the right pictures in the hands of buyers when the trend peaks can mean a healthy increase in your cash flow. Alas, these fads don't last long, so don't spend all your time covering them. I can't remember the last time I got a call for a shot of a hula hoop.

One lucky shot of a trend or a hot topic can result in quick turnover of the image and repeated sales. During the reconstruction of the Statue of Liberty, I was invited to cover a press event on Liberty Island. Before going, I obtained a "spec" assignment from a trade paper because one of their big advertisers was a corporate sponsor of the fund-raising drive. I loaded up on film and lenses, caught a boat from Lower New York, and arrived on the island to find the inevitable brass bands and a big crowd of school-

children armed with American flags. As various speakers, including Lee Iacocca and Walter Cronkite, waxed eloquent, I busily snapped away at the kids with the flags, singly, in a group, and with the Statue as a backdrop. Later, a group of photographers were invited to go up the scaffolding's elevator to the top of the Statue. Overcoming an innate fear of temporary elevators, I clambered aboard and shot details of the work in progress and of the Lady herself.

During the Statue's re-

construction, I made some quick sales of the shots I took that day to a number of regional and international markets, but the shots that have continued to sell are those of the group of children with the flags. At least three civics textbooks and a number of social-studies books have used these pictures for unit openers and covers. While the shots of the reconstruction are now of historical interest and may someday be requested again, the trend calling for kids with flags is what made the day worthwhile.

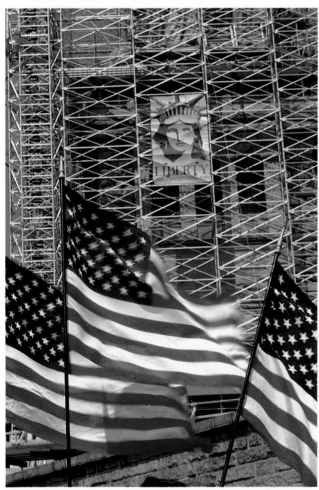

A recent example of a "hot" topic was the reconstruction of the Statue of Liberty and the party that followed. Luckily, I was involved with a number of press events early-on in the hoopla, months before it became feature and front-page news in every newspaper and magazine in town. Frankly, I didn't anticipate the later demand, but my instincts told me that the pictures would have a later historical interest. Though calls for these shots have lessened, they still yield few sales.

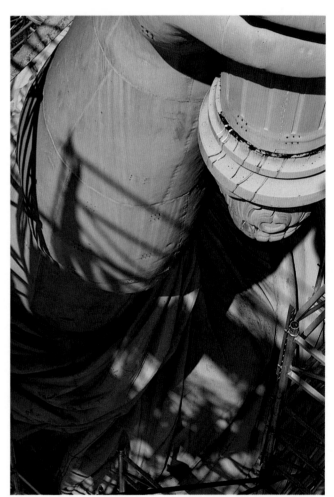

Part of an early press tour included riding the scaffolding elevator up to the Lady's old torch. As we ascended, I looked down and saw the play of light on the statue's metallic skin. This photo often served as a smaller detail picture in layouts that featured overall shots of the reconstruction work. Try to think like an art director when making stock shots, and offer a number of different points of view in your submissions— this can only increase your chances of making sales.

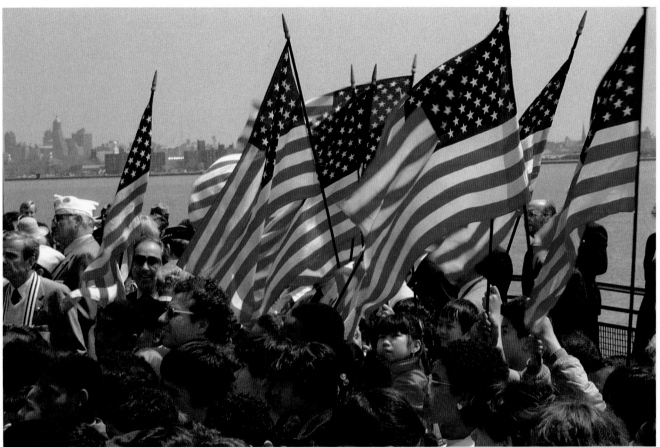

Ironically, one of the best sellers from the Statue of Liberty file didn't even include the Lady in the picture. Part of one press event included a marching band, color guard, and a busload of children all supplied with American flags. As the band played on, and other photographers made pictures of the Statue, I waded among the kids and made a series of shots with a wide-angle lens. This photo has done particularly well in the textbook market.

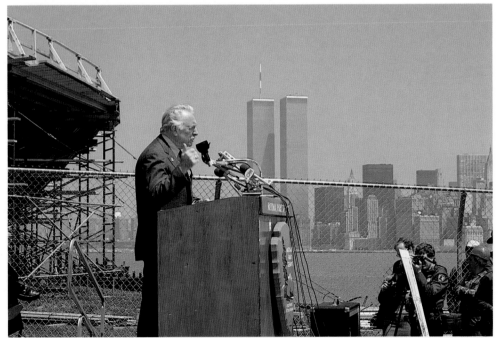

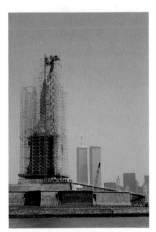

This "context" shot became the lead picture in a number of articles, and even ended up as the cover for one publication. Always keep lead pictures, the ones that tell the overall story, in mind when doing photo coverage for stock.

It's very rare for me to photograph celebrities, but here Walter Cronkite was part of the event, thus my coverage of it. Some photographers make a good living from their famous-faces stock file, and they become steady suppliers to the personality press trade.

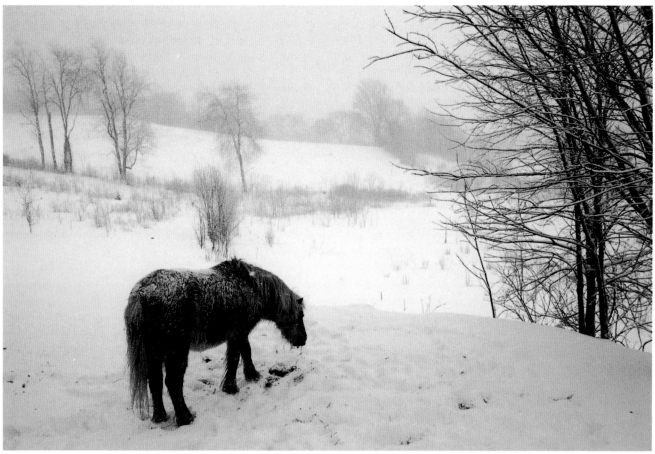

My approach to scenic, or locale, photography is to make a number of predictable "record" shots, then begin exploring the moods of the time and place. As I get more involved with a subject, I hone in on the abstracts, or details of a place. Naturally, this doesn't always happen in the same order. This shot, made during a Vermont blizzard, is a mood piece.

Macro floral photography is an enjoyable way to spend an afternoon, though shots like this one have a limited market. But don't be discouraged—this photo has sold to a photographic magazine, a public relations firm, and will probably be used on a greeting card.

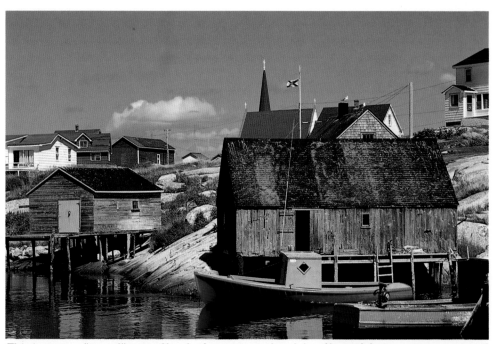

This is more a "record" type of locale shot, not very inspiring (for me), but a necessary part of travel coverage. After making this long shot, I went into town (Peggy's Cove in Nova Scotia) to shoot detail work, but I was driven away by hordes of tourists. If you have limited time, however, you have to do the best you can in each locale.

Scenics and Florals

Not every locale shot must include people. In fact, many markets don't want a soul in the picture. Quiet hillsides on a foggy morning, soft dew drops on the petals of a rose, bucolic farm scenics filled with rustic charm, and romanticized urban scenics all have their place. Overall, color pictorialism doesn't represent a particularly strong suit in stock photography, but if you enjoy shooting this kind of picture, by all means continue.

Marketing these pictures is another matter. You'll need a keen eye to consciously avoid making clichés. Buyers are overwhelmed by this camera-club, contest-winning type of work, so the results really have to be graphic and punchy to make the grade. Don't submit pictures with starburst filters or any overdone special effects. These are okay for some camera-fan magazines—though editors for the photo trade journals and consumer books are sick of seeing such work—but won't get too far in the sophisticated stock photography market.

The same goes for most abstract compositions and extremely personal interpretations of a scene. Art photography can be an exciting form of self-expression, and you should practice it to expand your interior horizons. However, selling these shots on the open market is unlikely. You may find a card or poster company that's willing to publish your personal vision, but don't expect to earn any steady income from scenic-and-floral shots. You might be able to grab some revenue from them once you've earned a name in the business, so be patient. Too many young photographers drop out of the market because they feel that "no one understands them." I don't mean to discourage your self-expression; I just feel that you should balance your art work with a more market-oriented approach. Let your income-producing work provide a "scholarship" for your more personal work. This approach may not be utopian, but then again, film isn't being given away these days.

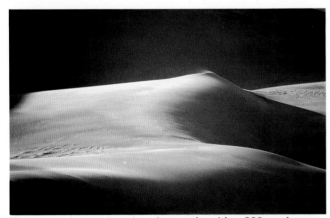

Exploring an area for stock means taking the time to find and compose the design elements at hand. This photo is part of a continuing series on the beaches of Long Island. We enjoy strolling the shore with our cameras, doing a sort of visual beachcombing as we go. Shooting for stock allows for such pleasant days.

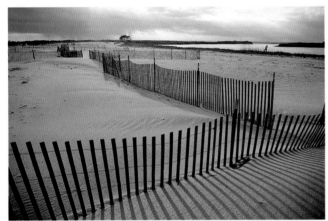

This is an abstract location shot made with a 300mm lens at the Great Sand Dunes National Monument in Colorado. Abstracts are more personal, fun pictures that are made less for the market than for the pleasure they give. But these shots can also be sellers, as art directors use them to show a personal interpretation of a place.

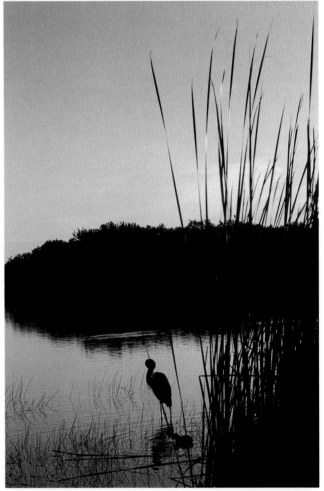

The market for nature photography—wildlife, wilderness, and earthscapes—is getting stronger all the time, especially as the megalopolis continues to gobble up the open land. Though I don't consider myself a wildlife photographer, I won't pass up a shot like this one in the Everglades National Park. Be aware, however, that this aspect of the stock photo market is very competitive—there were ten photographers gathered at dawn around the same pond at the same time this photo was made.

Hobbies and Special Interests

Pay a visit to a stationery store or a supermarket that has a large selection of magazines and scan the racks. You'll see cover titles on backpacking, skiing, running, cycling, motor homes, needlepoint, and gardening, among others. In fact, if you enjoy a hobby that involves products—and therefore advertisers—then there's probably a magazine produced to serve and promote that activity. Some of these journals are low in circulation and pay, others are big-run monthlies stocked with stories and pictures supplied by staff and free-lance photographers.

As with most magazine markets, there's a big turn-over in "life-style" pictures and a constant demand for quality work. Many articles and hobby columns are submitted as text-picture packages, and writer-photographer teams or individuals with both skills often have the best chance of success. However, photo essays and individual shots strong enough to be covers or fillers are still good earners. If you write (even if you just write good captions) or can link up with a features writer, so much the better for you, but don't avoid this market if your forté is only with the camera.

These life-style shots of leisure-time activities also sell in the posters, paper-goods, and textbook markets. And don't forget that advertising copy is often wrapped around an activity shot. For some odd reason, shots of vigorous, healthy leisure activities, such as windsurfing and skiing, are often used as illustrations for cigarette ads.

A good way to get model-released life-style shots is to discover what hobbies your friends and neighbors enjoy, then join them in their pastimes for a day of shooting. Or you can take these shots while on vacation or on a Sunday drive. Make people you know aware that you'd like to join them with your camera, and offer to swap a print for the privilege of shooting and a model release. This can be done over a weekend, since that is when most people will have the freedom to "recreate" and are more visible.

On a recent trip to New England to visit friends, I discovered, somewhat to my dismay, that they kept bees. Luckily, I had arrived in time to watch them harvest honey; so donning protective clothing and mounting a long lens on my camera, I joined them. I snapped away at each step of the procedure and made a good visual record of their activities as well as some closeups of the bees as they swarmed around the combs. Subsequently, I was able to market these shots to a holistic magazine and a self-help magazine, and I sold a shot of the couple in their beekeeping outfits to a rather weird fashion spread.

When shooting for the hobby or recreational file, go with your natural interests and photograph the activities you normally enjoy. This way you'll double your pleasure, and your pic-tures will display authenticity or even your passion for the subject. We often scour flea markets for props, and while we're at it, we shoot the booths of collected gems as "found" sets.

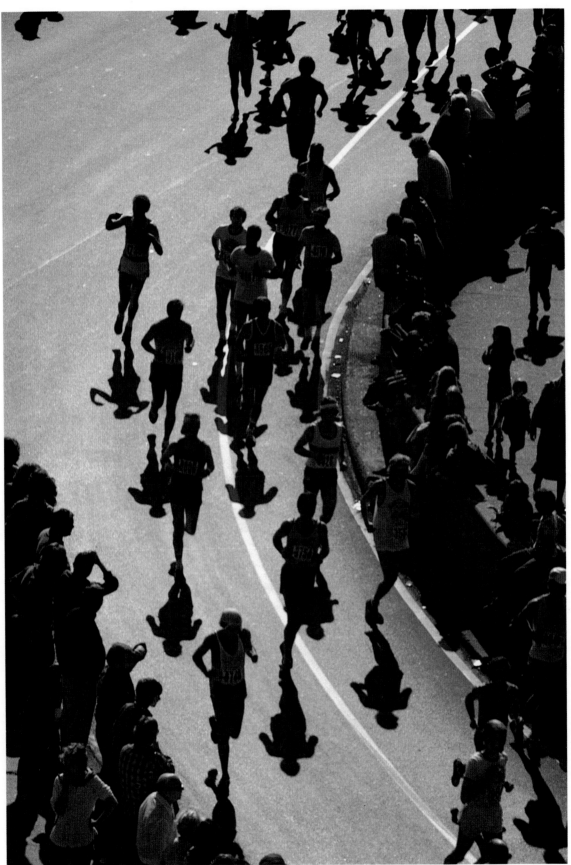

Whenever possible, try to gain a unique vantage point when photographing events that normally receive heavy coverage. This shot was taken at the New York Marathon, and the combination of a bird's eye view and the direction of the light has given this picture a competitive edge.

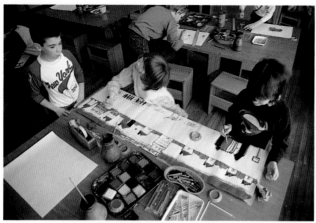

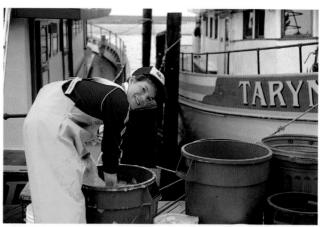

Successful stock photos needn't always be of exotic locales or special events. In fact, most of your sales will probably come from pictures you make in your own neighborhood, community, or region—even from those you shoot in your backyard or workplace. Most of our Children stock file comes from the time when Grace worked as an art teacher.

Weekend shooting trips or Sunday drives are excellent times for beginners, and those who can't afford extended self-assigned journeys, to build up their stock picture files. This photo of a young mate scrubbing up after the day's catch was made at the charter-boat docks not far from our home. Local areas are a constant source of excellent stock photos.

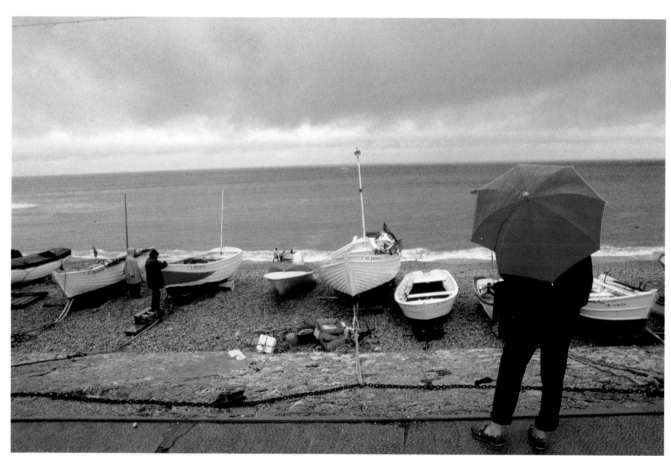

Even a cloudy or rainy day shouldn't discourage you from working on the stock file. This beach shot might have been a bit dull if only the boats and shore were included, but a touch of red showed up and I moved back to incorporate it into the scene. The shot later sold to a photo magazine to illustrate just that point—how color can serve as a counterpoint to a gray day. This happy coincidence spurred us to purchase and carry color-splash props for rainy-day shooting trips. Umbrellas, beach balls, and colorful towels are now a standard

part of our location kit. Some photographers simply won't shoot a setup stock shot without it having a splash of red, thinking that it's an absolute must for cover sales. I don't agree, but understand their reasoning. In any case, the lesson here is to look for color to enliven an otherwise gray shot, and to supply your own should none happen to walk by. Remember, each moment is unique. The convergence of light and subject matter, and more important, you and the locale, may only happen once, so make the most out of each shot.

This seasonal shot was made on a Sunday drive to the eastern end of Long Island. Short trips around your own region are a way to freshen your eyes.

I live on Long Island, an area that may or may not be typical in its offering of leisure activities. Here are some potentially marketable shots I found on a weekend self-assignment. My hometown is situated on a cove, where there are a number of marinas and small beaches. During the summer, sailboats, power boats, and windsurfers are seen in abundance. Across the water are a series of bluffs, sandpits actually, where hang-gliders take advantage of updrafts in the air currents and dirt-bikers zoom around a makeshift race course. Speaking of courses, the local public golf links are crowded with duffers, and the playgrounds have tennis, basketball, and paddleball courts. We even have a local art center, where crafts and painting courses are given for kids and senior citizens.

So rather than sit around on weekends, I spend a few hours exploring and shooting. This commitment of time and energy pays off, especially when I sell to special interest markets. Check your area and local paper for events and activities, and always keep an eye out for a leisure-time "grabber," or a once-in-a-lifetime shot.

Emotions and Concepts

Like most clichés, "a picture is worth 1,000 words" is true, yet making those provocative pictures is not always a simple matter. A stock call list may request renditions of such concepts as gravity, inertia, or speed; you may be called upon to supply shots of such states of mind as thought, concern, or anticipation; and such emotions as anger, love, or tenderness may be on the list. Going out and looking for these pictures and making them work may be one of the toughest self-assignments you'll face.

Rather than waking up

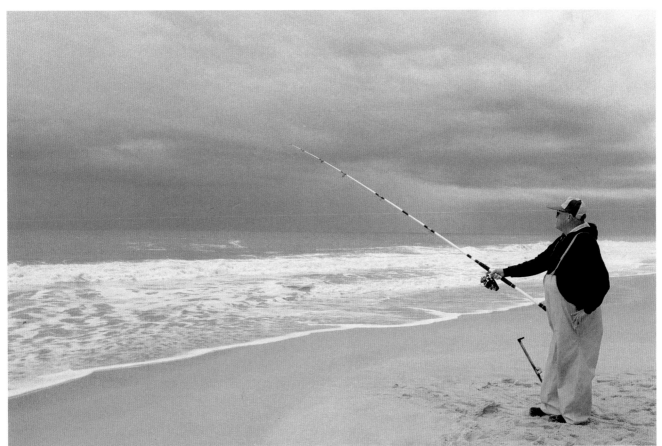

The entire East Coast of America (except for the major urban areas) is one big fishing pier, and this scene is as familiar to Long Islanders as it is to those in Delaware, where this shot was made. Grace had travelled down to the Delaware shore on assignment for a travel magazine, but hit nothing but rain the first two days out. Rather than pack it in, she scouted for subjects and found this surf caster, with requisite bright yellow boots, working the shore. After meeting and greeting the cooperative gentleman, she made a number of long, medium, and close-up shots. This composition was made with a double-page opening shot in mind; close-ups are more useful for in-text portrait blocks. Whenever you have the opportunity, take a number of poses of your subject, and keep the printed page in mind. And when you come across such a cooperative subject, be sure to get a signed model release and to send a tear sheet of the published work to your model. Establishing and maintaining good interpersonal relationships is an important part of this business.

one morning and deciding to search, for example, for a scene that expresses gravity, I'd suggest that you keep this category of shots in the back of your mind when doing general shooting and especially when editing. As I discuss later, cross-referencing and knowing the contents of your files can open up more than one market for a particular shot.

Recently, a textbook company sent us a list calling for a shot of "communication with emotion" for a chapter heading of a book dealing with interpersonal relationships. Instead of setting up a shot of talking heads wagging at each other, we combed the files and found a picture of a minister laying it on the congregation under our CHURCHES subject file. We hadn't cross-referenced the shot; so finding the picture was a matter of chance guided by necessity. That episode illustrates the importance of looking at and filing pictures in more than just a narrow, strictly descriptive fashion.

Communicating a sincere emotion in a picture is one of the real challenges in photography. Although almost any situation or event can be set up, it's your eye and instincts that will cut through the artifice and result in a telling picture. Your unique vision and trained abilities are what separate you from everyone else— your individual reading of what's going on beyond the factual information in a scene is what makes a good picture "universal."

Concept shots, or pictures that illustrate physical principles or laws of nature, work in the same way, and one picture that sums up an event or a phenomenon can become a very good seller for you. Certain shots stand out as classics in this area and serve as archetypes, or models, for all of us to study. As you become visually trained, you'll begin to see these moments in everyday life or recognize the pictures when you see them on the printed page.

What pictures come to mind with the words flood, spring, winter, war, luck, walking, poverty, affluence, or greed? Think about them, and you'll begin to be able to visualize shots that will always be wanted in the market. Depend on your own visual associations for your guide, and you won't go wrong.

Technical ability, along with certain special-effects techniques, can be useful in

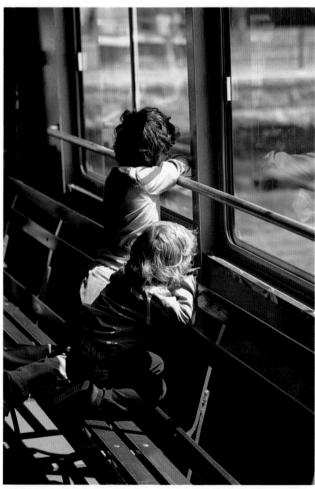

Pictures with strong emotional messages, or those that evoke a response beyond a mere recognition of place, are always in demand in the stock-photo market. This grab shot of two children looking out a ferry window can be used to illustrate wonder, curiosity, or "looking to the future." Finding and making "concept" shots is one of the most challenging aspects of this field.

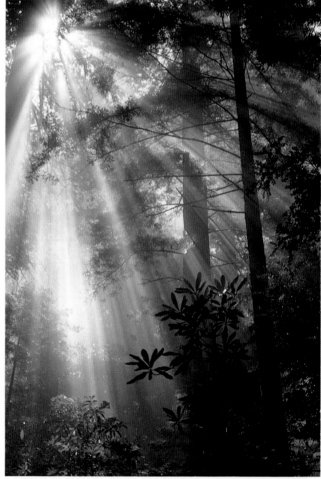

Nature, too, has its emotional side and can serve as excellent subject matter for photos with inspirational themes. This classic shot of light rays breaking through the early morning mist carries with it a message of hope and an expression of the miraculous world in which we live. Most of the time shots like this will find you; just be ready with camera and film when they do.

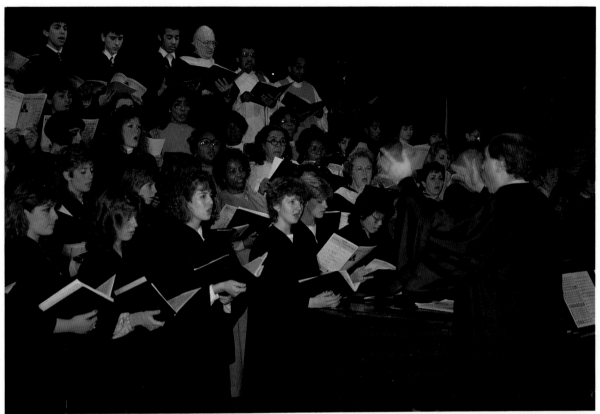

Communicating emotion also means knowing when to make a picture. This shot was made in a local church, and it not only tells you something about a choir, it's really a message about singing.

The lesson of this shot is "When you see it, shoot it." Twenty minutes after this picture was made, the morning mist burned off and the light changed; all would have been lost through hesitation.

accomplishing these shots. Take, for example, the concept of speed—using a zoom lens and pulling it back during exposure or the blurred motion captured by a slow shutter speed can add visual punch to your photo illustrations. Creative use of lighting to set a mood and the right lens for a particular point of view can add so much to these images.

You probably have pictures like this already in your files, or you'll add them as you go along. Specific, informational shots do well, but generic, concept-oriented shots are always in demand, so keep these broader concepts in mind when shooting and editing.

Serving Many Markets

A photograph often goes through an "evolution of use," and the original intent of its creation expands as it serves a diversity of needs. Take, for example, a shot of boys playing around an old cannon. Subsequent uses might include: 1) a generic summertime shot for a daily newspaper; 2) a creative playtime illustration for a parents magazine; 3) a sharing photo for a civics textbook; 4) a cute opener for an article in an Engineer's trade journal, to name a few.

The universality of any shot will lead to repeat sales, thus to survival and success in the stock photography market. This multiplicity of use comes from the nature of the shot itself and, perhaps more importantly, in how it's marketed. Making generic shots comes first through seeing, then applying the proverb: Let One Picture Serve Many Uses.

Specialization

Each of us has photographic strengths—those scenes, situations, and places where we tend to continually make pictures. One of the best ways to identify those strengths, or areas of specialization, is in the initial filing and editing of your picture library. During the process of organizing work, certain patterns emerge; you may find that you have pages and pages of spring flowers, but no shots of autumn. You may have a bursting file of boat pictures, but no bicycles. What you begin to see is what subject matter has attracted you.

Let's say that you have lots of boat pictures—working ships, recreational craft, people fishing off party boats, yachting regattas, etc. This specialization can be exploited by exploring markets for these pictures. In the magazine field alone there are *Boating, Canoe, Chesapeake Bay Magazine, Field and Stream, Yachting,* and *Sailing,* among others. All these represent potential markets for your work; many are

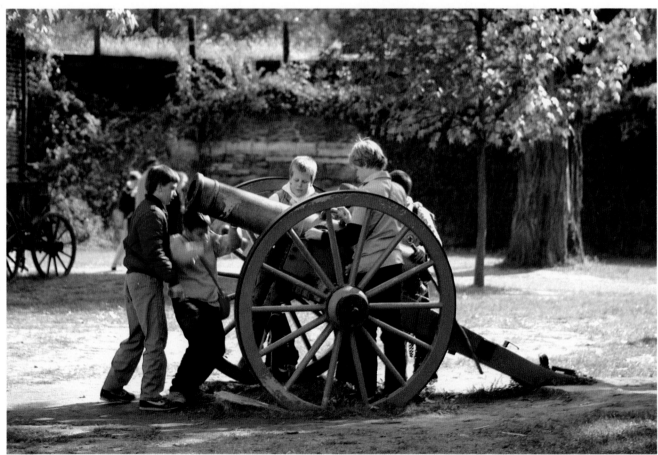

Pictures, though mute, say many things to different people. This photo of children playing on and around the cannon is a case in point. Originally made as part of coverage of Harper's Ferry, Virginia, it has come to mean something entirely different than a "location stock shot" to me. Finding such

pictures in your files is a matter of taking the time to see the meaning of your work and of noting the various associations, or cross-references, as you go. This pays off because the more uses you find for your shots, the more efficient and profitable your files will become.

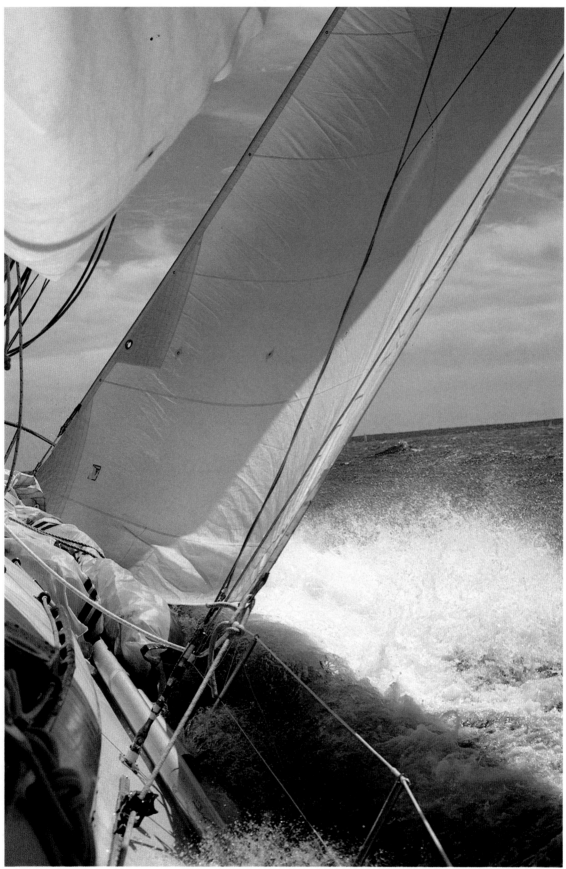

One of our larger overall files is Boating, and it's broken down into such subtopics as Pleasure, Work, Power, and Sail. Making subclassifications will make it much easier to find a specific shot. This shot is from our Sail-Action file.

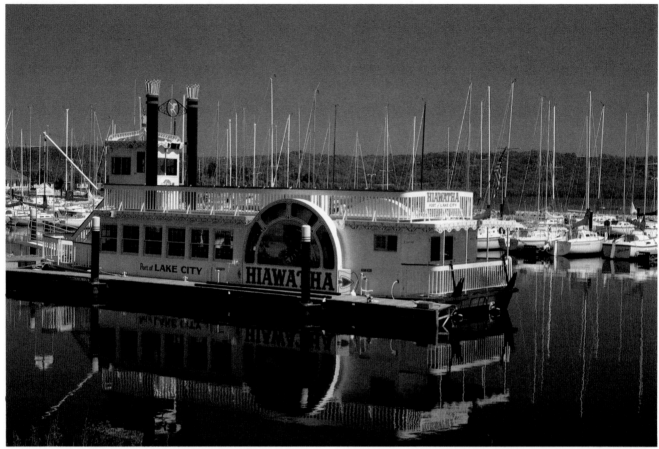

Specialization in a topic means that you have concentrated photo coverage of specific subject matter. This doesn't only mean that you have a large volume of pictures in an area, but that you have shots with many points of view utilizing various lenses and techniques, and that you have complete and comprehensive captioning material and notes to back the pictures up. Specialized files can range from hundreds to thousands of pictures—quality counts as much as, and often more than, quantity. This shot of a paddlewheeler on the Mississippi (made in southern Minnesota) was one frame out of two or three rolls shot in the same locale. Each picture from the take varies slightly in terms of the lens used (wide and telephoto), the cropping, the use of filters, and the vertical or horizontal composition. When you make pictures of a subject you think will sell (or in this case one that's on a stock call list), don't hesitate to shoot a few rolls of film to get it right, and to offer art directors a choice of pose. One solid sale will more than make up for the extra film used.

Using a variety of focal lengths will add visual spice to your stock coverage. In this photo of docked fishing boats, I used a 300mm lens to compress space and give what's called "stacked perspective" to the scene. This lens is hardly lightweight, but we usually carry it for the special "view" it affords. Choose your own gear according to your needs and budget, but add a new lens to the batch every so often to stir up your eyes and add variety to your shots.

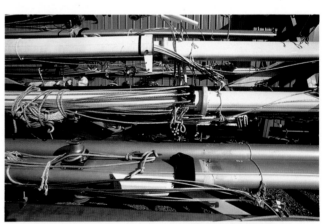

One of the earliest lessons we learned in dealing with the editorial market is to shoot details. When we were just breaking in, we'd always go for the overall shot, the "big picture" that would tell it all. This was fine, but it didn't fill the corners, the back pages, or the "nooks and crannies" of a layout. Such details as these stacked masts at harborside can also be reproduced large for abstracts, or they can be used as illustrations for technical or purely descriptive text.

monthly magazines, so their need for pictures is endless.

Using your specialization for a base can be a way of branching out into other markets. Following the boating example, the places where the boats are being used and the types of activities that go on around people in boats suggest many other stock picture opportunities. Perhaps you can get some shots of wildlife along the shore of the river on which you're recording some canoeing activity, or you might take time off from a windjammer cruise in the Bahamas to make pictures of the old Nassau straw market. Whatever you specialize in will always take you into other areas—nothing exists in a vacuum. But find a base, a reason for being in a place and taking pictures, and then let that foundation carry you into all the experiences you desire.

Once you've found your area of specialization, ask yourself: "Do I really like taking (boating, or whatever) pictures?" Once you've decided to concentrate on making pictures for a certain market, you should be fairly certain that it's an area you enjoy and one that holds meaning for you. Without an involvement in your subject matter you'll just be wasting your precious time. But don't be afraid of locking yourself into one type of subject matter.

Just because you first break into the market via a specialization doesn't mean you've signed a lifetime contract to make the same sort of pictures again and again.

Once you hit upon an area of choice, take the test and measure yourself against what's being published in the field. Get samples of magazines covering your chosen specialty, study each publication, and see how your work stacks up. If it doesn't pass the grade, ask yourself why. Is the problem technical, aesthetic, in composition, in approach? You may need special tools, lighting, or lenses. For example, if you're shooting boating regattas from the shore, you'll need a long lens. For canoe trips, an all-weather camera might give you more action-oriented shots. Every photographer who works a certain "beat" has his or her tricks of the trade. Books, photography fan magazines, and talks with photographers you meet in the field can help you discover special techniques and tools needed to get the best shots possible.

Your study also should include thorough research of the topic in order to gain expertise in the field. Lisl Dennis, a well-known travel photographer, once told me a story about an assignment on horses. Lisl was on location to shoot a series of Appaloosas, a special breed. She made wonderful shots,

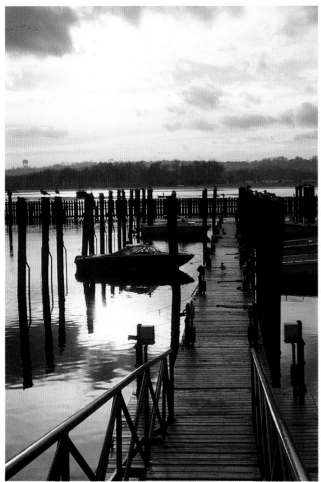

This photo, part of our Docks and Harbors group, makes use of lines that lead the viewer's eyes into a peaceful scene. Study the rules of classic composition—then break them, and find your own style.

Dazzling light requires a judgment call when shooting slide film. At times you'll want to control it with a polarizer, other times you can take your chances and let it come sparkling through.

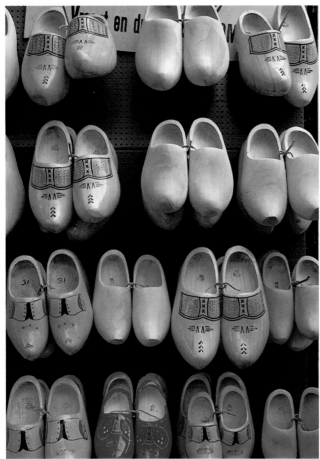

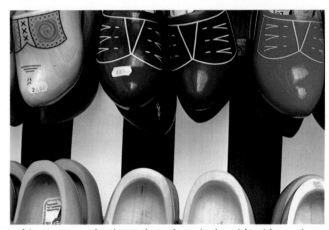

Bracketing exposure means shooting at full or half stops above and below the recommended reading to get on-the-button exposures and to capture special nuances in a scene. Bracketing composition means taking a variety of views of the same *subject matter—horizontals and verticals, with wide-angle and telephoto lenses. When you get a winner in your view-finder, give it both treatments, just as we did with these wooden clogs in the Amsterdam Flower Market.*

full of drama and spirit, and sent them off with full expectations of a warm reception from the editors. The pictures were all rejected. Why? It turned out that there are certain characteristics that separate these horses from other breeds, and photos that failed to illustrate these characteristics were worthless to the editors. You can bet that the next time Lisl shot those horses, she knew what features to include. That's the kind of information you should have in whatever area you choose.

Specialization is an excellent way to get a start, and it can lead to a very busy schedule and work load. Given that whatever you choose has enough outlets, you could spend the rest of your stock-producing career making pictures for one market. All this, naturally, means supplying buyers with good work on a consistent basis.

Vertical or Horizontal

When confronted with a potential stock picture you may be in a quandary as to whether to shoot vertically or horizontally, or whether to shoot with a wide angle or telephoto lens. The answer to this dilemma is simple: Use your best instincts and shoot as many approaches as possible. Although layouts are often built around photographs, your chance of a sale increases when you give buyers, and their art directors, a choice.

Let's say the layout calls for a horizontal picture, two columns wide, and you submit same in good faith and get a tentative okay. A late ad comes in, and copy has to be cut thirty lines and the picture squeezed into a one-column space. There's a chance that your horizontal shot doesn't offer attractive cropping possibilities and printing it as a smaller full-frame horizontal throws the whole layout out of balance. Having a vertical picture available as an alternative with the submission will make the art director's job easier, improve the chances of your work being used, and, further, will ingratiate you with a whole gang of production people (and thus, the editor and buyer). Whenever possible, shoot and submit as many angles of view with compositional bracketing as you can.

Color or Black and White?

The overwhelming number of sales made in today's market are of photographs taken with color transparency film. While there is some demand for black and white pictures, most buyers are quite willing to make conversions from slides. This doesn't preclude black-and-white pictures as stock—it just means that, given a choice, or when carrying only one camera body, use transparency film.

Color slides have a distinct advantage in storage, retrieval, viewing, and transportation. They're also less expensive both to shoot and to sell. Black and white stock not only commands a lower price than color (a situation that, happily, is changing), it will cost you more in time (searching through contacts, leafing through prints), in printing costs (making individual 8 × 10s rather than sending original or duplicate slides), and in mailing costs (twenty 8 × 10 prints weigh considerably more than a sheet of slides) to make a black-and-white submission.

If you do get involved with black-and-white stock, you'll need to make 8 × 10 glossy prints with a minimum border of one-half inch all around the picture area. Caption information, copyright, and your name and address must be affixed to the back of each print. Make prints that are full-toned and open, rather than the deep-toned prints you would make for gallery viewing. RC paper is fine for reproduction and is easy to print, process, and dry.

Film

First, never shoot color negative film for stock—it's fine for casual snaps but of little or no value in this market. The format of choice is 35mm color transparency film, although there's still a market, albeit a shrinking one, for larger format chromes. These are still used for calendars, jigsaw puzzles, and posters, although the excellent films and optics available today make the differences of the past less apparent.

Choosing which 35mm slide film to use is a matter of taste, convenience, and how concerned you are with a slide's longevity. Not too many years ago, non-Koda-chrome films were considerably less stable than they are today and thus earned a bad reputation in the stock photography business. Every slide is a long-term investment, so anything that shortened an image's life was, and still is, a matter of grave concern.

Today, the Kodachromes still have the edge in stability, although modern E–6-type films, such as Ektachrome, Fujichrome, and Agfachrome, have improved longevity characteristics. In the face of this, you might ask, "Why shoot anything but Kodachrome?" E–6 films can be processed by nearly every custom lab and even amateur labs in locations around the country, and their processing turn-around time can be as short as three hours. This can be a lifesaver when you're on location. Also, E–6 films can be push-processed, which means you can get greater speeds out of them than what's listed on the box.

Another factor is the "look" of the different slide films. Every transparency film has a personality, a way that it renders colors, contrast, and highlight saturation. Some films give a deeper, almost "wet-paint" color, while others render colors warmer than those of their competitors. All this may play a subtle but significant role in the way you make pictures and the results you obtain. Experience will give you a sense of how you can change the feelings in a scene through the use of different films.

All this doesn't negate the fact that the Kodachromes still reign as the most stable of films (under proper storage conditions), and thus are probably the best overall choice for stock work. You might also run into a prejudice among buyers against anything but Kodachrome; they feel that their separators are geared to this film's particular color balance and that any other film will reproduce poorly. Realistically, this is nonsense, because different emulsion runs of Kodachrome can differ in color balance as much as any other film.

Regardless of the film chosen, it's always important to use "in-date" film and to test emulsions before going out on a major shooting expedition. Try to purchase film in "bricks" (twenty rolls of the same emulsion number), and only buy from reputable film dealers. In the last few years, "grey market" films have swamped this country, often imported under less than ideal conditions and subject to wild swings in color. Test one roll from each brick and make sure it meets your standards. If the film is "green," it probably is too fresh; if it's "magenta," it's either out of date, too ripe, or has been exposed to deteriorating conditions. Nothing is more discouraging than shooting for a week and getting back off-color results—so test, test, test!

Whenever possible, use professional-type film emulsion (usually it's designated by a "P" in the emulsion code). These are manufactured to specific color balance points, then shipped and stored under refrigeration. These films retain their character if you refrigerate them until a few hours before exposure and then process them promptly after use. Obviously, these precautions can't be followed if you're on a long trip.

Regardless of the film you use, don't expose these organic emulsions to high temperatures or humidity, and have all film hand-checked at airports. In short, do all you can to maintain the fidelity of your valuable exposed film.

PART I

SETTING UP

YOUR BUSINESS

PROTECTING YOUR ASSETS

BEFORE YOU BEGIN SELLING REPRODUC-
tion rights to your photographs, you need to
be sure that your merchandise is well pro-
tected. Securing copyrights, insurance, and
model releases for your work is essential for
legal as well as financial reasons.

Copyright

On January 1st, 1978, a new copyright law was
passed by Congress that expanded and defined the protec-
tion afforded photographers and their works. Knowledge of
the provisions of this law is important to everyone involved in
stock photography; the law provides for protection from
unlawful copying or use, and for use without payment. Of all
the rights considered here, copyright is the most important.

Under the provisions of the revised copyright law, a photog-
rapher owns all rights (thus, the copyright) to his or her
pictures at the moment of creation. Under the old law, copy-
right protection began after publication or registration. As of
January 1, 1978, all work done by the photographer, whether it
be freelance or on assignment, is the property of the photog-
rapher. The only exception to the rule on assignment work is
when the photographer signs a contract that states that the
work being done is "work done for hire." These are the specific
words that must be on the contract, or the contract must
state that the photographer assigns all rights to the client.

There has been some recent dispute over the work-for-hire
status of works done under the direction of an art director or
under specific directions of a client. While this had not been
fully resolved when this book went to press, my best advice is
to list rights on any contract and stand fast against work-for-
hire demands from clients.

In any case, the duration of copyright protection begins
upon the creation of the work (when you snap the shutter), is
valid for the life of the photographer, and continues for fifty
years after his or her death. Unfortunately, as with so many
works of art, value tends to multiply after the death of the
creator. The duration clause of the copyright law serves to
protect the photographer's heirs.

There are two ways of protecting yourself in copyright
situations. The first is to have a copyright notice put on all
published works. If you do not, you may be putting your work
in the public domain, and public domain means that anyone
can use it. A copyright notice does not mean just a "©" with
your name next to it. The notice is specifically worded in the
law to read:

Copyright © (your name) 19--

All rights reserved.

The "all rights reserved" line is optional, but does extend
copyright protection to other countries. You should have this
notice on all published work, whether it be posters, greeting
cards, calendars, or any other printed material.

For photographs published in larger works, such as books
and magazines, you also should have a notice posted. If this
can't be done because of space limitations or the policies of
the publisher, make sure that the larger work is copyrighted
and that the publisher reassigns the copyright for the pic-
tures (assigns it back to you). However, your best protection is
to have the notice printed with each shot published.

Registration provides the best copyright protection. You

may register a photograph up to three months after publication. Also, you may register unpublished work, or work that you consider to be highly marketable in the future. Registration is particularly important for valuable work, that is, those photos that provide you with multiple sales. Most important, no legal action can be taken on copyright infringement unless a picture is registered.

You don't have to register every photo singly; the $10 registration fee, not to mention the paperwork involved, would be prohibitive. The Copyright Office has established Form VA for the use of photographers and other visual artists. The form can be used for individual and bulk filings. Those submitted in bulk, however, must have one "title" or theme, such as "abstracts," "scenics," or "Mexico"; probably the best way to do it is to file by year with a bulk filing of "photographs by (your name) in 1987."

You can file using contact sheets (color or black and white), microfilm, microfiche, and even by single-framing motion picture film. There are now services through which you can put many slides on a video cassette, which may provide a filing system of the future.

If you have any questions about registration, or are unsure about an acceptable bulk form, contact: Register of Copyrights, Library of Congress, Washington, DC 20540. Phone: 202-557-8700. Request Form VA.

There is a clause in the copyright law called "fair use," the text of which states that no infringement of copyright has occurred if the picture is used in teaching, criticism, reviews, or news. In other words, if there is no direct, intentional, commercial use of your photo you cannot sue for infringement. If someone reviews your work and publishes a picture as part of that review, they are exempt from the law. The rules for fair use are stringently defined, and overuse or abuse of this provision is a violation of your copyright. The information you get with Form VA goes into more detail on this matter.

If your work bears a copyright notice, is registered in the Copyright Office, and is copied or reproduced in any form without your permission, you may sue the company or individual who violated your rights. Damages can be quite heavy, so most publishers will not attempt to steal work. Your protection applies even to derivations of your work; a pop artist was successfully sued because he made silkscreens of a published work and printed them as his own without the permission of the photographer.

I am not an attorney nor an expert in legal matters but have tried to give you the outlines of the law as I understand it and apply it to my own work. If you have any questions, consult an attorney with experience in this field of the law or write directly to the Registry of Copyrights in Washington. My main purpose here is to make you aware of these matters, and to encourage you to protect your work so that you may derive the full benefits of your labors.

Filling out the basic information on Form VA (above) and mailing it, along with evidence of your photography, to the

Copyright Office in Washington, D.C. is the best way to secure copyright protection for your photographs.

This is a copy of the model release agreement we carry with us on 3 × 5 cards in our camera bags. You may want to change or alter the terms of the agreement, and to consult a lawyer to see if it meets your needs. For a more extensive release form, and for forms that cover minors and property, consult a copy of the ASMP Professional Business Practices in Photography, *available in most libraries or from ASMP (American Society of Magazine Professionals, 205 Lexington Avenue, New York, NY 10016).*

SAMPLE MODEL RELEASE

For valuable consideration received, I hereby give G & G Schaub the right to use photographs taken of me this date for publishing, illustration, advertising, trade, or promotion, or any other use in any medium for any purpose. I release G & G Schaub from any claims and demands coming out of the use of the photographs, including all claims for libel. This release also covers G & G Schaub's legal representatives and any licensees of these photographs. I understand that photographs will be copyrighted in G & G Schaub's name and may be used in conjunction with others, as part of a composite, or in any form whatsoever.

I am over 21 years of age, and I fully understand the terms of this release.

Witness _____

Signed _____

Date _____

Stock Insurance

We are an insurance-conscious society, constantly paying bills (directly or through taxes) to protect our cars and homes; we even take bets on our lives. As stock photographers, we should be equally concerned with one of our chief assets and legacies—our photographs. Yet getting an insurance policy to cover privately held picture files is not a simple matter.

Although there are prices fixed on photographs when in the hands of a buyer, agency, or editor (by delivery memo, contract, etc.), it is almost impossible to assign a value to *potential* sales that wait in files. Yet dormant slides can have as great or even a greater value than those in circulation—you never know when a picture will get "hot."

For that reason, slides in inventory are as valuable as the lenses and cameras used to make them, but their very potentiality has much less of a verifiable value than material items of metal and glass. That's the problem.

According to a spokesperson of the American Society of Magazine Photographers (ASMP), the only way to assign a value (thus get an insurance policy) to a personally held stock photo library is to get an Internal Revenue Service audit and have them verify value. If you decide to do this, the IRS may or may not agree with your estimation. Also, if you have 10,000 images on file, and get an assigned value of $1,000 to each picture, your premiums will probably exceed your income. Although everyone agrees that most pictures are irreplaceable, there's no real way to tell what each one will get in the marketplace until an actual sale is made.

Works of art are generally insured on the basis of what they have received in the open market or at auction. A Rembrandt is worth millions only because that's what someone has agreed to pay for it. In and of itself, it has no fixed dollar worth, other than the joy and knowledge we get from seeing it.

Where does this leave us? First, everything possible must be done to protect work from physical damage. High-selling originals can be kept in fireproof safes or vaults, or at least stored in a *very* protective fashion, and removed only for necessary duplicating. Always consider a worst-case scenario (leaking ceiling, fire, smoke, etc.) when storing and shipping material.

It's also important to have a strong liability clause when dealing with buyers. If anything *does* happen, you can bet that the liable party will start reading chapter and verse from any contract or agreement that exists. Even though pictures are irreplaceable, at least you won't have a total loss on your hands.

Regarding actual insurance policies, the best that a number of independent brokers we contacted could do was offer a documents-and-records policy, but if you purchase one don't expect a high settlement should disaster strike. If you have a very select group of images you want to insure, you'll have to go through the trouble of having them appraised, and then convince an insurance company to take the risk for the value you've assigned.

In short, proper protection, storage, shipment, and ironclad liability clauses in contracts are your best insurance policy.

Model Releases

Let's talk about yet another kind of protection—the model release. Technically, the only shots you need model releases for are those used in advertising. In reality, it's always best to get a signed release whenever possible. Lack of a release precludes the sale of the shot to certain markets; having a release provides you with protection wherever the image may appear.

A release is a simple form stating that the signer allows you to make whatever use of the image you deem appropriate, short of allowing you to use the picture to demean or hold anyone up to ridicule.

An example of a "demeaning situation" case came to our attention recently. A well-known photographer was traveling through the countryside when he met a middle-aged woman doing chores in her yard. Attracted by her appearance, the landscape, and the light, he made a number of exposures as she worked, got a model release, and went on his merry way. One of the most charming pictures turned out to be one of the woman hanging some bloomers on a clothesline, with a somewhat shy, but puckish, look on her face.

The plot thickened, unfortunately, when an editor back in New York chose the picture for a collection, but published the innocent hanging the wash juxtaposed with a stripper doing something entirely different with her own bloomers. The magazine, the editor, and the photographer were all duly sued for holding the woman up to ridicule.

This is an extreme case, and over time most picture editors have learned some hard lessons, but it just goes to show that even with a model release it isn't all roses.

You might go through an entire career without being challenged in this way, but merely once can be enough. So the rule is: If possible, get a model release. If you can, limit the use and markets of the picture. Better yet, get friends to pose, hire models, or make shots using people as *generic* rather than as recognizable subjects.

Releases are generally not necessary in crowd scenes or places of public gathering, where no one face stands out. But if you shoot a picture of someone's home, and a photo buyer uses it to advertise chain link fence, you'd better have a property release. And if the owners are leaning on the fence, and you don't have a model release, then you're in for double-trouble.

Getting someone to sign a release can be a problem—not many people are amenable to signing a contract handed to them by a stranger. One way around this is to carry some form of credentials, or a letter stating that you're on assignment. A photographer we know was on an extended assignment from a newspaper in Japan to photograph Japanese people and their life-styles while they worked and lived in the United States. He always carried a laminated letter from the newspaper, which introduced him (in Japanese) and explained his assignment to his found subjects. It also related the importance of his getting a model release with the shot. Most people responded and gladly signed. We always carry model-release forms in our camera bags, and we are always surprised by the willingness of people to cooperate. Generally, this only works after you establish rapport with people—you'll never get a signed release if you sneak a candid shot and then shove a pen and a form into their hands.

You might not be on a specific assignment when you shoot on speculation for inventory, but you might be able to get a letter from a local newspaper stating that you're a roving reporter on general, open-ended assignment and that if a subject signs a release there's a greater chance that the picture will be used. Many people are eager to see themselves in print, so carry a card and get their addresses so you can send them tear sheets. This air of legitimacy will go a long way towards getting model releases signed.

You won't always be able to get a signed release, much less permission to take someone's picture. Respect people's privacy and their right to say no. Also, once you get a subject's cooperation, don't be afraid to ask him or her to pose for you in a certain way—unposed photographs don't always result in the best shots. Being personable and honest, but persistent, can pay off.

ORGANIZING A PICTURE FILE

THE FIRST STEP IN ANY BUSINESS IS TO set goals. In the photograph marketing business, those goals will take shape as identifying areas in which you'll want to sell your pictures. This is an important step, as the first markets you go after will often determine the course of the rest of your career, and success or failure in your initial ventures will either discourage or reinforce your continued work.

Too many budding photographers set their sights too high—they expect doors to be flung open and the buyer to shout "Eureka!" when they open their portfolios. There are no overnight successes. Only in rare instances does a photographer's initial work revolutionize the way buyers and editors see pictures or does a first showing lead to instant success.

Even if you do make an initial coup, you still have to follow up and continue to make top contributions to the field. As one long-working photographer once said, "Photography is like the restaurant business—you're only as good as your last meal."

Marketing pictures takes many years of hard, determined, and consistent work. This is not meant to discourage you— it's just that success in the photo market requires that you take a realistic view of the way the business works. "That last photo essay you gave us was great," is the line of most buyers and editors, "but what have you done for me lately?" Also, you may have the greatest pictures in the world, but you still have to take a lot of time and energy to market and publish your work. In short, you'll have to pay as much attention to the details of marketing as you will to making good pictures.

Before you even think about submitting work to buyers, you'll have to begin at square one and organize, edit, evaluate, caption, and generally prepare your inventory. This will necessarily be an ongoing effort, perhaps more fully realized as you begin to sell, but in any case you'll have to get at least half of your top photographs ready for market before you begin any serious push.

At the same time you're getting your files together, you'll have to prepare for the business end of the operation, which means obtaining a set of books, professional stationery, packing materials, shipping forms, a business address and phone, and a comprehensive list of the types of photographs you'll be offering. Tying all that together, you should also begin to research the markets, finding outlets for your pictures, querying editors and buyers, and beginning to make contacts in the field.

Though this organizational effort can be handled in any order, all of the pieces must come together before you can make any headway. You may shift from one task to the other as time and patience permit, though it's probably a good idea first to evaluate what you have in your picture inventory, then conceive of a way to organize that group that makes for easy filing, retrieval, and refiling.

Organizing your files can be one of the most agonizing, boring, and bothersome jobs you'll face, and it's one that most photographers didn't anticipate when they first picked up a camera. The tediousness of the whole affair can be discouraging, although its one positive aspect is that you'll gain an intense familiarity with your body of work.

If you're like many photographers, and begin to get

organized only after years of taking pictures, then the task can be even more backbreaking. Yet, the time spent filing when you begin this process will make life so much easier down the road. It wouldn't be an exaggeration to say that a good filing system is one of the essential ingredients that separates those who succeed from those who either have limited success in the photo market or give up in discouragement altogether. More than one excellent photographer has quit the marketing challenge because of the chaos of his or her picture files.

Picture this scenario: you get a call from a buyer who offers to pay $250 for a color slide of the Taos Pueblo in New Mexico. You know you have the shot, and you tell the buyer that you'll have it to her in a day. But when you try to locate the image, it's nowhere to be found. You spend the rest of the afternoon, and a subsequent evening, ripping apart drawers, disrupting your workspace, and going through obscurely marked boxes in a vain attempt to find the picture. Where is it? Was it in a slide tray you showed at a camera club lecture last month? Is it circulating at another magazine?

Finally, in frustration, you are forced to call the buyer and tell her you couldn't locate the slide. What you've done is wasted a day's efforts, caused yourself untold frustration, and possibly alienated a buyer, who now suspects that you can't follow up on your promises. Not only have you lost out on a sale, you've tarnished your image as a professional.

Inevitably, a week later, when the request has been fulfilled by a photographer whose files are in order, your picture turns up in a slide sheet of florals, placed there hurriedly because there just happened to be an empty slot on the page.

This all-too-familiar scene takes place every day and is one of the leading causes of dropout in the photograph-selling field. Some prolific photographers solve this dilemma by turning all their market-directed work over to a stock agency that handles the paperwork and organization. This is certainly an alternative, but it should be pointed out here that most stock agencies won't accept your work unless it's been put in some sort of cohesive order in the first place.

Assessing Your Filing Needs

A filing system should fulfill a number of tasks: It must provide for easy entry of material; retrieval of specific slides should be effortless; it should be flexible enough to handle cross-referencing; there should be a specific place for each image; and the system should provide for safe storage of fragile photographic materials. While filing, a severe and highly self-critical editing process must take place, and somewhere within all this each and every slide must be stamped with a copyright notice and captioned with pertinent information about the picture itself.

Let's start at the top and figure out a rough organizational plan, one that starts us on the road toward separating diverse subject matter. Prepare a work space—a large table, for example, with all sides open to the room—and begin to scan the photos you feel are marketable. You may already have them organized in a loose file, such as by trip, by year, or in other general categories. As you look through your slides, jot down all the topics that come up, and then place those topics in alphabetic order. An initial list might read: "Animals," "Arcades," "Battleships," "Colorado," and so forth.

Take a look at the final list and ask yourself: Will this setup help me find a slide, a specific slide, if I should have to locate it in ten minutes? Does the list give a good indication of what I have to offer? Is every category on the list strong enough to warrant its own section? Those groups that satisfy these requirements should be retained. Those that don't might be better off absorbed into another topic for the time being.

For example, let's say you have ten shots of skiers, but those pictures really aren't that strong. Rather than put "Skiing" down as a general topic, you might be better off placing them in the file that denotes where the photos were made (or, if they're really weak shots, you might want to eliminate them from your file altogether.) Thus, the skiing shots would be placed in, say, the "Vermont" or "Colorado" files, or even in a general file of "Winter Sports." If, at a later date, your volume and quality of skiing shots increases, then you can consider retrieving those shots from other files and making a separate heading for the subject.

The overall volume of your photo files will also suggest how you organize your work. If you have 5,000 pictures to start with, you can probably file in a more general fashion and then find specific pictures through a process of association. For example, one of the most popular categories of pictures sold relates to occupations, to people working on a specific job in a particular environment. When you begin to sort through your work you may find pictures of people operating construction equipment, farmers driving tractors, people keypunching in offices, etc., but you may also find that you don't have enough in each category to justify a separate heading for each. Initially, you may choose to keep all the shots in an "Occupations" file, then branch off into distinct occupation headings as your picture volume in various classifications expands.

The point is that your filing setup must respond to the type of logic you'd use to track down an image. Filing is a very personal matter, and each of us works on a different principle of association. The whole idea is to be familiar with the keys that open the various image doors in your own mind.

Any system you choose should have the ability to change and grow as you become more involved in the marketing of pictures, and as you see what types of pictures are in demand. While the more specific filing system might be better in the long run, initial attempts at setting up a system are better done by going from the general to the specific. Too many categories will artificially inflate the extent of your coverage and make the whole process cumbersome. Get on the road, and then deal in specifics as you move along. Think of the file as organic—treat it as something that can grow as you become more involved.

This scenario changes, however, for those who are entering the market with a high volume of material already in hand. You may be an avid amateur who's been shooting for twenty years and has just decided to make a go of marketing pictures, or a professional who's seen the opportunities available in your vast library of images.

Although a large collection will require the same making of lists, it will also require that the initial categorizations be as specific as possible. A photographer may have amassed a huge collection of pictures of steam locomotives, or have pictures of birds from all over the Southeastern United States. In these cases, a simple heading of "Birds" or "Trains" will be useless, because finding a specific shot within a large collection will be very difficult. Rather than have a category of just "Birds," it might be more useful to have file headings with the specific state in which the pictures were made, of the

ecological area in which the photographs were shot (such as "Swamp Birds," "Meadow Birds," etc.), or, if the file is extensive and the knowledge available, of the specific species of the birds photographed.

Safe Storage Techniques

At this point, you're confronted with a large number of pictures and a selective list of file headings. The next step is to start placing pictures into the physical file, and for this you'll need slide pages, a file cabinet or binders, hangers for the pages you'll be placing in cabinets, or hanging-file folders.

While everyone's file setup will be geared to his or her individual inventory, and, inevitably, all files will be a unique reflection of each photographer, the way images are stored should not be so subjective. Certain materials sold as filing sleeves and containers pose dangers to film, especially over the long run. The whole idea behind making pictures available to the photo market is based on the fact that they represent an investment in your future. Protecting and preserving that inventory should be an important consideration.

Although there are many ways to file slides (see the manufacturers list), one of the most popular is slide sheets. These are clear pages with twenty 35mm slide-sized pockets, and they provide a handy way for you and the buyer to quickly scan the pictures. Slide sheets also provide a practical way to access and eventually refile slides, because the whole face of each slide (image and identifying caption) can be seen through the pocket.

In recent years, manufacturers have become more conscious of photographers' demands for safe storage materials. This has resulted in a general lowering of price and greater availability of an assortment of styles of nondestructive filing materials. Unfortunately, this was not always the case. Even today, some inexpensive and possibly damaging film storage materials are offered to an unaware public.

You should stay away from non-acid-free cardboard and paper in boxing and cabinets, and from low-quality glassine enclosures, and especially avoid vinyl and plastic sheeting made with PVC (polyvinyl chloride). According to Kodak and other authorities, pages made of PVC and related compounds (notably plasticizers added to increase flexibility) may emit hydrogen chloride, which can cause image deterioration of color films. A good way to check whether pages are harmful is to sniff them when they come out of the box or package—if they give off a noticeable odor, they probably contain potentially harmful ingredients.

Materials that can be recommended for long-term storage are sleeves made of uncoated polyethylene, polypropylene, polyester, Mylar, and cellulose acetate. Metal containers, including file cabinets, should have a baked enamel finish. Though some photographers have used nonrecommended storage materials for years without harmful effects, you shouldn't gamble with your valuable slides.

Slides stored in sheets should never be stacked. If you use a binder rather than a filing cabinet, don't overfill it—this can cause pressure marks to form on emulsions. In some cases, pressure combined with excessive heat can result in a slide actually ferrotyping to a storage page. The same goes for hanging slide files in a cabinet.

The climatic conditions under which you store slides can have a dramatic effect on their long-term stability. The general storage area should be cool—around 60–70F, with low to

Maintaining orderly files is a must if you want to succeed in this business. We use hanging file folders with major topics as headings.

moderate humidity—around 40 percent RH. Light also has a strong effect on transparencies, so make sure no sunlight falls on your slides. Never leave them on a table near a window. Also, when viewing your slides, don't submit them to long projection times, as the intense light will eventually cause colors to fade.

Modern Kodachromes, kept in dark storage under recommended conditions, should have a useful life of nearly a century; modern E–6 films offer about half that longevity. In light storage, or when frequently exposed to light, the long-term stability is substantially less, particularly when deterioration is accelerated by damaging climatic conditions. Interestingly, E–6 films have a longer life than Kodachromes when both are submitted to long-term projection. In any case, make sure that you have a stipulation on any originals sent out for submission that projection by the client is forbidden.

Most of us can't afford the absolute climate controls demanded for archival storage (practiced these days by conscientious museums), but we do have locations in home or office that are less hot and humid than others. Common sense should prevent you from storing film under the eaves of the attic, where temperatures can fluctuate, or in basements where dampness is a problem. If necessary, use a dehumidifier in your file area during damp seasons; an air conditioner is an excellent investment as well.

Photographic film is organic matter; as such it is subject to decay and deterioration. Chemical fumes, mold, and even small bugs can attack slides. Treat all materials with care and consideration; abuse them, or allow them to be subject to attack, and you'll not only shorten their life spans, you'll cut into your massive investment of time, money, and energy. Avoid excessive heat, humidity, and direct light, and store materials in safe sheets and outer containers. Understand the implications of the conditions in which you have your files, and be conscientious about their safekeeping.

Labeling and Cross-Referencing Slide Pages

Placing transparencies in titled pages is next in the series of filing-system tasks. Your own sense of order will dictate how this is handled, but here's a suggestion based on some experience: Select as many pages as you have headings on your list and place a 2 × 2 piece of white paper with the subject name

written on it in the upper-right corner pocket. Alphabetize the file pages and stand them up in a box; then place the box close to your light table or viewing area. As you take slides out of their present containers, place them under the appropriate headings in the page pockets. Do this until a subject page is filled, then place an empty sleeve behind the filled page and proceed as before.

Depending on the number of slides you have to file, and the total subject headings, this process can take days or weeks, so be patient. Don't edit too tightly at this time, but do eliminate extremely under- and overexposed shots, or those that have an obvious technical flaw. Put all duplicates, acceptable bracketed exposures, and variations on a theme into the pages.

More complete editing comes later—at this point, just concentrate on getting all your images into the easy-to-view pages. If you come across material that didn't show up in your initial scan, and for which you have no file heading, either make up a new subject page (and add the heading to your list) or put it aside for later consideration.

A number of roadblocks may slow your progress. Inevitably, you'll come across slides that aren't easily categorized, or those that you could easily place under more than one subject heading. For example, let's say you have distinct subject headings for "Boating" and "Docks and Harbors," and you encounter a picture of a pleasure boat moored next to some colorful fishing nets. This type of shot will require a judgment call on your part. Base the decision on your instincts as to which categorization will most readily lead you to the picture in your files.

If it's six of one, half-dozen of the other, place the slide in either subject file and begin to fashion a cross-reference list on what will become your Master File Reference. This is essentially a "see also" list. Let's say you have slides of Buddhist monks in the courtyard of a temple in Thailand. You have file headings under "Thailand," "Religion," and "Houses of Worship," and for ease of finding you decide to place the slide under "Thailand." In your Master Reference List you'd now note: "Religion": see also "Thailand," and "Houses of Worship": see also "Thailand."

Do this for every possible placement conflict as you encounter it, but take care not to get too obscure in your cross-referencing. Hone in on only those subject listings that will help you find a slide when you need it. You needn't cross-reference every object or possible clue in a picture.

Some pictures will not fit into any specific category. These usually include "art" shots, abstractions, and general nature scenics that speak of no particular time or place. While this subject matter is usually more difficult to market than more pointed images, you might as well file these slides under catchall subject headings such as "Color and Design," "Nature Scenics," "Trees," and so forth.

As you get more involved with the photo market, you may have to come up with some headings that at this point probably come as a surprise: such topics as "Transactions," "Emotions," "Blue," "Patriotism," "Parallel Lines," and other more abstract notions of what defines what's going on in the picture. In a later section of this book we cover Call Lists, which may prove to be a revelation on this matter. Just be prepared to change what you thought were excellent file headings!

Once the lengthy process of placing all your slides in pages under headings is complete, it's time to begin the equally grueling process of editing.

Manufacturers of Slide-Storage Equipment

The following manufacturers offer materials for slide storage, including pages, special cabinets, and accessories. Check your local phone book for office-supply companies that sell filing cabinets, self-sticking tabs, hanging-file folders, and other filing-system paraphernalia.

Advance Products
P.O. Box 2178
Wichita, KS 67201

DW Viewpack
113 W. 85th St.
New York, NY 10024

Elden Enterprises
P.O. Box 3201
Charleston, WV 25332

Franklin Distributing Co.
P.O. Box 320
Denville, NJ 07834

Kimac
478 Long Hill Rd.
Guilford, CT 06437

Kleer-Vu Industries
P.O. Box 449
Brownsville, TN 38012

Knox Manufacturing
111 Spruce St.
Wood Dale, IL 60191

Leedal/Matrix
1918 S. Prairie Ave.
Chicago, IL 60616

Light Impressions
P.O. Box 940
Rochester, NY 14603

Luxor
2245 Delany Rd.
Waukegan, IL 60085

Joshua Meier
7401 West Side Ave.
North Bergen, NJ 07047

Moorex
One Orchard Park Rd.
Madison, CT 06643

Multiplex Display Fixture Co.
1555 Larkin Williams Rd.
St. Louis, MO 63026

Nega File Systems
P.O. Box 78, Furlong, PA 18925

Neumade Products Corp.
720 White Plains Rd.
Scarsdale, NY 10583

Photo Plastics Corp.
P.O. Box 17638
Orlando, FL 32860

Plastican Corp.
33 Laurel St.
Butler, NJ 07405

RNI Photo Marketing
P.O. Drawer 638
Ocala, FL 32678

EDITING YOUR WORK

EDITING CAN BE A PAINFUL PROCESS, BUT it's necessary in order for you to make any progress in the market and enjoyable use of your photography. The first phase of editing is purely mechanical—it is to eliminate those out-of-focus, highly under- and overexposed and blurred pictures that always slip through into files. Though you may be reluctant to toss these shots out, there's no way that they should find their way into submissions, and their presence in your files just takes up space. They may be personal favorites, one-of-a-kind moments that you've become attached to, but let's face it, they are the results of foul-ups. They certainly don't present the professional image you wish to project.

Even though you may have a majority of excellent pictures in your submission to a buyer, sending along technically poor pictures with the lot will adversely affect your chances and your future business with a buyer. They'll look upon the poor pictures as filler, or, worse, conclude that you can't discriminate between a good and a bad photograph. The rule is: Submit your best, even if you submit less.

The next phase in editing can be described as educational—it's to become familiar with the quality level of what is being bought, and then come up to that level in your work. In order to be able to carry this phase out, you should immerse yourself in a study of the pictures used in magazines, textbooks, packaging, advertising, greeting cards—in whatever market you'll be trying to reach.

Spend time in the magazine section of libraries, browse the card racks in stationery stores, search out pictures in all possible areas of use. If you're interested in the travel market, for example, gather as many past and present issues of travel magazines as you can and study the pages. If you encounter a picture essay that was done in the same locale as one you have covered, so much the better.

In the course of your study, take the published pictures apart in terms of composition, balance, context, and angle of view. Note how intimate or removed the photographer was, what involvement people in the picture have with their environment, and the overall "feeling" the picture presents. Compare that coverage with your own. Be self-critical, don't balk at recognizing a need for change.

This recommended phase of editing is not meant to imply that successful sales rely on cloning the style or approach of already-published pictures. This would result in a constant repetition of the same pictures being published over and over again. It is meant, however, to provide you with a criteria for judging your own work.

You may come away from this with the happy surprise that your pictures meet or surpass those already published. In all likelihood you'll come up with a mixed bag—in some cases your strength will match that of what's being sold, and in others you'll begin to recognize the need for some improvement on your part.

One of the wonderful, although at times exasperating, aspects of photography is that there's always room for improvement. You can count on the fact that most published pictures are made by photographers who went through the same self-critical procedure that you must now endure.

There are very few perfect pictures—in fact, there are

mostly pictures that fit a certain need at a certain time. There's always room for a new way of seeing, a fresh perspective on what's been photographed before. The idea is to use this educational process as a way of increasing your chances of success. Never be negative about your work, or dwell on self-doubt. Education and an open mind will provide the keys.

The First Cut

Once this preparation is complete, begin to go through your various subject files. Cull out those shots that are "expressionless," that have neither visual nor contextual punch. Look for shots that communicate a sense of place, a feeling, or show a strong sense of visual impact. If in doubt, hold the slide for the next round of editing.

Your "firsts," the shots you keep in your picture file, should all be of top caliber. Competition is fierce in the market, and you'll always want to put your best work forward. Search out those pictures that best fit the profile of successful sellers, as well as those that best exemplify your unique photographic abilities and perceptions. Make an effort to be self-critical.

The watchwords of this process should be: Be merciless. Pull the seconds from your file, but don't toss them out just yet. Keep them in a slide box marked: "(Subject) Rejects."

Why save the rejects? In the earlier stages of editing work, you may unwittingly toss out a potential seller. Don't think every shot that's sold has to be a contest winner. In fact, you may have a very mundane picture that one day will earn you good money. It's one of the oddities of the photography marketplace, but it's a phenomenon that you should note.

For example, you may have a picture of people wheeling their shopping carts from the supermarket door to their parked cars—hardly the sort of image you'd expect to win a Pulitzer or to place first in an art contest. Yet, there may be a day when you get a call for a shot just like that one, and it may

end up selling better than the sensitive picture you took of a willow tree. "You never can tell what will sell" is a rhyme to keep in mind.

As well as honing in on your best work, the editing process will be an invaluable experience in that it will assist you in gauging your photographic strengths and weaknesses. For example, take a good look at your people pictures. Are you close enough? Do you depict a sense of involvement of the people with their environment?

Then check your locale shots. Is there a good sense of light, of composition? Is there a mix of horizontals and verticals (allowing an art director some leeway in layout), as well as potential cover shots with room at the top for the magazine title? Would a wide-angle lens have been useful, more effective? Make notes on ways to improve your work, then follow through in practice next time you're in the field.

Editing will be an ongoing process—each subsequent roll you shoot should be subjected to the same rigorous perusal. As your experience in the marketplace widens, you'll be continually going through your files and sharpening the look. Your standards will become more critical, your eye will become more tuned to the needs of the market. This can only serve you well as a photographer.

As you edit and shuffle your slides around, keep an eye open to the arrangement of pictures on the slide-storage pages. Envision that page in the hands of a buyer, and get a feel for the visual impact it presents. See each page as a whole, as well as a collection of individual images. Look for flows of color and design, and try to keep slides of equal density together. Although there will be instances when individual shots are pulled from a page for submission, other times will call for the entire page to be shipped. This isn't a crucial point, but it can give you an extra edge in the competitive marketplace.

Editing can be a painful process, but it's a necessary first step in gearing up for the stock photo market. Out-of-focus or poorly composed and exposed shots have no place in your presentations.

CAPTIONS, CODES, AND COPYRIGHT

THE NEXT STEP IN PREPARING YOUR slides for market involves the lengthy and time-consuming task of captioning. According to people from all areas of the photography buying field—editors, art directors, publishers, and stock-agency personnel—an informative caption can increase the salability of a photograph by 100 percent! In addition to this very good reason to caption, most stock agencies and editorial buyers will not even consider pictures without caption information. If you fail to caption upon submission, you'll probably get a call from the potential buyer for the information anyway, so save everyone time and money and caption before you offer your pictures for sale.

Captions should go right on the slide mount. Separate sheets can be supplied with supplementary information, but primary captions are most easily read when they sit right along with the picture. Obviously, there isn't a lot of space to work with in the confines of a ½″ × 2″ piece of cardboard or plastic, so being concise is very important.

If you have neat handwriting, you can write directly on the mount, but there's always the danger of the pen slipping or of your running into the classic "plan ahea/d" problem. The best method is to use peel-and-press labels, available from commercial stationery stores, upon which you can write or type as you see fit. Available on long rolls or sheets, these labels can be run through a standard typewriter, giving you an opportunity to type two or three single-space lines of about 20 characters each. Computer programs for captioning are also available, and depending on the typeface you can usually get more information on these than on typewritten labels. With either setup, there should be enough space for the information you need to communicate.

Captions should answer as many of the who—what—where—when questions that apply. Generally, the first line or word of the caption should match that of your file heading; the remainder of the cap can then be used for specific information. Having a caption that merely states, for example, that the photo was made in Mexico City will not be enough to add to its value through words. When composing captions, you must assume that the buyer has no idea what the shot represents, and that it's your duty to pinpoint information that will increase the possible field of coverage of the picture and thus the likelihood of sales in a number of different venues.

Let's take an example: You have a shot of a war memorial in an American town. It's located in a park surrounded by trees, and thus could be Anywhere, U.S.A. Without a comprehensive caption, there's a chance you might sell the shot as a generic "Monument" picture, but not a great one. But if the shot is captioned: "WW II Memorial, 3 Riv. Pk., Pitts., Pa.; erec: 1948; sclptr: Moebius," you have then pinpointed potential sales to illustrate books or articles on Pittsburgh, World War II monuments, and even on the sculptor Moebius. This series of notes expands the market range of the material, and, by using abbreviations, gives the viewer a broad range of information without cluttering the mount. (*Note*: Use abbreviations whenever possible—standard ones are listed in the back of most dictionaries.)

Jot Down Captions as You Shoot

Good captioning practice begins with taking notes in the field. While shooting, keep a small notebook or cassette recorder with you and jot down or record as much detail as you can about the area, objects, and people you're photographing. If the locale has a Chamber of Commerce or tourist information office, pick up all the maps, brochures, and descriptive material you can carry. These will become aids in jogging your memory when it comes time to caption processed film.

A recent assignment we had demonstrates the importance of such squirrel-like behavior. The story we were out to illustrate covered a broad excursion through the Ardenne, in Belgium, a region in which we had never traveled before. All we were given was a list of towns mentioned in the article, including places like Spa, Stavelot, Orval, LaRoche en Ardenne, Dinant—hardly household names.

Because of our experience with this type of assignment, our first stop in any town was the tourist information office, where we loaded up on maps and brochures. In addition, we kept a shooting diary, particularly when no travel aids were available. Roadside shots were marked on a map, as were out-of-the-way inns and restaurants we frequented.

This note-gathering turned out to be invaluable, because when we finally got to sorting slides it was very difficult, at first look, to separate one medieval ruin from another, one *auberge* from another small hotel. The shoot was so varied (it wasn't like one big effort in a small area) that without notes and guides our sorting would have been a disaster.

One picture we always tried to take, at least when we switched locations, was of roadside signs and historical plaques. These became visual reminders, a type of on-film memo, that helped us label rolls of film prior to finite sorting. It's rather amazing how the mind works—once you've ascertained where a roll was taken by one simple cue, the rest of the take seems to come back clearly into memory.

You may have the memory of that proverbial elephant. But if you're covering fifteen sites in two weeks, and don't get to caption the take until three weeks after your return, it's a good bet that you'll be hard-pressed to remember all the small, but pertinent, details of your shoot.

Those bits of information that are important may well depend upon your perspective, and the ultimate purpose of the shoot. If you shoot flowers for the greeting card market, for example, captioning the scientific name for a specific plant won't be necessary. If, on the other hand, you're shooting for a botanist's journal, then that specific information is essential to a sale. You may want to cover all bases by including the name of the flower, its habitat, and its possible nutritional and medicinal value. As stated above, the more complete the caption, the greater the market coverage the slide will have and the more likely the sale.

Common-Sense Abbreviations

Abbreviations are certainly helpful in the limited space afforded by a slide mount, but the shorthand should be understandable. Don't make up your own lingo—you may know of what you speak, or may feel that everyone across the country knows local expressions. Buyers, however, might be left scratching their heads in wonder when confronted with one of your captions, and this certainly won't help sales.

An understandable caption of a shot taken in the Luxembourg Gardens in Paris on Bastille Day in 1976 might read: "Paris, Fr., Luxembourg Gdns., Bastille Dy., '76." A typically incomprehensible caption could be: "G.O.B. w/bru @ Sm. B. Pic., Gv., T.75." This might make perfect sense to the caption writer as: "Good Old Boys having a beer at the Sam Bowie Picnic in Galveston, Texas, 1975," but won't get through to most picture buyers.

Caption as soon as possible after the shoot. Double-check your information on specific, and unfamiliar, pictures. A miscaptioned slide can cause embarrassment to a picture editor and result in the loss of a client for you. No one wants to

Keeping notes, and collecting brochures and pamphlets as you travel, will be a great aid when it comes to captioning the shoot later.

appear foolish, especially when they're on the staff of a high-circulation magazine. If they feel that your captions are suspect, they'll hesitate to buy from you; it's as simple as that.

Providing Background Information

Many times, a picture editor will call back for very specific information on a photo, and this is where your backup information comes to the rescue. Not long ago, we received a call for pictures of Rome, a very broad topic on which we have extensive file coverage. Upon investigation, we learned that the article for illustration was titled "Michelangelo's Rome," and as the editor skimmed the text with us we found that appropriate pictures would be of the artist's works and the locales which he may have frequented when in Rome.

Needless to say, this required extensive research, first ascertaining which areas of Rome were active during the sixteenth century, and second, where Michelangelo's works were located today. We consulted three file areas: "Rome," "Statuary," and "Vatican City," and pulled all pertinent slides. Then, we consulted a brief history of the city and trimmed the submission accordingly.

Homework done, we shipped the slides. A few days later, we received a call from the picture editor with a list of questions. What are the names of the columns in our shots of the Forum? What is the name of the bridge over the Tiber that we had in a sunset shot? What year was Michelangelo's *Moses* completed? Who were the characters in a panel in the Sistine Chapel? Once again, we had to research our topic.

This incident caused us to make a number of changes in our captioning procedure, and to draw conclusions about filling the needs of editors and buyers. Though you may find that such attention to captioning is unnecessary, we've found that all our research has paid off, first in broadening the range of each picture, and second, and perhaps most important, in projecting an image to buyers that we're thorough and concerned with helping them get the most out of the product we offer.

In this situation, we, as the photographers, were being asked to function as caption writers as well. Apparently, the story was already in-house, the writer paid, yet no illustrations were available. A few days of research landed a good sale, and we learned a lesson in the bargain. From that day forward, our captions, and our backup notes, became much more precise. And our sales have reflected the attention we gave the material. Here are some captioning tips:

1. Generic captions are fine for filing, but need fine-tuning for hard sales.

2. If captioning an historic scene, include specific names, dates, locations, and other references.

3. Research a topic as you go; become a consummate tourist and immerse yourself in the subject matter. Keep notes, and file notes where they can be easily referenced.

4. Be prepared to back up your initial captions with even more thorough research. Most times you won't be called upon to be both caption writer and photographer, but you'll certainly raise the sense of professionalism of your operation if you can help editors out when they need more information.

5. Assume that a buyer knows little about the subject matter, and be prepared to be an authority on a picture you might have made while just "passing through."

6. Design your captions as information, not as entertainment. As they used to say on *Dragnet*, "Just the facts."

The Model-Release and Copyright Notations

Another piece of information that should be placed on the mount, though it has nothing to do with where or when the picture was made, is a model-release notation. This is very important in many markets, particularly advertising. These notations, which should go in the upper right-hand corner of the slide mount, include MR (model release available), NMR (no model release available), PR (property release available), and NPR (no property release available).

The marks will tell a buyer that there are certain markets in which the picture can and cannot be used. Model-released photos of people are certainly easier to sell than those without such a release, and most advertising firms will not even look at people pictures that lack a release. But if you don't have a notation on the slide, the buyer will have to call you back for the information or might assume that you don't have a release. Save both yourself and the buyer time by making sure you include these small notes on the mount. If, however, the shot is a "generic" one, such as of the Taj Mahal, no release information is necessary.

A very important piece of information that you *must* put on the mount is a copyright notice. This should read:

© (Your full name), 19--.
ALL RIGHTS RESERVED

This not only identifies the slide as yours, it serves notice that you are the owner of all rights on the picture, and that only you can assign and lease usage of that image. Without that notice, you put every slide you send out in jeopardy. With that notice, you provide legal protection for yourself and the image. A simple rubber stamp can be used to mark slide mounts with the copyright line. Don't let a slide leave your files without it.

An optional piece of information you can put on the mount is your full address. If you have no room for this, attach a preaddressed sticker on the back of the mount, or imprint it with a rubber stamp. The reason this is optional is that you may move every so often, and changing address labels on your entire file can be a real pain in the neck.

The case for including full address labels is that slides can become separated from their mailing envelope or reference sheet as they bounce around the buyer's place of business, or even at the printer's while being prepared for publication. Most people you'll be doing business with are careful about original work, but even in the most orderly environment pictures can go astray. So use an address label as a safeguard, but only if your lease is long-term.

Encoding Slides for Quick Identification

Another optional, though important, caption is a slide-numbering, or encoding, system, which will enable you to identify and locate each individual picture in your files. A number or letter-number encoding system accomplishes many things.

1. It assigns a definite place in your files for each and every picture, a slot in which the slide resides and returns after submissions. This is a great help in refiling.

2. It gives you a reference number to use for invoices, rather than a blow-by-blow description of every picture you send out. An efficient code will make transactions simpler.

3. It makes cross-referencing specific to certain images, rather than to a broader topic listing. You can make your see-also list with coded numbers within even major files.

4. This setup makes the logging-in of new material easier. A

system that works with numbers can give you a specific count as to how many pictures are in a certain file, and then can be expanded just by adding more numbers to the slides as they are logged in. Thus, your last slide in a file will give you the total count under that topic.

The only real disadvantage to starting an encoding system for your slides is the extra labor involved in getting it going. Although no absolute quantity can be given as a cutoff point, a file of 5,000 slides or less may not require the services provided by encoding. With a relatively small library such as this, simple visual inspection (coupled with topic headings and a cross-reference sheet) will help you locate a slide readily enough. However, larger collections certainly will benefit from setting up a coded system.

The system can be made versatile enough to include keyed information about the subject matter of the slide being coded. It can also be a "cold" numbering system. The first type of encoding requires more work, but in the long run it is probably more useful. Let's say you're encoding your "New Mexico" file, and decide on NM as the file abbreviation-prefix. Each slide in the group thus becomes: NM1, NM2, NM3, etc. To give even more precise information, you might decide to expand the prefix with specific information within the topic, such as: NMSF1 (New Mexico, Sante Fe, #1), or NMCC2 (New Mexico, Carlsbad Caverns, #2), and so forth. Each time you assign a prefix, note it on a separate sheet and be sure not to duplicate your prefixes in any other part of your files.

With this setup, each time you add a slide to the file, you merely add another number to the series. This setup has the

attraction of making each slide a unique unit, and it makes refiling and billing easier. It does mean a lot of initial work and continuing work as long as you keep logging in pictures.

Another slide-tracking system used by many photographers is one in which each slide is assigned an arbitrary, though unique, number. You can work with the date on which the picture was made (6–21–87–3 would indicate the third slide filed or shot on June 21, 1987) or with any number from zero to infinity. This setup is attractive because you can get numbers from sequential numbering stamps available in stationery stores or from twin-check labels used in large photofinishing plants.

Whatever setup you choose, once a slide is coded it is also a good idea to assign a definite "home" for each picture you file. This is done by duplicating the code on a self-sticking adhesive label and attaching it to the pocket on the slide-viewing sheet where the slide resides. This provides a quick, visual reference that tells you which slides are out, and will cue you to check delivery memos or invoices as to which buyers have what material in their possession.

A coordinated system of checking up on slides out of file is to place a white, 2″ × 2″ note in the picture's file-home. This note will let you know who has the image, when it's due to be returned, and whether a sale is made or pending. Of course, all this information should be fully spelled out in your pending invoice-correspondence files. The "home-note" will be a great help in making sense of the seemingly endless paper trail, and most of all, it will cue you in on any overlooked transactions.

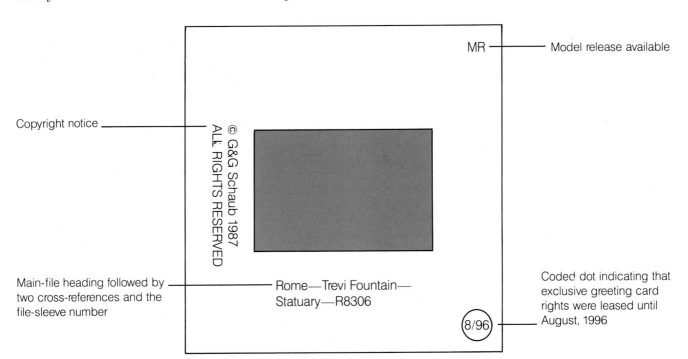

Captioning your slide mounts is always a good idea. A copyright notice is mandatory. A model-release indicator tells the client if a model release is available (MR), if no model release is required (NMR), or if a property release is available (PR). The filing information includes a sleeve number that is used to locate the number, return it to the file, and as an invoice reference number. A self-sticking dot can be coded to show what rights are limited for release to certain markets.

The Rights-Sold Notation

Another item you might want to put on your slide mount is a "rights-sold" sticker. In most cases, you'll be leasing pictures for one-time, nonexclusive usage. There are occasions, however, where exclusive rights, limited by time and specific markets, will be purchased.

One of those market areas is greeting cards—here, you're expected to sell exclusive, worldwide greeting card rights, sometimes for a specific period, other times "forever." Another market area that often demands exclusive rights is in advertising, where a package or display advertising designer will want to lock in your picture for a few years, or at least as long as the campaign that uses your image continues. Keep in mind that you're giving up certain rights to resell the picture but not your copyright on the image itself. This is a very important distinction. Full buyouts are another matter.

Naturally, selling exclusive-to-market or time-inclusive rights has the affect of lowering the marketability of an image, and in most cases this doesn't help out your cash flow. But in the cases cited above, the need for these exclusions becomes obvious. No greeting card company wants to pay for a particular picture that then appears in a competitor's line, and this is also true for a company putting on an ad campaign or product promotion. Companies pay a great deal of money to produce and promote an image. However, you should give up these rights selectively.

Once you sign a rights-exclusive contract, real trouble will ensue if you don't honor the terms, even if the subsequent sale is an oversight on your part. For that reason, assign a code and have a referral chart for exclusive rights sold, then enter that code onto the slide mount. A space-efficient way of doing this is to use small, color-specific dots available in stationery supply stores. For example, a red dot may indicate "exclusive greeting card rights sold," and this will bar the slide from future submissions to other greeting card companies. A blue dot may indicate "exclusive five-year rights sold," and you might want to date the dot to give you the full term of the agreement.

Customizing Your System

There can be no single captioning, encoding, or numbering system that works equally well for every photographer. Just as file headings are subjective, based on market targets and individually meaningful cues to finding an image, so the captioning and coding should be based on the particular logic of the person handling the files. The point is to pick one system and stick with it. Think it out well before you begin, and be sure that whatever setup you choose has the capability to expand and grow along with you.

Even though you may have your mount captioned to capacity, be prepared to recaption your slide after it has returned from the buyer—in order to make separations, almost all repro houses slit the slide out of the mount, and there's no guarantee that you'll get the transparency back in the same mount in which you sent it. If you do get the same mount back it will probably be damaged in some way—if only with a slit through it—and you should remount it before submitting it to another potential buyer.

If you get your image back in a generic mount and have to research and caption it all over again, you will be pleased that you kept all your caption information handy on a separate sheet of paper ready for reuse.

Computers can be a great aid in captioning, as each coded slide can have caption information in storage to be recalled when needed. There are even programs that, allied with specific printers, will print out 35mm mount-sized captions on adhesive paper. Designed for the larger library, these programs are invaluable in cutting down on the amount of time needed to organize all the slides you wish to circulate. Check out your local software outlet for specific details.

A MASTER LIST FOR BUYERS

DURING THE FILING, EDITING, AND cross-referencing procedure, you have been making a list of section headings. This is an ongoing job, and each new file you create should be included.

At one point, usually immediately before you make your first forays into the marketplace, you should sit down and prepare a Master List of all subjects that you'll be offering to buyers. The Master List can be prepared in any number of ways, including straight alphabetical listings, grouped listings, or listings geared to a particular market segment. Having this list will improve any sales effort.

Not every client with whom you deal will benefit from receiving your Master List, but magazine editors, textbook publishers, features syndicates, and advertising agencies will often demand such a list before they consider you to be a source for pictures. Here are some lists you might consider making of your work.

The Alphabetical Listing

The alphabetical listing is just that—it shows every major topic in your files. You might want to aid buyers by indicating areas in which you have heavy coverage with an asterisk next to the file name, or by using boldface type. This should be typeset on a letterhead or other business form bearing your name and address. Don't print hundreds of Master Lists the first time out; just make enough to cover your initial mailings, then update them every six months or so as new topics are added to your files.

Group-heading lists help buyers focus directly on their needs. Rather than having your "Country" coverage, for example, spread throughout an entire alphabetical listing, you can have a major listing "Countries," below which you specify such entries as Armenia, Brazil, France, or Germany. This can apply to any other select listings where you have extensive coverage. For example, under "Fishing" you might list Boat, Commercial, Fly, Pier, Trout, etc; under "Cities" you can show Atlanta, Boston, Chicago, and so on.

An even more specific way to show what you have to offer is to prepare separate lists for very select markets. Travel markets, for example, will need to know more than that you have coverage of a certain country or city; they'll want to know festivals, areas of the town or country, people, and seasons in which you have pictures of a certain place. Such a list is helpful because it serves as a way for buyers to pinpoint you quickly as a picture source.

Rather than merely naming, for example, "Paris," you might list all the sights in the city under that main heading: Eiffel Tower, Les Halles, Montmartre, Notre Dame, Ile de la Cité, Pont Neuf, etc. This specificity may make a difference in whom the buyer picks up the phone to call first. In a competitive market, you need every edge you can get.

A personal computer (PC) is a tremendous help when compiling and updating your Master List. Retyping every time a new topic is entered can become tedious, and may even stop you from entering updates quickly. A basic word-processing program will allow you to insert and print out topics on a day-to-day basis. Also, the PC can sort topics, making it easy to customize lists for selected clients.

Typical Picture Lists for Buyers

Here's an example of an alphabetical Master List with asterisks to denote in-depth coverage.

A
Abstracts
Agriculture
Airports
Amsterdam
Antiques
Antwerp
Architecture
*Arizona
Arles
*Atlantic City
*Autumn

B
Bahamas
*Bangkok
Barns
Bastogne
*Beaches
Belgium
Bicycles
Birds
*Boats
Boston
Bridges

C
Cactus
California
*Camping
Carnivals
Caves
*Chicago
Children
Churches
*Clouds
Colors
*Computers
Construction

D
Dawn
Demonstrations
*Denver
Deserts
Docks
Dunes

E
Ecology

Education
Elections
*Erie Canal
Evening
Everglades

F
Farms
Fishing
*Flags
Florals
*Florida
Florence, Italy
Food
Forests
*France

G
Gardens
Germany
*Glacier Nat. Pk.
Graffiti
Greece

H
*Halloween
Harbors
Height
*Hiking
Hong Kong

I
Ice
Indiana
Iowa
*Italy

J
Japan
Jelly Beans
Jersey City

K
Karate
Kids
Korea

L
Lace
Lakes
*Las Vegas
Laziness
Leaves
Logging
*Los Angeles

M
Marathons
*Mardi Gras

Masks
Mexico City
Mohawk Riv. Val., NY
Monet Gardens
*Montana
Monument Valley

N
Nature Scenics
*New Mexico
*New Orleans
Newport, RI
*New York City
Night
*Nova Scotia
Nuclear Power

O
Occupations
Oregon

P
Painted Desert
Palm Trees
Parades
*Paris
People
Philadelphia
*Pinball
Politics
Psychology

R
Raritan Val., NJ
*Reims Cathedral
Rodin Mus., Paris
*Rome
Rowing
*Running
Rural Scenes

S
*Sailing
San Antonio
San Diego
Sand
School
Spring
Statuary
*Summer

T
Tap Dancing
Tools
Trailers
Travel

Trees

U
United Nations

V
*Venice
*Vermont
Versailles
Vietnam Mem., DC

W
Wall Posters
*Weather
*Western Landscapes
West Point
Winter

Y
Yellowstone Nat. Pk.
Yosemite Nat. Pk.

Z
Zion Nat. Pk.
Zoos

A Topic Heading List, derived from the same file that yielded the alphabetical Master List might look like this:

Abstracts
Color and Design
Geometric
Multiples
Nature

Boating
Docks
Pleasure
Power
Sail
Working
Yachts

Cities
Amsterdam
Antwerp
Arles
Atlantic City
Boston
Bruge
Chicago
Cologne

Denver
Florence
Halifax, NS
Hong Kong
Indianapolis
Iowa City
Las Vegas
Los Angeles
Mexico City
Newport, RI
Paris
Philadelphia
Portland, ME
San Antonio
San Diego
Santa Fe
Venice
Versailles

Countries
Bahamas
Belgium
Canada
France
Germany
Greece
Italy
Japan
Mexico
United States

Ecology
Agriculture
Animals
Beaches
Clouds
Construction
Deserts
Forests
Farms
Gardens
Lakes
Mountains
Swamps
Valleys

Festivals
Carnivals
Chinese New Year
Christmas
Easter Parade
Halloween
Mardi Gras
New Years
Rodeos

Education
Art Students
Colleges
Computers
Grade Schools
Martial Arts
On the Job
Religious Training
Vocational Schools

Farming
Agriculture
Animals
Barns
Fields
Haystacks
Harvest
Irrigation
Plowing
Tractors

Gardens
Beekeeping
Cultivation
Formal
Greenhouses
Monet Garden
Organic
Topiary
Vegetable
Versailles

National Parks
Carlsbad Caverns
Cape Breton Highlands
Everglades
Glacier
Great Smoky Mountains
Yellowstone
Zion

A select list, say, for the travel market is helpful for pinpointing sales. Here's a sample listing:

Belgium
Antwerp: harbors, cafes, Rembrandt House
Bastogne: Battle of Bulge Mem., McAuliffe Sq., Malmedy Mem.
Bruge: architecture, cafes, costumes, Memling Museum
Brussels: general scenes
Dinant: fortress, river, cafes
Francorchamp: inns, Grand Prix
LaRoche en Ardenne: fortress, market
Malmedy: Memorial
Orval: abbey
Semois River: camping, kayaking
Spa: baths, nature trails, Ardenne Forest, natural springs
Stavelot: Circuit museum, abbey

Florida
Everglades: flora, fauna, trails, tourists, boat rides, Seminole Indians
Cape Kennedy: space shuttle
Homestead: vegetable stands, farms, migrant workers
Key West: architecture, boating, highway, food
Miami: Art Deco hotels, street scenes, Orange Bowl Parade
Orlando: Disney World
Palm Beach: Flagler Museum, country clubs, shopping
Singer Island: resorts, hotels
St. Augustine: docks, historic houses

Thailand
Bangkok
Bazaars
Buddhism: statues, monks, temples
Chang Mai: temples, monks
Floating markets
Oriental Hotel: lobby, tours
School children
Thompson's Silk House

Another facet of the Master List is a travel itinerary, a futures call-board that lets clients know where you're going and when you'll be traveling. By keeping clients aware of your activities, you may be able to pick up an assignment on the road or fill a need for an upcoming issue of a magazine. Most publications have an editorial plan that looks months ahead, and although the editors may not be working on a future article at the moment, they usually know what's going to be needed down the road. Keep in touch with them, and you'll be surprised at how much extra work you'll pick up.

How Picture Buyers Use Master Lists
In order to understand the importance of a Master List, let's go to the other side of the desk and put ourselves in the shoes of a picture buyer. Let's say the buyer works for a national travel magazine. Each month, he or she receives an editorial lineup, projecting articles to appear sixty or ninety days ahead. Some of the submitted articles have complete illustrations provided, others have partial or poor picture coverage.

At that point, the picture editor has a few weeks to get the best possible illustrations he or she can for the article. Over the years, buyers have developed reliable sources for many areas of coverage, and their first instinct is to call agencies or individual photographers who have come through for them in the past. They usually don't have trouble locating pictures from major tourist areas, such as Yellowstone National Park or Mexico City, but not every article deals with these well-traveled locales.

Once they've tapped familiar resources, the picture editors will then resort to poring over Master Lists submitted by freelancers. In their search for, say, a photo of a small-town rodeo in Wyoming, they may come across your Master List that includes "Wyoming, Rodeos," or "Western Towns, Festivals." That's where the specificity of listing comes in, and that's when you'll probably get a call. (For further discussion on dealing with travel buyers, see the section on "Editorial Markets.")

Once you deal professionally with a buyer, you're more likely to get a call the next time around. When he or she sees that you're a consistent supplier of good photography, you'll then join the buyer's list of regular sources. That's how it works—there's no magic involved. It's just getting a first lucky break, then following through. For now, suffice it to say that Master Lists are one of the most important ways in which you let buyers know what you have to offer.

COMPUTERS CAN HELP

THERE'S NO QUESTION THAT A COMputer can be a great help in running a photography-marketing business. It's a perfect filing tool, designed to take many pieces of information and sort them out efficiently. Software can handle billing, create a file-and-retrieval system, tell you where slides are and notify you when they're supposed to return, provide ready-made forms, and make invoicing and mailing easy. In short, a computer setup can help you run a tight ship.

Of course, no software program exists that you can plug into a slot and have all your slides filed, contacts listed, and business forms up and running—*you* are the one who'll have to program and type in all the nitty gritty information. Just as sorting and editing your slides takes a good deal of time, keypunching all the necessary data to make the system meaningful to your business will be an ongoing and enormous drain on your energy and effort. Yet, all that work will have to be done anyway, so why not get it plugged into a form that is certainly more cohesive than a mass of 3 × 5 cards and bulging paper files?

Assessing Your Computer Needs

The decision whether or not to computerize should be based on a number of factors, the first of which is cost justification. If you're planning to run a part-time business with, say, under 5,000 slides, you may not need the services provided by a computerized setup. A computer system, with the capacity to handle most of the affairs of the trade, will probably run between $3,000 to $5,000, including basic software. Even if you expect to earn double that figure in the first two years of operation, you still may have more informational capacity than you really need.

The second factor to consider is that of time, probably the most valuable asset one has. Assuming that you'll be running the business on your own, or even in concert with a friend or spouse, a good deal of time will have to be spent staring at that little green screen. While there's no dispute that a computerized operation has the potential to save time, regardless of the size of the operation, you'll have to weigh the benefits gained against the time spent keypunching.

Those taking a casual approach to this endeavor will find that feeding the program facts and figures probably takes up more time than it's worth. Keep in mind that you want to save some of the valuable time in your life for creating, for making the photographs that are the main impetus for this effort in the first place.

But for those who want to dedicate themselves to the task of building an ongoing photograph-marketing business, and whose picture file numbers above 5,000, a computerized setup is a tremendous help and a natural way of handling the mass of data storage and retrieval required.

Researching Computer Options

Once the decision to computerize is made, you need to answer a number of questions before you go out to buy a system. You can't simply put down your money on a system just because you've heard it touted in advertisements—you must go in armed with facts and a list of needs. Find a helpful

salesperson who'll take the time to sit down with you to figure out what's right for you. You should even consider taking an introductory training course before you finally commit to a particular brand or capacity of computer.

The first thing to do is make a list of what you want the system to do for you. A typical function list might include: an accounts and contacts file, with room for comments; a billing system, with accounts receivable, gross billing, and revenue projection capabilities; a filing system for slides, with ability to handle a large volume of small units of information, along with a cross-referencing key setup; a merge or collating capability, in which diverse bits of information can be assembled through a computer-led search; a bulletin board for memos and reminders; a form-creating system, in which invoices, delivery memos, and other business documents can be held and then retrieved for each transaction; a red-flag calendar and billing system, which would announce slides that are overdue from buyers; a mailing list generator, which would collate and order to print selected names and addresses from a master mailing list; a word-processing program for business correspondence and caption writing; and whatever other functions you deem necessary for your operation.

Add to that a good quality printer, a modem (for plugging into market networks and other electronic mail systems), and expansion modules for increasing storage capacity as your file needs expand, and you've got a basis for discussion with a computer salesperson.

The sound advice given by computer experts is to "shop for the software; then buy the hardware that will run it." This means that you should first locate the programs that will handle your needs, then get the computer that will handle that software. If you feel you have the time, you can get an "open" program, or a data base managing system, but this requires a fair amount of programming knowledge, and dedication of time, to get going.

A good number of software programs already exists, and more come out every month, geared toward every phase of business, and, more specifically, to the photography and photograph-marketing businesses. Check the photography trade books for appraisals. If you can, get an introductory packet from the maker (often available at a fraction of the full program price, usually applicable to the purchase price if you decide to buy) or get a run-through of any program you're contemplating before buying.

Another good piece of advice is to begin your work on a computer with a single task and hold off expanding into other problem-solving situations. In other words, don't expect to get your slide files, mailing lists, and accounting going at the same time—don't have a grand opening of all departments. Get one function on-line, work out the bugs, and then move on to the next area of organization. This advice is especially good for those with little or no experience with computers, as well as for those whose budgets preclude making a large, overall investment in a do-everything system.

Evolution is the key to the process of computerization. As you learn more, and earn more, you can begin to invest in more sophisticated programs and modules. So start with one function, say, billing, and go from there. Just be certain to get a system that can grow with you, that will continue to meet your needs as you expand. Work with a reputable computer salesperson, and take a good, hard, long look before you plunk down your money. Too many people have made rash purchasing decisions, only to find that they outgrow the capabilities of their system before they've paid off the installment loan.

Computers can be a great aid in handling the business-end of your stock photo sales. Along with providing quick access to picture files, they can be used to keep track of clients, store correspondence, make and file delivery memos and invoices, and even print out labels for slide mounts. Keep in mind, however, that you'll have to keypunch all the information into the computer yourself.

THE PAPER CHASE

IF YOU'VE EVER HAD THE RARE OPPORTUNITY of working in a corporate office, you know about the huge quantity of paper that can be generated every business day. Running your own photograph-selling business doesn't mean that you'll be exempt from this paper chase. Although the forms and stationery required for doing business are fairly standardized and straightforward, you still have to record and file every transaction that enters and leaves your place of doing business. You might not have reckoned on this record-keeping when you first thought about selling your pictures, but failure to keep accurate records will result in a loss of control and inevitable confusion. In the real world, this confusion will lead to discouragement, and in all likelihood, failure.

We've talked about many of the aspects of record-keeping: making Master Lists, caption files, picture-information notes, and cross-referencing. Now let's look at some other essentials of a well-run photography-marketing business.

Professional Packaging

Projecting a *professional* image is important in this business; promptness, reliability, and, as your third grade teacher once warned you, neatness count. If a buyer receives a scribbled handwritten note requesting guidelines, or if a picture submission arrives in a sloppily presented package, then more often than not the correspondence will be ignored or dismissed. You may have the greatest pictures in the world sitting in your files, but, human nature being what it is, the style of presentation is what will at least get you in the door.

With that in mind, order your letterheads from a commer-cial printer. Don't go for overly showy or pretentious logos on your stationery—keep it simple and stylish. Many times you'll be sending large packages of slides or prints and tear sheets. Rather than have oversize envelopes printed, invest in press-and-peel address labels. These can be used for a mailing of any size. While you're at it, have large labels printed with your mailing address, useful for "Stamped and Self-Addressed" submissions.

You'll also need a supply of shipping cardboard (to keep the damage to a minimum when running pictures through the postal gauntlet) and such shipping labels as "Fragile," and "Photos—Do Not Bend." Preprinted request forms, for sorting mail and telephone requests, can also be helpful.

The Submission Form

Two forms are an absolute necessity, one for making submissions and one for final invoicing. The submission form is one that accompanies the slides you send on "approval," and it states the number and code (or title) of pictures being sent to buyers for consideration. A number of submission forms have been suggested by professional photographic organizations (the ASMP and the Advertising Photographers of America [APA]), and each version varies slightly in stated terms. Whichever you choose (a sample form is on page 58), make sure it does the following:

1. Lists your name and business address, the editor or buyer who made the request, the potential buyer's address, and the corporation to which the pictures are being sent. This way there can be no confusion about accountability.

2. Fully lists the pictures sent, their identifying numbers or

description, their presentation format, the total number sent, and the date of mailing or delivery.

3. States that all photos are copyrighted and fully owned by you and that no reproducing, duplicating, or copying may be done without your consent. If any photos have had restricting rights sold previously, this must also be stated.

4. Notifies that no transparency may be projected for inspection, and explains that projection, no matter how short, will have a debilitating effect on slides. If a number of buyers decide to project to inspect the slide, the effect will be cumulatively destructive.

5. Notifies of liability on the part of the buyer for loss or damage of the work. Over the years, a court-approved figure of $1,500 for each slide has been used, subject to arbitration. Most buyers are aware of this figure and will respect material accordingly. (Note that some buyers will balk, or flatly refuse to recognize their liability, and will state this in their guidelines. In this case, you might decide to refuse to deal with such clients, or send only duplicates on approval.)

6. Announces your (optional) holding/research fees. Holding fees are common practice with professionals and stock agencies; they stipulate that any pictures held over a certain period of time (say, two to four weeks) by a buyer are subject to a per diem charge. This is done to encourage buyers to make up their minds, to help keep your pictures in circulation. The fee is usually waived if a purchase is made, or is canceled if the buyer indicates a strong interest in some of the submitted work and returns the remainder promptly. The customary fee is $5 per week per slide beyond the agreed-upon date.

A research fee is a one-time surcharge that covers your expenses for selecting pictures from your files for a specific call for images. Obviously, you can't charge a research fee for a "blind" submission. Most stock-picture agencies use research fees to keep up their cash flow. Those of us who market on our own rarely make use of them. You might decide to make use of this charge once you get a firm footing in the business.

7. Notifies that any disputes (over unlicensed use, loss, or damage) involving the photographer and client will be brought in the home courts of the photographer (if under the ceiling for hearing in a small claims court), or in any court of law of your choosing, and that in cases of liability or infringement all attorney and court costs will be borne by the buyer.

8. Notifies that unless written notice is received to the contrary, all terms of the submission memo are binding.

Please note that any contracts should be constructed with the aid and advice of an attorney, and that I am not an attorney. The above terms are guidelines followed by many of today's selling photographers. Amend and add to it as you see fit.

Also, note that all the items covered in the suggested form are there to protect your pictures and your rights. Don't take verbal assurances from buyers that a contract is unnecessary and that "Of course, should anything happen you'll be covered." The buyer may be well-intentioned and honorable, but when push comes to shove a written agreement will have more weight than any "good buddy" handshakes.

By agreeing to the terms of your submission memo, the buyer is showing respect for you and your valuable images. Too many times, photographers are bulldogged by buyers and their corporations and made to feel as if their rights in a business agreement are small indeed. Remember: The pictures you send are your lifeblood, your precious inventory worth their weight in gold. They must be protected from the devil-take-it attitude of some buyers. Let them know you mean business—you'll get more respect for it.

Packing a photo submission: A typical mailing includes sleeved and captioned transparencies, delivery memo, and an updated stock list. Use solid, strong cardboard mailers, and always choose a return-receipt form of delivery. Many buyers also request an SASE with submissions.

The Invoice

The other form you'll need is an invoice. After submission, a buyer will contact you and tell you which pictures he or she wants to use, and how they will be used. The buyer may state a price up front, or will simply say "Send me an invoice." The price may be based upon a rate sheet sent along with the buyer's guidelines, or you may have to negotiate a price on the phone. ("How Much Is That Picture Worth?" describes the negotiation process.)

An invoice is more than just a bill. It states the rights you're granting and defines what uses a buyer can and cannot make of a picture for the money paid. It restates the liability clause, requests tear sheets, and notifies the buyer that any uses beyond those granted will invite further negotiation and charges. It should also notify the buyer that a copyright notice must accompany publication, and that rights granted to the buyer cannot be transferred. A sample invoice is shown here for you to use or adapt as you see fit.

Business Procedures

A business filing system is necessary for quick reference of all invoices, delivery forms, and picture requests. A simple In–Out setup is best, with papers filed by date. Let's follow a few transactions through a normal course of events and see how the paper shuffles.

You receive a call or letter from a buyer, requesting pictures covering New Orleans' Mardi Gras. You fill out a request memo and file it with date due on your research bulletin board. Then you pull the file and select twenty images. In each pocket from which you've taken a slide, you put white 2×2 notes on which you write the date pulled, the potential buyer, and the expected return date of the slide. You also flag the file (with a stick-on memo or red stationery flag), signaling you that pictures have been pulled and submitted from that file location.

You then fill out a submission memo listing all the slides sent, keeping the carbon for your files and sending the

This is the form we use in our submission of prints and transparencies to our clients. For your own submission form, you may want to add or delete certain provisions, and to consult with a lawyer to make certain it meets your specific needs.

SUBMISSION FORM

G & G SCHAUB

TO: Carol D'art
Acme Magazine
1234 Main Street
New York, NY 10000

DATE: 10/22/87
CLIENT: Acme Magazine
EDITOR: Susan Wild
JOB #: 12345
OUR FILE #: R8307

#	DESCRIPTION	FORMAT	COLOR	B & W
	(Show ID#s, describe shots) Example:			
(20)	Venice, canals	35mm	*	
(10)	Florence, statuary	35mm	*	

Important Notice: The enclosed photographs are for inspection purposes only. No rights are granted, except with proper invoice or purchase order, with rights requested clearly noted. Photographs are submitted for inspection under the following conditions:
1. All care must be taken to protect valuable photographic work. Client is responsible for loss or damage, and liability is set at $1,500 for each transparency and $_____ for each print lost or damaged.
2. A reasonable amount of time is granted for inspection of work, but after _____ days a charge of $_____ per day per print or transparency will be assessed as a holding fee.
3. Photographs or transparencies should not be duped without written permission from G & G Schaub. Transparencies should never be projected.
4. No rights are granted without written permission from G & G Schaub.
A purchase order or invoice must be received by G & G Schaub before any rights are granted from copyright holders, G & G Schaub. Likewise, no subsidiary or ancillary rights are granted without permission.
G & G Schaub must be notified of any objection to these terms within one week of receipt of this submission form. If no notification is received, it is assumed that client accepts all terms.

original out to the buyer. The submission file is best kept in date-order, within which you file memos in alphabetical order by client. This lets you make periodic checks on what's out and when it's due back. If you find that pictures are held too long, a phone call or inquiry note is in order to learn the status of the transaction.

After a period of time, all or part of your submission will be returned. You then will immediately file unsold returns, removing the 2 × 2 reminders in the slide sheets and checking off number codes or titles on your original submission memo. When a picture is held by a buyer or is purchased, fill out an invoice and send it off, keeping two copies for yourself—one to attach to your correspondence file (call or submission memo) and one for a regular balance-due file.

When you've been paid, mark both invoices accordingly but be sure to keep all correspondence in the active file until all slides are returned from the buyer. It may take a month to six months for purchased images to be returned, especially with the long publication dates of some magazines and most books. Anything beyond four months from date of purchase to return should be followed up strenuously, as you're losing possible sales when that image is out of circulation. (Remember that making a sale does entail having the picture out of your hands for quite a while.) Keeping your images moving is a key to success in this business.

Once all materials have been returned, and your invoices have been paid, put the paperwork in a storage file for as long as your accountant deems necessary (usually seven years). If you're computerized you won't need to have reams of paper sitting around, and that's one reason to consider this option for record-keeping.

Another scenario involves "blind" submissions, in which you play picture editor in response to a general call for greeting cards, posters, and other paper products. These come from guidelines issued on a general basis to inquiring photographers, and may include broad topics such as "In-

INVOICE

G & G SCHAUB

CLIENT: Carol D'art
Acme Magazine
1234 Main Street
New York, NY 10000

INVOICE #: 254
CLIENT P.O. #: 1080
EDITOR: Susan Wild
DATE: 12/6/87

#	PHOTOGRAPHS	RIGHTS PURCHASED	AMOUNT
	(Describe individual picture or sets, with file ID#s, etc.)	(List rights)	
1	35mm transp.: Maine coast M34	1st NA, unit opener	$250
3	B & W 8 × 10: Cape Kennedy	One-time, 1/2 pg.	@ $50 = $150
TOTAL			BALANCE DUE:
4			$400

Terms of sale: Purchase is of photographs and specific rights shown. No other rights are granted. All requests for subsidiary, edition, or secondary rights must be made in writing and must be accompanied by a purchase order.
Liability: These valuable photographs must be protected from loss or damage. A value of $1,500 for each transparency and $_____ for each print is set on work, and client assumes full responsibility for these amounts. All photographs are copyright G & G Schaub. A copyright notice must appear with all reproductions.
Terms of payment: 30 days, 2%; 60 days net from date of invoice.

This is the invoice we use on our stock transactions. When making up your own, consult a lawyer to be sure it meets your requirements. Be as specific as possible in the rights-purchased section, as this will define usage and later fees. In a separate cover letter, or on the invoice itself, include a request for tear sheets of published photos.

spirational Scenics," "Humorous Pets," or "Anniversary Cards".

Here, you will follow the same basic procedure as above, knowing that not every general submission buyer is going to abide by the liability clause in your submission memo. Most of these companies dictate submission terms in their guideline letters. In this case, sending duplicates is the best way to go. Some may print from duplicates, others may want originals once they decide to buy a certain image. When this happens, request a purchase order and then send along the image with your regular submission memo.

Another scenario involves appointments where pictures are selected from your portfolio on the spot. You know the procedure—just remember to carry submission memos and invoices with you on your calls.

In all cases, protecting your pictures is of utmost importance. Contracts and forms are a regular way of doing business. Get all transactions in writing!

Delivering the Goods

Most of your transactions will be done through the mail, and there are any number of carriers available for shipping your work. The best way to mail via the U.S. Postal Service is by registered mail. This provides a return receipt (which you should attach to your correspondence) and optional insurance. If, as is often the case, clients want pictures in a hurry, you can make use of the Postal Service's Express Mail service, which handles overnight or two-day delivery to most places in the U.S.A. and even to foreign countries. The fee for this service is reasonable, given the fact that the package is handled separately from regular mail, is traceable via receipt, and is insured.

Private couriers, such as Federal Express and Purolator Courier, are an excellent way to speed priority shipments. They also work with receipts, offer insurance, and have a pickup service. Also, many publishers have charge accounts with couriers, and they may give you a traffic number with which you can have material picked up and delivered at no charge to you.

Whatever service you choose, always make sure it offers a return receipt and some form of insurance. Never send photos by First or Third Class Mail. The signed receipt is the best form of protection against problems down the road.

Office Management

Revenue from selling pictures is taxable income, so you'll have to keep a set of books for Uncle Sam. Open a separate checking account for business income and expenses, and keep a daily (or weekly) diary of business activities. You're in this business to make a profit, so keeping accurate records will not only show you how you're doing, they'll also meet your obligations to the tax man. Many of the expenses connected with running the business, including supplies, equipment, telephone, postage, entertainment, travel, etc., will be deductible. Consult and retain a reliable accountant who will school you on the benefits and liabilities of your business. The few hundred dollars this will cost is well worth it in the long run.

Besides file cabinets, a light box, a typewriter, a computer, and other hardware needed for running a photograph-marketing business, one essential piece of equipment is a telephone-answering machine. If a buyer can't reach you quickly you'll probably lose the chance for a sale. For a small investment, you'll guarantee that you're never more than one day away from returning a sales call. Much of this business is done over the phone, and if you're beginning by working nights and weekends, an answering machine is an absolute necessity.

HOW MUCH IS THAT PICTURE WORTH?

BEFORE DISCUSSING PARTICULAR MAR-
kets and ways of selling your pictures in them,
let's discuss some general ways to determine
the value of a photograph.

While you may feel that a certain picture is
worth X dollars (because of the expenses that
went into making it), the photography market
works on the principle that a picture's value is
based solely on its usage. At times, you'll be
overestimating a picture's value; other times, happily, you'll
grossly underestimate it. The same picture may be worth
$100 in one sale and thousands in another.

A number of forces determine how much you get for a sale.
Supply and demand, industry standards, venue of reproduc-
tion, rights sold, size of reproduction vis-à-vis the full page,
and market area of use all affect price. Within each of these
areas, subtle forces, such as your powers of negotiation, can
drive up or bring down the price you get.

Though the tendency for beginners in this field is to take
any price offered just to get picture credits, more experience
will eventually show you how to get a better price for your
valuable work. The first sale I made was to a greeting card
company. They bought twenty pictures for which I received
the whopping sum of $700. Full of enthusiasm, I told an old
pro photographer about the company's willingness to con-
sider photographs for their lines; he subsequently reported
back to me that he'd been able to get only $100 a shot from
them. Live and learn! I was so eager to get the work out there,
and to have samples to show other clients, that I agreed to the
first figure they proposed.

Supply and Demand

At first supply and demand may be difficult to determine. An
image's uniqueness and how it meets the immediate de-
mands of the buyer will raise its value. This sort of experience
takes place every day in every market in the world: For a
number of years I commuted to New York City, where a
variety of peddlers ply their wares at the exit doors of the
train station. If rain was in the forecast, many of these street
hawkers sold umbrellas. I began to notice that if the clouds
were rolling around and there was a good chance of rain, then
the price of the umbrellas was $2, but if it was already raining
the price would suddenly be $3.

The same goes for the picture market. If the need is
greater, and the picture offered meets an immediate demand,
then the price will be higher. Legendary sales figures have
been attained in the spot-news market, where a photogra-
pher in the "right" place with his wits about him got the
picture of the assassin raising his gun or the plane as it began
a fiery dive. Less gruesome events, such as the home run that
broke the Babe's record, or the pie-in-the-face of the politi-
cian, have done well for the paparazzi of every country.

Stock pictures also can fit into the supply-and-demand
scheme. You may have, say, photographs of vintage cars from
1957, and you become known as a specialized source, one
who has in-depth coverage no other photographer or agency
can match. Rather than fishing around, and trying to piece
together disparate sources for these pictures, most buyers
will recognize the efficiency of buying from one outlet—you.
They'll be happy to pay a higher price for your "one stop"
picture supply.

HOW MUCH IS THAT PICTURE WORTH?

Industry Standards

As the photography market expanded and matured, various groups of photographers and buyers began to recognize the need for "ballpark" figures on pictures used in regular markets. In some cases this raised the price on certain licenses, in others it lowered them. Price fixing is against the law in the United States, so no one claims to have reached a price agreement on anything. Yet many times you'll hear, "We pay ASMP rates," or "We pay standard industry prices."

An ASMP rate refers to a set of figures published in a booklet entitled "ASMP Professional Business Practices in Photography," available from the American Society of Magazine Professionals, 205 Lexington Ave., New York, New York 10016. The Society bases these rates on a survey conducted among members, agencies, and buyers, and breaks down the listings by category of photograph and type of use.

Whether these rates bear a direct relationship to the reality of the day-to-day market we face is another question. They do, however, give a guideline from which to figure a price, and, in fact, many of your future clients use this book as a price bible.

"Standard" rates can mean anything, depending upon the license you're selling and the medium in which a photograph is reproduced. In the greeting card market, the standard could be anywhere from $50 to $200 a photograph. In textbooks, it may mean $150 for a quarter-page or a full page. Standard is whatever the buyer determines it is, and it usually means the lowest price they can get away with. Be prepared to bargain when you hear those two magic words, as standard rates will probably mean two very different things to you and a buyer.

Venue of Reproduction

This is the factor that will determine whether you get $100 or $1,000 for the same picture. An editorial shot run in a million-plus-circulation magazine will garner quite a bit more than the same picture in a 50,000-circulation trade journal. Naturally, competition is much tougher for the better-paying markets, as are the standards for quality.

Getting into the higher-paying markets right off the bat can be difficult for another reason—it's the old story of "who you know." Having your name known, having personal connections, and having a track record will get you into the higher-paying publications. (Of course, this reputation is backed up by top-quality work.) Don't be discouraged if you hit a brick wall in the beginning, or feel that your work is equal to what is being published but is being ignored. Everyone has to start "humble," then go after the big markets. The first year or two in this business is an education—take it as a learning experience and persevere, and you'll eventually work your way up.

Aside from magazines, photographs can be sold to audiovisual production houses, to broadcasting companies for on-the-air graphics, or to publishers for large-edition books. In each case, the bigger the market of the buyer, the greater the fee to you. All this is based on what the folks on Madison Avenue call "number of impressions."

Size of Reproduction in a Given Medium

Just as advertising is sold on the basis of page size (full, half, quarter, eighth, etc.) so are fees for photographs reproduced on that page. In the textbook market, for example, a quarter-page reproduction might get you $75, and a full-page may yield $275. A double-spread, or unit-opener, may get you as much as $400 per shot.

Art directors make decisions based on the graphic quality of pictures—they are always on the lookout for "grabbers" to open a section or story, then go to the "meat and potatoes" shots for illustrations in the body of the text. As size of reproduction is proportionate to payment, you should keep this in mind when shooting and submitting pictures.

Rights Sold

Most pictures licensed are done so on a one-time rights basis, in which after use the picture and all rights revert back to the owner of the copyright, usually the photographer. This guarantees that the image will be the source of further income for you in years to come. Most rates are based on this situation. There are times, however, when a buyer will want further rights granted, and this should mean that you receive a higher figure for the sale. Let's look at a scenario dealing with multiple rights.

You sell a photograph to illustrate a point in a book on tennis. The author and art director are so impressed with the image that they decide to use it in the text and on the cover. Subsequently, the publisher's promotion department decides to go with the picture and places ads in national magazines for the book, using the cover shot (not simply a picture of the book) as a full-bleed illustration. Finally, a tennis magazine gets rights to excerpt parts of the book, and it uses your shot for a lead illustration for that article.

If you were attentive to your rights, you should receive some financial consideration for *every use of the shot*. Remember, you are the copyright owner; thus each use of the photograph must be licensed by you. If you're presented with a contract or purchase order stating that the photograph may be used for initial publication *and* promotion, let those words remind you that the publisher may get a lot more mileage out of the picture than you originally thought. At that point, you should begin the process of bargaining to raise the price or make some stipulation for payment when the picture is used for more than text illustration. There's nothing worse than feeling ripped off by a publisher, so keep your eyes open and *read your contract or purchase order carefully.*

There are occasions when buyers will want exclusive rights for a specific period of time, rights to use a picture in any number of mediums, or exclusive rights to use a picture in a particular medium. In each of these cases, you should get more than a regular, one-time fee. The multiplication of fee will depend on how much money you think you stand to lose by tying up the image for a period of time, or by eliminating it from a portion of the marketplace. If, for example, an advertising agency wants to use a picture for part of an advertising campaign and requests that you give them a three-year exclusive on the image, bargain for an increase in payment.

In some cases, you may be requested to give a "buyout" on a photo, or sign a contract that the picture was made on a "work for hire" basis. In either case, you're being asked to relinquish all your copyright protection to the buyer. Consider carefully before you enter such an agreement; many photographers simply refuse to do so. The argument photographers have as a group against this business practice is that any image surrendered to an advertising or publishing concern shrinks the market for other photographers, and subsequently, for themselves. Also, with modern digital scanning

equipment, it is possible to assemble entirely new images from parts of preexisting pictures, giving agencies a stock of their own that might cause a decline in the future need for freelance photography.

Another recent tactic of some buyers is to send a payment check that states that if the photographer endorses (cashes) the check he is, in effect, stating that the pictures sold were done on a work-for-hire basis. This practice is quite rightfully being questioned in the courts.

You may never encounter these situations, but it pays to be aware of them. Firms you'll want to work with deal honorably and "on the table" with their freelancers. If you're confronted with a buyout or work-for-hire invoice, negotiate strongly to maintain your rights to your creations.

The one market in which media-exclusive rights are usually asked for and granted, and in which, traditionally, there's no bonus for surrendering the right, is the greeting card market. Competition is so high, and turnover so frequent, that these companies have found themselves in a position that is strong enough to let them dictate terms. Right or wrong, that's the way it is. Remember, though, the rights you'll be selling are for use as *greeting cards only*; the pictures remain under your copyright, with the right to sell the images in every other market.

Various Licensing Rights

Working in the stock photo market means that you'll be licensing reproduction rights, rather than making outright sales of your images. Here are some types of rights you may encounter.

All rights: Holding exclusive rights to an image. Can be amended to time or specific media usage.

Buy-Out: Selling the copyright and therefore the image and any subsequent usage.

Collateral Uses: Taking an image used for one purpose (such as packaging), and using it for another, related purpose (such as advertising).

Copyright: At the moment of creation the photograph is, in essence, under the copyright of the creator (photographer). This copyright can be transferred only by written agreement.

Distribution Rights: Assigning the right to use an image in a certain geographical area, such as a local publication versus a national newspaper or magazine.

Exclusive Right: An agreement that the use of the image is granted to the buyer on an exclusive basis for a certain time, in a particular medium, or in other ways.

First-Edition Rights: Selling rights only to the first printing of a book, poster, etc., with any subsequent editions to be negotiated.

First-Time Rights: An agreement that a photo will not be used prior to publication by the buyer; once published, all rights revert back to the photographer.

Nonexclusive Rights: The user has no claim on the first use of picture.

One-Time Right: A tightly defined license of a photo that allows a buyer to reproduce it only once in a certain medium. Further usages (subsequent editions, other media, etc.) must be negotiated.

Specific Rights: Granting those, and only those, rights that are spelled out in the contract/invoice.

Worldwide Rights: Granting the buyer license to use the photograph in international markets. Sometimes amended by other specifying clauses.

STOCK AGENCIES ARE A MARKETING OPTION

STOCK AGENCIES ARE LARGE PICTURE LIbraries, sometimes made up of millions of images, that are in the business of selling and leasing photographs. Many are full-blown corporations with offices around the world, others comprise photographers who work cooperatively, usually with a business manager and a small staff. Some are run by photographers who invite you to add your images to supplement their own files, and thus increase their market coverage.

Many professional photographers choose to place all their stock-style work with agencies in order to eliminate paper work and still realize the benefits of further marketing of their images—among these pros, a large percentage also market their work on a one-to-one basis with established clients.

Although placing images with an agency has decided advantages, there are a number of pitfalls. The process of choosing the right agency to handle your work should not be undergone casually. Placing pictures with the wrong agency, or with one that does not work for your best interests, can result in a discouraging, sometimes disastrous, experience.

Scores of agencies exist from which to choose. Some are general interest concerns, whose file coverage goes from A to Z; others specialize in a particular market or subject matter. Agencies can tailor their files to buyers wanting pictures of, for example, animals, high technology, or celebrities; others work in specific market areas, such as travel, corporate/industrial, advertising, or paper goods. These limits are more often than not defined by the size of files or staff, or the expertise of the agency. Many times, agencies consciously limit their file size and focus so that they can become known as a dependable source of one specialized type of image. The Picture Agency Council of America (PACA) provides a sample listing of agencies with their market specializations, and we reprint parts of that list on page 67.

I encourage you not to place all your work with an agency until you've gained a good deal of experience in this field. Here are some pro and con arguments concerning stock agency placement, and if you think the pro arguments seem best for you, there are also some suggestions to help you choose the right representatives for your work.

Why Stock Agencies Can Help

As you've probably realized by now, marketing photography for results entails a tremendous amount of energy, time, follow-up, and paperwork. It can take a year to set up a smooth, coordinated system of selling. Having an agency handle the business end for you can lift what at first seems a real burden, and it leaves you free to do what this is all about anyway: taking pictures. An agency has contacts, leads, and business opportunities that might take you years to develop, or that you might in fact never develop on your own. Many agencies also make it their business to keep you abreast of the market's needs, thus giving you an inside track on making pictures that are likely to sell. Some agencies will act as your broker on assignments, and in general increase your photographic activity and earning power. A photographer-agency relationship thus can become a dynamic one, and result in a business arrangement in which each party has the best interests of the other at heart.

Of course, a stock agency doesn't do this for free. The standard split on sales is fifty-fifty, or sometimes less for the photographer when subagents or foreign sales are involved. This is a reasonable split, especially when you consider the work that goes into selling and invoicing. But it always seems like a big bite to those who've previously marketed on their own and used that extra 50 percent to cover expenses.

The Disadvantages of Joining a Stock Agency

Giving your pictures to a stock agency can mean that you effectively give up control over those pictures; "surrendering" might be a better word, with all its connotations. When you sign a contract with certain agencies you could be required to give them an exclusive on the pictures you hand over. Some might even require that you give them exclusive rights to market all your stock work, prohibiting you from making other stock sales on pictures not registered with the agency.

This might work out fine, but it might also limit your individual potential and initiative, particularly if you pick the wrong agency to market your work. There are many horror stories wherein a photographer gives his library to an agency, only to find that the agency doesn't aggressively market the work. At that point, because of contractual obligations, the photographer is stuck, and his pictures end up languishing in limbo in someone else's file drawers.

Some photographers avoid agencies because they feel that to use them would be like kissing their pictures goodbye. The fine print on some agency contracts may contain a clause that states that once pictures go into the files, and the photographer decides he wants them back, it can take one to three years to retrieve and reassemble the body of work. Some contracts state that 35mm slides are not recoverable, or that a research fee will be charged to the photographer to get his or her own pictures back!

An agency going out of business can pose a real problem for those who have pictures in its files. In some cases, the agency claims the right to sell your pictures, lock, stock, and barrel, as part of its assets to another concern, without your having any say in the matter. If the agency is involved in bankruptcy proceedings, or any business-disrupting litigation, your material may be cast into another sort of limbo. There have been cases in which images as assets were footballed around the courthouse for years.

In the worst case, disreputable agencies fail to report sales to photographers, or those in financial difficulties delay payment just to cover their operating expenses.

How to Find the Right Stock Agency

If you do want to assign all or a portion of your work to an agency, our discussion should prompt you to do two essential things: 1. *Read your contract*, and 2. *Choose your agency carefully*. Many beginners blissfully sign away their work just because they're thrilled to have someone represent them, only to find that they've landed in a near-feudal business relationship. Many abuses in this business have been corrected over the years, and industry associations such as PACA have addressed many of them, but problems definitely still exist.

Pay very close attention to exclusivity clauses, return-of-work provisions, bankruptcy, sales reporting and subsidiary sales procedures in the contract. Remember, no clause is ironclad; renegotiate as you see fit, or strike any onerous or

questionable provision in any agreement before you even think of applying ink to that dotted line. If one agency's contract seems to be too one-sided, shop around until you find an agency that fulfills your needs.

Check out a prospective agency carefully when you begin to consider it to represent your work. What markets does it serve? What type of pictures does it sell? How many images does it have on file? How well-promoted is the business? Do your images and its markets mesh? Those are questions you should be answering.

Before you consign pictures, pay a call on the firm and see how its staff treats the work. Initiate personal contact with the in-house editor who'll be handling your precious material. Request three or more references of photographers whose work the agency handles, and follow through with frank phone calls to future colleagues. And, although this may seem unfair to struggling new businesses, I don't recommend placing work with any agency in business less than three years—it takes at least that long for an agency to stabilize and work through the kinks.

Contacting agencies for interviews and photograph appraisals is done in the same fashion in which you'd approach any other client. Choose a name from the list supplied here, or look in the phone book of the largest city closest to you under "Photography—Stock Agencies." Geographical proximity can be helpful in terms of business dealings because many agencies specialize in regional coverage. Send an introductory letter requesting the agency's submission-and-review requirements and, most important, a sample photographer-agency contract.

If at all possible, bring your work personally to the agency for your interview. You can send sample portfolio work through the mail, but, as personal chemistry and a solid understanding of each other is essential to future success in the relationship, a visit in person is a must before you interchange contract and photographs. Failure to do this can present real problems down the road—it would be like sending your kids to camp without a visit, only to have them discover that the swimming pool is a swamp and the chief counselor is the Marquis de Sade.

From the agency's point of view, you are a supplier of images, and it will require quality, consistency, and a steady stream of marketable pictures. You are one of the people who supplies what it sells, and generally, if you treat it well you will be treated well in return. You must prepare your work for market just as if you're selling freelance—the procedures for captioning, labeling, and model-releasing of images are as we described them, no matter who markets the photograph. When you deliver pictures, they must be market-ready. Some agencies have their own order of captioning, so always check their system before submission.

How much work should you hand over on the initial submission? That depends on the agency, and your own marketing objectives. My best advice would be to build a strong foundation of work before you even think of contacting an agency, then prepare a cross-section of your best material for consideration. In some instances, your initial submission might have to be a few hundred slides—in others, a few sheets may be enough.

Just as with your own stock-selling business, gaining momentum (a steady stream of sales) will take time. First, your work has to be plugged into the pipeline; second, billing and

receiving will take a few months. You must also continually feed the kitty; don't expect to submit a few hundred slides, sit back, and collect the rewards of your labors for years to come. The energy you put into an agency is proportionate to the returns you receive. Don't be impatient if you see little or no results the first year or even beyond.

Communication is the key to a successful agency relationship. You must get continual feedback on picture quality, content, and volume in order to make the relationship work. Sending hundreds of pictures, most of which have no market relevance, would be an exercise in futility. Request want lists and market survey trends on a regular basis, to find out the scope of material requested of the agency by buyers. If you travel, post your itinerary with your agency contact—this can often result in profitable side-trips when on location. Use the agency as your source for vital market intelligence.

If you decide to combine some agency representation with your own marketing efforts, be aware of any possible conflicts of interest that may arise. For example, let's say that you sell an image with limited rights to a greeting card company. The agency has the same or duplicate slide, and sells it to a different greeting card company with the same exclusive rights proviso. Communication is the key—to head off any serious contractual conflict you would notify the agency that you were about to sign an agreement on your own.

Some photographers get around this sort of problem by segregating the images they send to an agency from those they market themselves. You might want to notify the agency of your steady clients when you come on board, thus preventing possible conflicts. This self-marketing/agency representation situation can be a delicate one, but can be worked out successfully when handled with frankness and honesty—an up-front way of doing business. Remember, you and your agency are after the same goals—selling pictures and making money. Don't treat it as an adversarial relationship.

The decision whether to put all or part of your work with a stock agency is yours. Just keep in mind that researching an agency carefully, understanding the nature of the business, and keeping your interests aligned, is what will make stock agency membership work or fail. Many photographers have found working with stock agencies a fruitful experience; others have nothing but horror stories to tell. For you, the time and energy you can spare for self-marketing may be the deciding factor. Just don't make the leap before you know all the facts.

Why Editors Work with Stock Agencies— A Lesson for Freelancers

Many art directors and editors who need specific pictures in a hurry have come to rely on established picture sources— stock agencies—for their needs. As one editor told me, (and her view was echoed by many others interviewed), "If I want a picture of a sunset, all I have to do is pick up the phone, call a stock agency, and I've got 100 sunset shots. For most of my needs, a stock agency has the selection, the efficiency, and most important, the organization to handle the job."

Note the order in which this editor places her priorities. The first is access—picking up a phone and getting a response. Not wading through a series of answering machines or services, not waiting three days for a response or having a child answer the phone and relay the message. The second priority is selection—having a variety of good pictures of one subject from which to choose. Not one-half of one slide sheet of a topic that was put on the seller's Master List just to make the file look impressive.

The third is efficiency—having the pictures in her hands in a matter of days, even hours, if necessary. Not waiting a week for a request because of backlog, or having the submission sent First Class to save on delivery costs. And last, but certainly not least, organization—a recognized, agreed-upon way of doing business, in which rates, invoicing, deliveries, and returns are understood, in which professionalism is the rule, and tutoring is at a minimum.

Check yourself and your way of doing business against these criteria and see how you compare. Although it's tough to go up against a million-image-plus agency with its staff of twenty or more, there are ways that you can attempt to meet and beat the competition.

1. **Make sure that every topic on your stock Master List is backed up by top material.** Don't get your bluff called—it may work in poker, but not in this business. Even if trimming your list narrows it down quite a lot, it's always better to give an honest appraisal of what you have to offer.

2. **Specialize if your picture file is small.** Getting known as a good source for a limited type of material may get you fewer calls for your general work, but will pay off in the long run when someone needs what you have.

3. **Develop a personal rapport with your clients.** Many times, large stock houses haven't the time or disposition to deal with "lower-paying" markets—their overhead precludes their working with picture fees that may, however, seem attractive to you. Smaller companies are prime market territory for freelancers. Rapport also helps in the higher-paying markets, though gaining personal access to the client will take time and patience on your part.

4. **Update your Master List frequently with mailings and postcard reminders.** As your files expand and change, keep clients and potential buyers aware of your work (and your continued existence!) with publicity and information updates. Buyers respond to a certain amount of aggressive marketing.

5. **Don't charge a research fee.** Many stock houses make a good piece of change by charging clients X amount of dollars per subject, or per slide, for researching and submitting requested material. Though this fee is normally waived when a sale is made, the figure can become quite high over the course of a year. You might in fact lose money by not charging a fee, but consider it an investment, as one cost of being competitive.

6. **Don't charge a holding fee.** The "kill fee" for slides held for consideration by a client over X amount of days is also a source of income for stock agencies, and waiving it can give you a competitive edge. Of course, should a slide be held for many months, a holding fee shows the client that you're serious, and it should be imposed. You might consider extending the normal time of two weeks to a month or more.

7. **Maintain a professional and businesslike attitude with clients.** Be prompt, efficient, and courteous in all letters and calls. Most picture buyers are busy people, so act accordingly. Don't badger them with questions or weekly queries.

Some Stock Agencies to Consider

Here's a cross-section of stock agencies, all members of the Picture Agency Council of America. PACA is composed of stock agencies around the country; its purpose is to develop uniform business practices within the industry, based upon ethical standards established by the council. (A full listing of members is available from PACA, 32 East 31st St., New York, NY 10016. Send $2 and a self-addressed, stamped envelope to defray the costs of printing and handling the booklet.)

Animals/Animals
65 Bleeker St. 9th Fl.
New York, NY 10012
212-982-4442

This agency specializes in birds, crustaceans, crocodillians, fish, amphibia, insects, mammals and domestic animals, throughout the world depicted in their natural habitats.

CLICK/Chicago
213 W. Institute Place #503
Chicago, Il. 60610
312-787-7880

A general stock/assignment agency with files that include such subjects as animals and natural history, foreign countries and people, industry and business, scenics, and science and medicine.

Comstock, Inc.
32 East 31st St.
New York, NY 10016
212-889-9700

Complete general coverage including life-styles, scenics, industrial, sports, travel, family, everyday situations, consumers, and business situations.

Earth Images
P.O. Box 10352
Bainbridge Island, WA 98110
206-842-7793

The agency's file depicts the nature of our planet, including microorganisms, plants, wildlife, ecology, volcanoes, and weather. A Geography section offers scenics of habitats and cultures from around the world. An Industry file portrays man working in nature, such as commercial fishing, logging (past and present), forest firefighting, mining, farming, and scientific research.

Focus/Virginia
501 Prince George St.
Williamsburg, VA 23185
804-565-2716

The agency fills orders for editorial, advertising, and corporate photography with particular emphasis on coverage of regional subjects.

ƒ/Stop Pictures, Inc.
P.O. Box 359
Springfield, VT 05156
802-885-5261

The agency specializes in color photographs of New England and rural America, although its coverage is much wider in travel and location work.

Hot Shots Stock Shots, Inc.
309 Lesmill Rd.
Toronto (Don Mills), Ontario M3B 2V1
Canada
416-441-3281

The agency offers a general advertising file with subject coverage including scenics, industries, people, and food.

The Image Works
P.O. Box 443
Woodstock, NY 12498
914-679-7172

The files of this agency represent all stages of life and development, both U.S. and foreign. Special focuses include children and family, education, France and Spain, social psychology, social issues, and esoterica.

The Photo Bank
313 E. Thomas Rd., Suite 102
Phoenix, AZ 85012
605-265-5591

(The Photo Bank also has an Idaho office.)
The agency's files are directed toward people: their life-styles, work, family, and recreation, etc. Other subject matter includes travel.

Sharpshooters
7210 Red Road, Suite 216
Miami, FL 33143
305-666-1266

The agency files model-released photographs of people having fun in "green grass-blue sky" locations such as Florida and the Caribbean.

Tom Stack and Associates
3645 Jeanine Drive, Suite 212
Colorado Springs, CO 80907
303-570-1000

The agency specializes in flora and fauna of the world, endangered species, underwater photography, and photomicrography.

Stills, Inc.
3210 Peachtree Rd. NE
Atlanta, GA 30305
404-233-0022

The agency gives special emphasis to the Southern United States, although worldwide subjects are also on file.

Third Coast Stock Source
P.O. Box 92397
Milwaukee, WI 53202
414-765-9442

The agency specializes in Midwest images, but also has general files on people and natural history.

View Finder Stock Photography
818 Liberty Ave.
Pittsburgh, PA 15222
412-391-8720

The agency provides a broad coverage of subjects, with emphasis on industrial, scenics, natural history, and people.

Stan Kanney and the Image Bank—
An interview with the president of one of the world's leading stock agencies

Stan Kanney's background includes ten years as a deep-sea diver, experience in marketing and foreign trade, and a stint as the director of a publishing company. Today he's president of the Image Bank, a stock agency with thirty offices worldwide. The Image Bank is responsible for creating a new way of doing business in the stock photography market, as it was among the first to sell stock for advertising.

In our interview, Kanney talked about how the Image Bank got started and revealed his own feelings about the special agency-photographer relationship. He also had some words of advice for photographers about the *business* of photography and how a photographer's career is shaped over time.

Kanney was working with a stock agency, and the problems that arose in the photographer-agency context, problems common to many agencies at the time, could not, in his opinion, be resolved. He broke away from that firm and began to formulate his concept of what a stock agency should accomplish. He was greatly aided in this effort by the late Larry Fried, who had a respected career as a professional photographer and who had served as president of ASMP. Together, Kanney and Larry Fried started the Image Bank.

In the past, "world-class photographers" (Kanney's term) had been hesitant to entrust their work to stock agencies, mainly because of the way those businesses were structured. What Kanney and Fried set out to do was, first, to change the structure and resolve problems attendant to the stock-marketing world, and then to build a business that matched the caliber of the photographers they represented and the clients they hoped to serve. Let's hear the story in his own words:

Kanney: One of the problems that exists in this business is that photographers are all individuals, all artists. They work by themselves, and often don't have the structure to deal in the day-to-day part of the business world. When I decided to leave the stock agency I was with, some of the photographers I had come to know approached me to start a stock agency. I knew that there were certain business precepts we wanted to bring to bear on the new agency, certain corrections of faults I had seen in the archaic way most agencies at the time ran their operations. One of the main changes we wanted to institute was a general upgrading of the stock picture itself. Many agencies represent thousands of photographers; we wanted to represent only "world-class" people. The initial group included Pete Turner, Jay Maisel, Larry Gordon, Morton Beebe—people who under other circumstances wouldn't be interested in dealing with a stock agency. We wanted to get stock away from the image of being a repository for amateur photography.

GS: What other changes did you institute?

Kanney: At that time, the general practice was to take 2,000 to 10,000 pictures from a photographer, send some to Tokyo and other cities, and leave the "best of the rest" in New York. I was opposed to that idea, and felt that nothing but the best work should be shown *everywhere*. I believe photography is an art form and should have an agency commensurate with its quality. That agency should have the organization capable of exposing it in the proper business fashion. For the most part, I found that typical stock agencies are composed mostly of editors, not business people. This is a two-sided business, with the photographer as artist providing the basic product and the agency as businessperson providing the organization for developing and marketing that product.

GS: Did you begin in New York and then slowly set up your other offices?

Kanney: No. Part of the original concept was to go worldwide. Here's how we do it: All the work goes through a rigid editing process, and then dupes are made and sent to our offices around the world. In that way, the master is always safe. We now have thirty offices around the world, with two more to come. These offices are operated through a licensing program and are subject to the same rigid standards as the main office here in New York.

GS: How is a typical office set up?

Kanney: We have a number of sections: One section deals with photographers, another with photography, and then there are sections that seek clients, manage clients, handle materials, and work with international contacts.

GS: Do you represent many photographers?

Kanney: We don't represent thousands of photographers—we do "rep" the established ones, as well as those who are not so established. Many of these photographers are as yet unheard of, but they do excellent work. At the present time we have 350 photographers throughout the world. Madison Avenue is still our center of activity, but there are great photographers in France, Italy, Brazil—we are very proud of our file.

GS: What types of clients do you sell to?

Kanney: We go directly after the advertising busi-

ness. This is quite different from what stock agencies traditionally did. We still sell to editorial markets as an adjunct to the work, but we're very selective about that business. For advertising, the material has to be of the highest order. Our prices are high, but the quality is there. In the past, advertising buyers and art directors were very timid about going to a stock agency for material. Now we have people coming from all over the world to utilize our vast library.

GS: I know you have printed catalogs, but I also understand that you're going into videodisc cataloging.

Kanney: The laser videodisc is a very exciting development for us. We send out a package that contains a videodisc and a disc player with computer capability with a viewing screen and hardcopy capability. Now clients can dial in just what images they want—for example, "Romance," "Anticipation," "Colors," or "Hockey"—and that series of images appears on the screen. This development probably signals the end to the traditional method of viewing and access, as well as giving a client the opportunity to have work in front of him or her at the conception stage of a project. We're now amplifying the system to include portfolio capability, so that a client can dial in a photogra-

pher's name and immediately see his or her book. The portfolio section will also have a short bio on the photographer with day rates.

GS: So you see this as a way of generating assignments?

Kanney: Yes, and we do a lot of assignment work throughout the world. Clients find this system—using our agency—a very cost-effective way of finding a photographer and having the quality they need for a job.

GS: Do you see the laser videodisc creating a problem in terms of copyright protection?

Kanney: First off, everything we have on file is protected by copyright, and although there is capability to make a good hard copy from the disc (the quality provided at present is good only for layout purposes), it is a very expensive one. We feel that the best way to deflect any negative utilization of an image is to provide top-notch service to our clients and to keep a good relationship going. Over the years, we've spent thousands of dollars on legal fees that have gone not only to protect photographers against infringement, but also to establish precedents for collections on losses. I think we have an excellent record on that.

GS: How do you screen a photographer who might be interested in joining the Image Bank?

Kanney: If a photographer has a few hundred pictures and lacks the ability to continually supply us with more we're really not interested, even if some of the shots are excellent. We're not looking for a lot of photographers. Second, the images have to be of an artistic quality, and have the ability to be salable on an international level. Next, the work has to have a market. Some photographers take only pictures of lampposts. Now, we've sold pictures of lampposts, but there has to be more diversity to a photographer's work than merely one subject area.

GS: How do you determine what is marketable?

Kanney: We make a very serious study of what the international market is demanding. We do this on a regular basis and develop a profile of the type of material we think is needed. Part of our development program with photographers is to make them aware of this.

GS: So you develop a set of guidelines for stock?

Kanney: It's really a studied analysis of what's being used and what the trends are. Different markets have different approaches to the same subject. For instance, some markets may want pictures of women with every hair in place, while others may want a more natural approach. We work very hard on market intelligence.

GS: It's a constant look at what's being used.

Kanney: It really comes from a constant interchange with clients. If we hear a demand for a certain type of shot from ten clients, we think it's significant; if we hear this from ten of our offices at the same time then we place greater emphasis on the information. We look at magazines—we have a number of people who travel who look specifically for that type of information. Market intelligence is really the lifeblood of our industry.

GS: Do you have any advice for those who want to get involved in the stock business, particularly photographers who might want to work with the Image Bank?

Kanney: I've seen thousands of photographers, and if there's any message I'd give them it's don't settle for second best. I've seen many photographers damage their careers by going after the first thing that was presented to them. They shouldn't give up—perhaps at one point they're not ready for what is the best route for them, but there's no shortcut. It might take six months; it might take two years. Once a photographer goes after second best he or she can become cast in that role and never be able to get out. I'd remind the photographer: Think in terms of your whole career.

PART II

SELLING TO

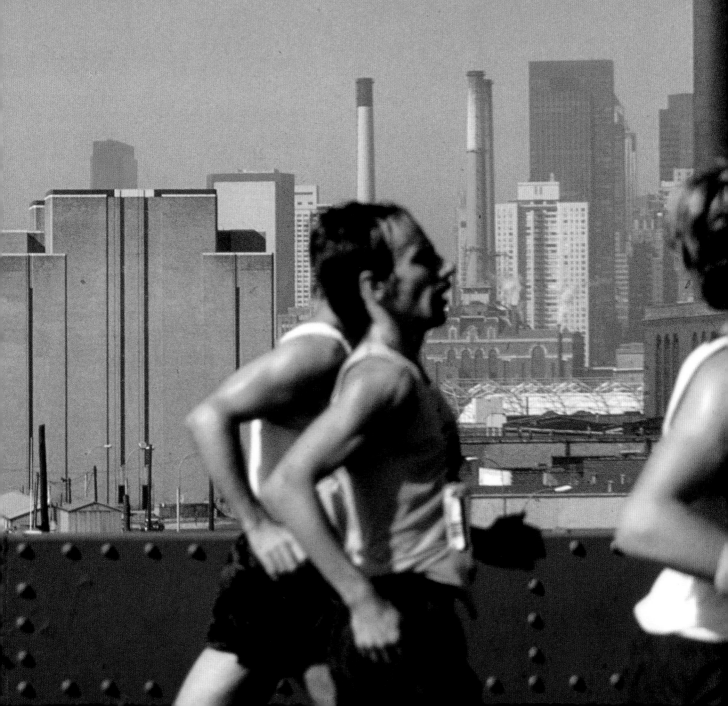

THE MARKETS

EDITORIAL MARKETS
A General Introduction

EDITORIAL MARKETS COVER EVERYTHING from fillers for daily newspapers to covers and inside photographs for trade and consumer magazines to unit openers for grade school textbooks. The subject matter that sells in these markets encompasses an area as wide as your interests and travels or as narrow as the specialized field the publication covers. Zeroing in on these picture outlets requires research, repeated submissions, and personal contacts with buyers, art directors, and editors. Although the payback in the editorial photography market is less than it is for the corporate/industrial and advertising market, the volume of work called for more than makes up for the lower rates. And editorial is the field where many successful photographers got their initial work and portfolio tear sheets.

Before breaking down this market, let's take a look at some standard operating procedures that apply in a broad spectrum of the editorial field. The assumption is that you're attempting to sell stock, or photographs already in your file, to these markets. Assignment work is a different ball game, although there's a very good chance that once you become a steady source of quality stock, you may become a contributing, assignment, or even staff photographer for these publications. If that's your aim, the road to assignment work is often paved with steady, quality stock sales.

The Query Letter

Selling stock to editorial markets generally goes through a contact, portfolio-submission, and follow-up cycle. Once you've targeted a potential buyer for your work, draft a letter—I call it a query letter—introducing yourself, and state your desire to submit work for appraisal and possible use. Enclose a brief, separate sheet listing publication credits (if any), sample tear sheets (if any), and any self-promotional brochures you may have. Close by requesting submission guidelines. You may want to start the ball rolling with a phone call, but you'll probably have to follow up with a letter for their files anyway.

If possible, try to visit the offices of the publication and meet the editor, art director, or picture buyer personally. This will give you a chance to show your work, get a handle on the publication's needs, and establish the rapport that is necessary in this line of work. Visiting might be difficult to do at this point in your work, but if you should happen to be in a city where many magazines are published, make a point of calling ahead to make appointments. Your first query letter can tell the dates you plan to visit the area and can mention that you can be available for an appointment.

When sending your initial query, address it to the person who makes the selection and purchasing decisions. This may turn out to be the art director, picture editor, editor, or creative department head. A letter addressed merely to the magazine, or to the wrong person on the staff, will probably drift around the generally chaotic office of the publication and more often than not get lost in the shuffle.

Obtaining the targeted person's name requires some research. Every publication has a masthead, a column listing names and titles in each department. Should this fail to yield information that is specific enough, call the publication and

request the name of the person who handles incoming photos. If that person is available you might as well chat with him or her and get the score—a few moments' conversation will probably get you more information than any form letter will.

Something you should know about magazines is that the larger the staff (and generally, the circulation), the more layers of decision making there are. For example, you may make a hit with the picture editor but strike out with the art director or editor-in-chief, or vice versa. Sometimes it's a wonder that any picture gets published, so tortuous is the road in that decision-by-committee world.

The "Hole in the Book"

Another editorial phenomenon is what I call the "hole in the book." Many magazines have closings (when pictures and copy are etched in stone and are shoved out to the printer) from sixty to ninety days before the bound copies hit the stands. Often, an article or set of pictures scheduled to come in is delayed for one reason or another, and the staff runs around wondering how they're going to fill the four-page color "hole" that has resulted. Believe me, things can get pretty frantic. At this point, your picture portfolio arrives and, even if it's been rejected twice before, it is now greeted joyously and ushered into the magazine. There's no telling about timing—it's often a matter of luck.

Granted, many magazines keep an inventory for such an occasion, but if something is in-house too long it grows stale in the eyes of the staff. When editors change (and they *do* come and go in the volatile magazine world) the decks may be cleared, and the mail brings your fresh approach that just fills the bill.

Making Lead Time Work for You

Take into account a publication's lead time when making submissions. Just as the fashion industry goes through its fall showings in the spring, many publications work months in advance of publication date—it has to do with the economics of printing and the time it takes for all the production matters to be cleared up.

For example, a magazine on which I worked had its June color deadline on March 3—this caused a strange sense of dislocation, as we'd often be working on beach articles while snow fell outside. As the cliché goes, the early bird catches the worm, so don't be shy about submitting Christmas or winter activity shots in August—you'll probably be right on schedule.

Another aid to submission scheduling is the editorial calendar, a some-

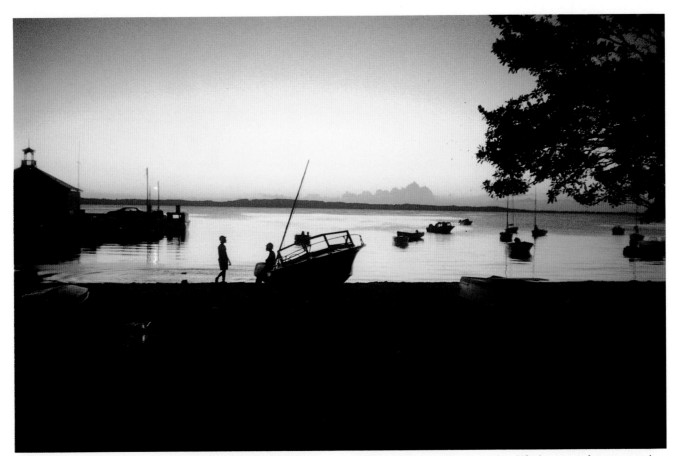

This sunset photo, made one quiet evening in the Bahamas, is essentially a wash of color that uses silhouettes as visual clues to tell about a time, place, and mood. It's also a canvas on which an art director or production team can paint words and titles or drop in other images. This "passive" type of stock shot, useful for backgrounds, posters, or double-page article openers, relies on a simplified approach to composition and information. Some photographers feel that every stock shot has to be crammed with the who-what-when of a place to be salable. Easing up a bit, and seeking a minimum of elements, produces shots with a definite market niche. Just be sure to include a few visual clues.

what loose projection of the publication's six-month to one-year coverage of people, products, and events. Although primarily drawn up for advertisers (so they can link product pushing with theme issues), this type of market information is invaluable to freelancers. Editors may not yield this information willingly to beginners (fearing a "leak" to competitors), but they do give it to steady contributors.

Establishing Rapport within the Editorial World

Getting this type of crucial information usually comes after you establish a personal relationship with the staff member who does the photograph selection and buying. Establishing rapport is one of the keys to success—without it, you'll always be adrift in a speculative sea, and far behind your competing photographer colleagues.

How do you gain this inside ear? The first step is working in a professional way—being honest about the quality and number of pictures you have, meeting (or beating) deadlines, and generally being a pleasant person to work with. Editors don't want to deal with a prima donna, no matter how good a picture source the photographer happens to be. Neither do they want someone who fawns over them (although some editors do need coddling) or makes too big of a deal about business arrangements. Most editors and buyers are overworked, and they appreciate photographers who will cheerfully roll up their sleeves and work with them to solve a last-minute problem.

Admittedly, there's a fine line between soliciting information needed to do business and outright badger-

I had been spending an afternoon photographing a lavishly decorated Buddhist temple in Thailand when this offertory plate outside a small shrine caught my eye. The simplicity and elegance of this scene contrasted with the strong colors and intricate designs I had been shooting for the previous hours, and I took the picture for a sort of visual relief. The rhythm of my shooting was picked up by an art director, who laid out the Bangkok essay using this picture as a break in the intensely colorful spreads. Shooting a picture essay for the editorial market means delivering pictures with a variety of rhythms and tones. Sometimes you can capture this in an afternoon of work, other times it may take days or even months to get the visual moods and tempos you need to complete a piece. The beauty of shooting stock essays is that you're allowed the freedom of time to complete the work to your satisfaction. And only when you're ready need you submit the work as a whole. The real reward is finding an outlet for all your efforts, and seeing the results of your diligence and your patience appear on the printed page.

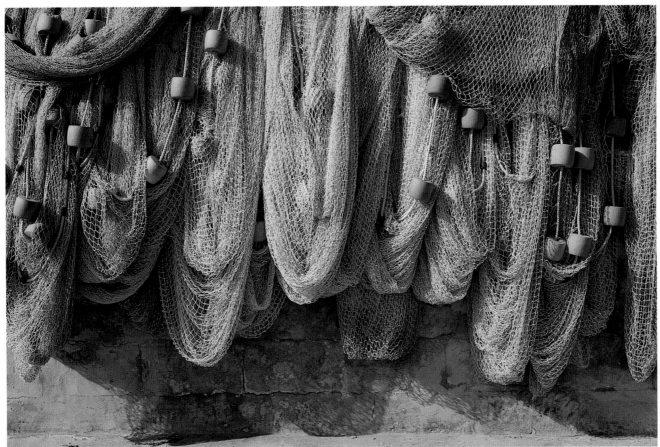

The equivalence of color, tone, and lighting makes this scene shot in Spanish Wells, the Bahamas, one of my favorite examples of a good detail stock shot. Its main visual interest springs from the happy coincidence of textures and tones in the sand, wall, and nets. Detail shots can serve as cornerstones that anchor a layout and serve as a source of visual interest in a multi-picture two-page spread, or even as a back-pager used to break up type. Take the time to inspect different issues of the magazines in which you'd like to be published. Look at the way they lay out pictures, and especially note the use of smaller, one-column shots. You'll soon get a feel for the style and content of detail shots, and how they serve as a consistent part of the flow of words and pictures in the spreads.

Detail shots can extend beyond the boundaries of the assignment at hand. This photo is of the ceiling and windows of a simple abbey chapel in Orval, Belgium. The picture is both a gem of a detail shot and a good representation of medieval architecture, which thus makes it a potential seller to the textbook market. Though the shot appears to have been done with fill flash, a late afternoon sun filled the interior with enough light for a hand-held exposure.

On a self-assigned shoot in Bangkok, a monk offered to give me a tour of some private temple grounds. At one point, we came upon this narrow hallway gallery of statues. Unfortunately, my camera was loaded with slow film and I had no tripod, so I leaned against a wall, used a low aperture to compensate for the dim light, and hoped for the best. An art director praised the shot for its interesting depth of field; I just smiled, knowing creativity often comes from necessity.

Early on in my photographic career, a mentor told me, "Look up, look down, keep your eyes open for a special point of view. Don't always shoot straight ahead from eye level." His sound advice certainly applies to the stock-photo market, where a unique perspective can often make the difference in a sale. Though the Rodin Museum in Paris yielded a good number of shots, this one giving a view down the staircase in the entrance hall is one of my favorites. In the last few years, I've taken to turning around every so often when I'm on a trail, and stopping and looking up when I'm in the city. This seemingly ludicrous behavior is just my way of "resetting" and startling my eyes into seeing a new direction of light and breaking a visual pattern. Other ways to do this are to change lenses in the middle of a take, try another speed (and brand) of film, and vary compositions between close and long points of view.

ing. Do what's necessary, push, but know when to back off. A monthly phone call is certainly more than enough for you to get the lowdown on potential sales. Many times, periodically touching base can lead to a three-month plan of action.

Familiarity with your targeted market is as important as personal contacts. Get a few back issues of the publications or several books published by a company you want to deal with and study them. Note whether they use photo essays, if picture credits are different from author credits, what the breakdown is of color and black and white, and if pictures receive a credit line. Those are the clues that will help you puzzle out the potential market.

Photo essays are making a comeback in many magazines. They are used either as a way to establish a rhythm in a book (by serving as an alternative to wordy pieces) or because the editors believe that their readers want pieces that capture the eye without demanding too much of their time. Tempting editors to run picture blocks requires compact, "meaty" submissions in which coherence depends upon both a graphic and thematic element running through the pictures.

Picture Credits and Their Implications

If when thumbing through the publication you notice that author names and picture credits don't match, or that a variety of credit lines stand in the margins, you can generally conclude that stock was used as a main picture source. Rather than be depressed over the fact that your credit line might not appear on the page, you should take heart that the

publication is open for potential sales. Cross-check the credit lines with names on the masthead—sometimes in-house or contributors-on-retainer may be getting a lion's share of the work.

Pictures with no credit lines should evoke a raised eyebrow. This usually means that the author (staff or freelance) supplied the pictures, or the images were "freebies," those given gratis to the publication for publicity purposes. Freebies are often used in trade and special interest magazines, where articles are actually thinly disguised "advertorials" or "informercials." These photograph/text packages also turn up in travel and consumer books, where advertising supplements in journalistic clothing are becoming common. There's no way to get pictures into these prepackaged articles from the *editorial* end— we'll discuss public relations and advertising agency work later in the book.

Covers are very important to a magazine, because they are the leaders for impulse newsstand sales. To you, the supplier of stock photographs, they represent a chance to get a good publication credit as well as top pay. Editors are on constant lookout for graphically strong material for covers. Doing the lead shot is an art in itself, something we discuss in more depth in the pages that follow.

Matching the overall photographic style, or visual approach, of a publication is also important, but only to a point. Your individual vision is what will carry you through this work and sustain your interest in the stock-picture world. Cloning all the work you see may get you some picture credits, but it won't necessarily give you the satisfaction that's the key to the whole exercise. Play the game, but do it within your own vision and style. With that in mind, let's take a look at some specific editorial stock markets.

Downtown Minneapolis has a maze of walkways and interior malls, all built to help inhabitants withstand the rigorous winter, and I felt that coverage of the city demanded some shots of these fascinating, above-ground burrows. When making photo essays on a city, state, or country, try to deal with the way people cope with the basics of life—food, shelter, warmth, getting around—then get into the more leisurely cultural aspects of the place. Dealing with the basics will usually bring you to the particulars. We are complex beings who have evolved equally complex notions as to what life is all about.

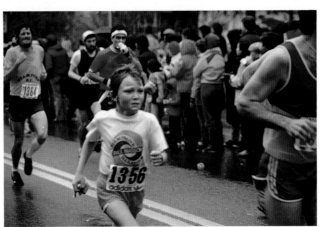

This child running in an adult world was photographed at the Boston Marathon. You can read this type of photograph as a "straight fact," or you can move it around in your mind so that it becomes an analogy or comment on an entirely different level of thought. That's the beauty of photography in general, and of stock photography in particular.

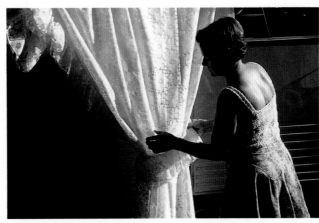

A multiplicity of meanings and uses in the market could be found for this shot of a woman folding lace drapes made at a street fair in Arles, France. The use of light, color, and design, plus a certain anonymity of face, allows the viewer to empathize with the subject and to speculate about the picture's meaning. The challenge of editing requires you to link such photographs with a market.

NEWSPAPERS

Feature and Filler Shots

YOU'RE DRIVING DOWN THE ROAD, MINDing your own business, and suddenly there's some action on the horizon. An ostrich has escaped from transport to the zoo and is dashing around a shopping area, disrupting everyone and everything it encounters. The police are called in, but they're baffled by the case. Finally, a cowboy comes upon the scene, lassoes the flightless bird, and the ensuing wrestling match has cowboys, cops, and zookeepers in a flurry of feathers.

Sounds unlikely, but it happened not long ago, and a photographer on the scene was quick enough to jump out of his car, get some pictures, and dash right down to the local newspaper office. The photograph was picked up by the wire services (the event took place in Nevada—I saw the shot in a New York paper) and the photographer probably made some change on the syndication, merely from being in the right place at the right time with a camera.

A few lessons can be learned from this and other potential feature and filler opportunities. The first is to always carry a camera. A pocket-sized 35mm with a good lens will do. Though these cameras don't have interchangeable lenses, they do just fine for spontaneous occasions.

The second lesson to learn from that scenario is the importance of being able to recognize a salable, newsworthy shot when you see one. If a noteworthy event occurs within your view, cover the happening as quickly as possible and get on the phone to the newspaper nearest you. I should mention, however, that events of great importance, such as political rallies or major calamities, are usually fully covered by staff photographers or stringers (photographers on call). Despite this, you might just have an exclusive shot when that airplane lands in your backyard.

"Filler" Photography

The more common type of stock photography sold to newspapers is "filler" material—ordinary people, animals, and things caught in extraordinary situations. The cute dog shots (pushing a carriage, confronting a duck, dressed in a raincoat, etc.) have been done to death, but, surprisingly, still sell. A more interesting shot usually comes about because of a change in a community's common experience.

You may have gotten a new computer in your home, and the baby toddles up to it and tries his hand at the keyboard. Or it's been raining for weeks, and haying has been put off; one day there's a break in the clouds, and the next morning everyone is out "making hay while the sun shines." Yes, it's a cliché, but much of this work has to do with making fresh pictures of the same old clichés. This may be due to the laziness of caption writers on papers, or the fact that such a regional shot speaks to an event that touches everyone who reads the paper. It's local, but universal at the same time.

Weather, particularly heights of a season, is always a good source of filler material. Shots of Smathers having to stoop down to open his mailbox because of the drifted snow, pictures of kids building a sand castle at the beach; photographs of people drinking cider as it comes out of the press, etc., are always good sellers. Scan the local papers for the fillers they use and you'll soon get the idea.

Many photographers get their start doing feature and filler shots for local newspapers. Sports pictures, such as this one taken at a University of Nevada–Las Vegas basketball game, are always of interest.

At their best, newspapers are forums for a community's common interests and activities. Photographing special aspects of a city, such as this sidewalk artist in Cologne, Germany, is a good way to get work published in local papers.

Although there's no set formula for filler material, count on graphic impact, humor, and a universal appeal as solid guidelines. If a picture writes its own caption you know you've got a potential seller. Don't submit shots with intricate detail or moody, dark lighting—newspapers can't get good "repro" from these shots, and most editors will reject them out of hand. If you have, for example, a paparazzo shot of a local celebrity and the face is a little dark, bleach back the area so you can see his or her features. Keep the sentiments simple, and let the picture tell the story. When submitting, caption the photo with the time, place, and event, and, if at all possible, have a model release for all recognizable people.

The greatest filler shot in the world won't do you any good unless you get it to the right person on time. Every newspaper has a slightly different policy on how it takes in and reviews work. Some want only finished filler prints delivered—others will take your roll of film, develop and proof it on the spot, and give you an immediate "no or go" decision.

When you've finished reading this, pick up the phone and call the picture editor at the newspaper located nearest to you. Start with the dailies, then hit the weeklies. Request their policies on receiving spot news and filler pictures, then keep the names and phone numbers of the contacts in your wallet and call whenever you think you have a shot they can use.

Don't expect a high return from fillers, especially from small-circulation papers. Do scrutinize the fine print on invoices and contracts, making sure that there's some provision for extra payment should the picture be picked up on the wires. Usually, you'll split fifty-fifty with the paper on subsequent sales, though you can negotiate prices on extraordinary pictures having national impact on an individual basis. Hard news will get you much more than fillers, and you should view the latter as a volume game that puts a few extra dollars in your pocket and adds a good picture credit to your book.

Fillers are always easier to get into smaller papers, but even then market competition can be intense. Wire services and staff photographers supply many of the fillers for large papers, but,

Meet the competition. The working photo press is made up of staffers (those on the newspaper or magazine payroll), poolers (freelancers who work on guarantees for a number of outlets), stringers (freelancers on call in regions around the country), and just plain freelancers (pros and amateurs who see newspapers as a steady source of picture sales). All this makes for some pretty stiff competition in the field, especially because news photographers (and in particular the personality-seeking paparazzi) tend to have a certain built-in aggressiveness in the making and marketing of pictures.

These folks don't share a serious character flaw, it's just that news photography is, in Harry Benson's words, ". . .not a gentile business." Getting the right "spot" for a news shot, catching the right expression or height of action, and competing with dozens of other photographers on the same event can make it a stressful affair. You can join 'em (it is an exciting business), or you can work the newspaper field from the relatively quieter distance of selling stock. Also, selling steady stock or spot-news shots to a paper can often lead to assignment work, if that's your aim.

as in all areas of the stock photograph market, there's always room for one more. Given the importance of photography in papers and the daily need for fresh views of the world, this market is one in which everyone with an eye, a camera, technical ability, a competitive drive, and a knowledge of marketing pictures can share.

"Feature" Photo Essays

The "feature" market in daily and weekly papers requires more research and dedication to a specific self-assigned task. Features should be thought of as photo essays on current events, topical subjects, lifestyles, travel, cooking, problems and solutions, and diversions particular to the market region served by the paper. Some papers have a daily second section where these photo essays are run, others have special feature sections that come out only on weekends. Larger papers have a weekly schedule for sections that in turn feature home, travel, science, sports, and other topics.

Some examples of feature photo essays might be: A Day in the Life of a Commuter; The Plight of the Homeless; Day Care—One Child's View; The Gardens of Frank T.—Topiary on a Backyard Scale; Teenage Fashions—How the Stars Determine the Mode; Chimney Sweeps—No Longer a Dying Breed; The Tenth Ward—Restoring the Past; A Night in the Emergency Room; Troubled Waters—Toxic Dumping in Slawson Creek; Pastry Pleasures—Local Chefs Shine; Mobile Homes—A Neighborhood View; Keepers of the Light—Our Shoreline Guardians; Just Fishing Around—The Charter Boat Trade; Weighty Matters—Slimming Down in Suburbia; and Off the Road—Four Wheeler Clubs. The list could go on and on. Gaining inspiration for topics is a matter of keeping your eyes and ears open, scanning the papers for notices of out-of-the-ordinary events, and photographing subject matter that you, yourself, find interesting.

Making pictures for feature essays is much more of a concentrated effort than making casual shots for fillers. First you have to arrive at a unique theme, then design a plan of action. You might want to do all the shooting and research in a few days, or return to the project repeatedly as time

Weather-related pictures always do well as filler shots. This photo, taken during a severe ice storm, served as part of a series showing slicked roads, fender-benders, and downed power lines.

Carrying a camera (even a compact 35mm) with you at all times is one way always to be ready for a surprising spot-news event. These balloons suddenly appeared overhead in Century City, Los Angeles, and the juxtaposition of elements made an interesting shot.

Almost every Sunday newspaper around the country has a Sunday color supplement. Though some use syndicated inserts (such as Parade) many offer their own specialized, regional coverage. These are good outlets for photo essays. This photo is part of our coverage of a group of kite flyers who gather each winter on the beaches of Long Island.

Theme shooting, or photo-compulsions, are the stuff from which later photo essays are made. For some it may be pink bicycles, for others outdoor cafés—there was even a photographer who made a series of pictures of the same chair in various locations around Europe and sold it as an essay entitled "The Travelling Chair." Sounds crazy, but it ran as the back page of a photo magazine for six months in a row. One of my bugs is walls and signs—I have pages and pages of them from around the world. For me, they always display a bit of their culture, and they serve as empty canvases on which the artists of the streets leave their mark. The sage advice in this photo was tacked up on a small outbuilding near the North Eleuthera airport in the Bahamas.

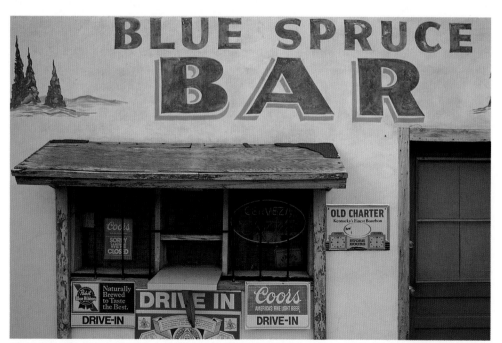

This drive-in bar carries more than a few hints about its location, and was used as a detail shot in an essay on Colorado. Many times, pictures such as this one serve as a sidebar to a layout. I usually make these shots on the roadside and rarely turn the motor off while I make the exposure. Though the wall shots don't tell the "big story," I treasure them as cultural icons—they are the spice I add to an essay's recipe. When you edit your file, you may discover picture "threads" that run through your own material. Consider placing these in separate files (being careful to caption their location before you do, as they may serve as detail shots for a specific location story) and presenting them as unified theme essays.

allows. This will depend on the nature of the essay, and on how you're able to focus your energy.

While shooting, be sure to keep accurate notes for caption material, and always carry model-release forms with you. Shot both in color and black and white—many papers now do color photo essays as regular parts of their press runs.

Don't make your theme so all-encompassing that the project becomes a life's work. Focus fairly narrowly on an idea, and explore that theme comprehensively. Too often photographers get grand ideas that somehow never get completed. Telling a story about an aspect of an event or area will always be more productive than trying to capture the great scheme of things. Let the particular tell the tale of the infinite, if you will.

Try to tell the story in ten pictures or less, though of course you'll be shooting many more pictures from which you'll edit the final submission. Begin modestly, sell the essays, and move along. You'll find that method more reinforcing, and more lucrative, than one that gets you bogged down in telling a grander theme. Writers, by the way, are subject to the same grandiosity—those who begin by tackling the Great American Novel generally end up with reams of typed paper that no one ever reads.

A side benefit of doing focused photo essays is that your general stock library increases as a natural by-product of the project. Working from the essay as your base forces you to produce more stock. This symbiosis increases inventory as it provides financing for future work. It's a good way to keep in business, while at the same time having your

camera lead you into many new life experiences. That is what the trip is all about.

A Talk with Tom McGuire of *Newsday*

Newsday, a Long Island-based paper that has recently put out a New York City edition, occasionally runs an ad stating that it buys news pictures. Picture Editor Tom McGuire and his staff review portfolios and screen work from a steady stream of freelancers. "Though we have nearly thirty photographers on staff or call," McGuire says, "we do review portfolios of work. Many people who come in make the mistake of showing too much—with about twenty shots the editors and I can tell if this is someone with whom we can work."

McGuire gives us a sense of the criteria *Newsday* uses in determining whether or not to buy a free-lancer's submission. "The main thing I can say about what we see is that the quality is not outstanding. For example, lighting is a major problem. People seem to know so little about it, and it's such a telling point. Most people just use the flash on the camera and shoot away—that work simply does not belong. The idea is to show us some knowledge of technique. Don't come in with underexposed pictures with the excuse that the flash didn't have properly charged batteries. You can't get work with excuses.

What kind of photographers will attract the interest of the picture editors at *Newsday*? Says McGuire: "There are two categories of pictures we buy. The spot news is usually a police or fire emergency, and with these we ask people to call in first. With a few questions we can usually determine whether it's worth their and our time to bring it in. We're usually not interested in a minor fender-bender, unless of course, it happens to involve the County Executive's car. We do look for good, solid picture layout ideas for our Part II daily section that contains arts, entertainment, recipes, regional focuses, and feature stories, and for our Sunday magazine. We are very selective about this work. For example, a photographer recently brought in a remarkable series on the homeless of Long Island, something not many people are aware of. Often if we like what we see in a portfolio, we give tryout assignments."

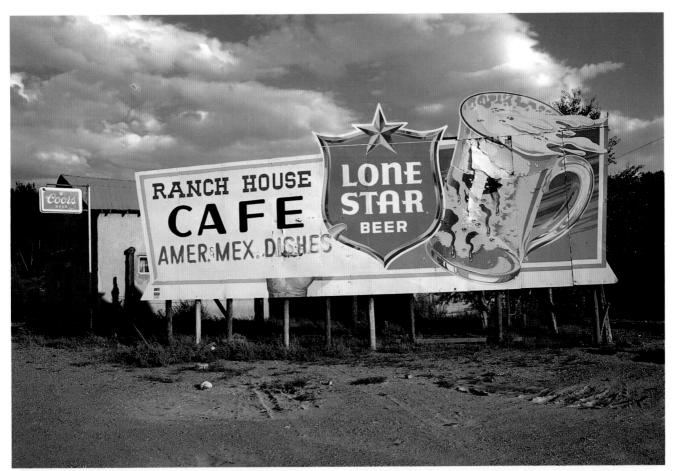

The day was bright and clear, the sign was shining in the afternoon sun, and that frosty beer looked awfully good to a parched photographer travelling the back roads of New Mexico. Cultural landmarks such as this sign may prompt me to get an "I brake for pictures" bumper sticker for my car. A year later, going over the same road, the sign had been knocked over and the bar was deserted. Such tragedies always remind me to make pictures when the light and subject matter are right, especially in the changing world of roadside America. Sic transit gloria mundi. Putting together photo essays is one of the more enjoyable aspects of stock photography. Many such projects are created long after shots are taken, on the editing bench or while contemplating a mass of work. Think of the photos in your files as being so many interlocking building blocks, pieces of a puzzle that can fit together in hundreds of ways. Match these constructions with markets, and you'll begin to discover a new realm of the photographic experience.

TRADE PUBLICATIONS AND SPECIALTY MAGAZINES

The Hidden Market

ALMOST EVERY INDUSTRY AND SPECIAL interest group has some form of publication. Some use very little freelance work, or they pay so little that all a freelancer gets is postage money and a photo credit, or they use nothing but advertiser or public relations agency-supplied work. But a good number of them buy a steady stream of photographs from freelancers. These publications feature everything from farming to heavy industry to leisure-time goods, and quite a few focus on very narrow areas within their fields. These magazines are rarely seen on newsstands—most are sent as freebies to industry insiders and end users of the products or services they cover. Their "low profile" means that you have to do some research to find them, but having found them you might be able to use them as a steady source of income.

Trade Publications

"Trades" come in all shapes and sizes, from bi-monthly bulletins to full-blown glossy magazines to tabloids (newspaper format). Some trades have substantial staffs, but most are operated out of small offices that are often part of a larger publishing concern.

The smaller trades are a good news–bad news deal for stock photographers. The good news is that a smaller staff means the possibility of building a more intimate, one-on-one working relationship, in which getting vital information is often just a matter of a phone call to an editor. When you become a reliable, technically excellent source of pictures for

such a magazine you'll find that you can become a very busy photographer. The bad news is that such a magazine usually pays a low amount, doesn't report as rapidly as you might like, and generally uses stock as a last resort because of its trade sources.

One aspect of trades that might be a problem for you is that they usually want photo/text packages rather than just photography. It's true that editors want the best pictures they can get for a spread, so you might be able to supplant the writer-supplied pictures with your own. The problem here is the editorial budget—even if your shots are better than those sent in by the writer, buying from you means that the magazine will have to spend more for the article than it might have planned. These situations cause friction between editors and publishers, one of the reasons for the high turnover of editors in this budget-conscious field. One way out of this is to link up with a writer and develop picture/story ideas; or, even better, take up the pen yourself. Writing for the trades isn't as demanding as writing for a major consumer book, although you still need to have some grasp of how to manipulate words.

Covers represent the best opportunity for getting good pay from the trade press. Front pieces usually have a separate budget, and editors are always on the lookout for "grabbers," shots that focus readers' eyes on the sell lines and make them want to open the book to see more. While each publication has its particular log and layout, a cover formula really has three aspects, which could be described as follows:

1. Vertical format: The logistics of covers usually call for a vertical format, although a cover box with type set on a color field can make use of a horizontal picture. However, editors

Shooting for the trades often means focusing on the commercial side of life. A close-up picture of flowers is very nice and perhaps useful for packaging or greeting cards, but the gardening industry would be more interested in a "wholesale" approach to plants. This lot of bulbs was photographed in the Flower Market in Amsterdam, a virtual paradise for photographers.

Trade journals need steady, reliable sources of pictures, and if you choose one area of specialization, you could become a very busy photographer. One advantage of this work is that you are always filling your stock files as a natural by-product of your shoots. This industry-oriented shot of the flower market in Amsterdam could serve equally well as travel or greeting-card stock.

Landscaping and gardening are but two of the hundreds of industries serviced by specific trade magazines. Photographing for the trades can be enjoyable if you like the environments in which they're plied. You may end up shooting heavy-duty equipment, aircraft, railroads, or even oil rigs.

Trade journals often need photos of their products' end-users. This photo could be used for an article giving advice about dealing with customers in a retail garden-supply magazine. It was originally made for a piece on bed and breakfasts of the Delaware shore. Such is the flexibility of stock shots.

Just because a trade magazine deals in business doesn't mean that photos you sell to them can't be a pleasure to make. Inside shots tend to be of the "meat and potatoes" variety, but covers are chosen on the basis of their eye-appeal.

tend to have a knee-jerk reaction that verticals are necessary for cover material.

2. Graphic design, bold colors: A picture with intricate design and details will do well as an inside illustration, but cover shots must make a simple graphic presentation of subject matter. Scan the racks of any magazine stand, and you'll see how these bold statements dominate the field. Trades don't rely on impulse for sales as much as consumer books, but they still want to have a grabber for a cover. Some photographers, by the way, feel that the color red is essential for a cover shot, and imply that without it they never make a cover sale. This is doubtful, but proves an interesting point.

3. Space: Although an uncluttered shot leaves room for sell lines, space at the top allows for easy placement of a magazine's logo. Some layout artists will go for a "full bleed" (edge-to-edge picture on the cover, with sell lines and logo wrapped around the image) if the picture is strong enough, but many prefer the simpler solution afforded by a picture with an "empty head." Photographers shooting with an eye for covers use this device to increase sales.

These three basic guidelines are not hard-and-fast, but they do hold for most magazines.

Sources of trade magazine titles and contacts are available through magazine-listing directories, or through suppliers of goods and services in the field that they cover. Listing directories are available from the following sources: The National Research Bureau, 424 North Third St., Burlington, IA 52601, telephone 319-752-5415; and R. R. Bowker Company, 205 E. 42nd St., New York, NY 10017, telephone 212-916-1681.

When you call or write for information from either of these firms, specify the market area in which you're interested (trade, consumer, etc.), and request a publications catalog and promotional literature. These two organizations offer a variety of publications that list publishers. If you're just starting out and can't afford the hefty fees they charge for these books, you might be able to find the books in the research section of a large library or be able to order them through an inter-library service. If you want a ready reference, however, you might be better off making the investment.

Another way to discover these often obscure (only in the sense of their targeted distribution) publications is to go to end users of the magazines' products and ask to see the magazines they receive. For example, if you have a friend who works in a marina, he may subscribe to *Boating Industry, Boating Product News, Boat and Motor Dealer,* and *National Fisherman.* An acquaintance in the landscaping business may receive *Garden Supply Retailer, Grounds Maintenance, Landscape Archi-*

Making pictures for a business magazine doesn't preclude making a pleasant shot. Though some of these magazines use illustrations that look as if they were made on high-contrast film through a dust-covered lens, the up-and-coming trades are paying more attention to graphics and style. This shot of a houseplant is intended to offer a more graphic look.

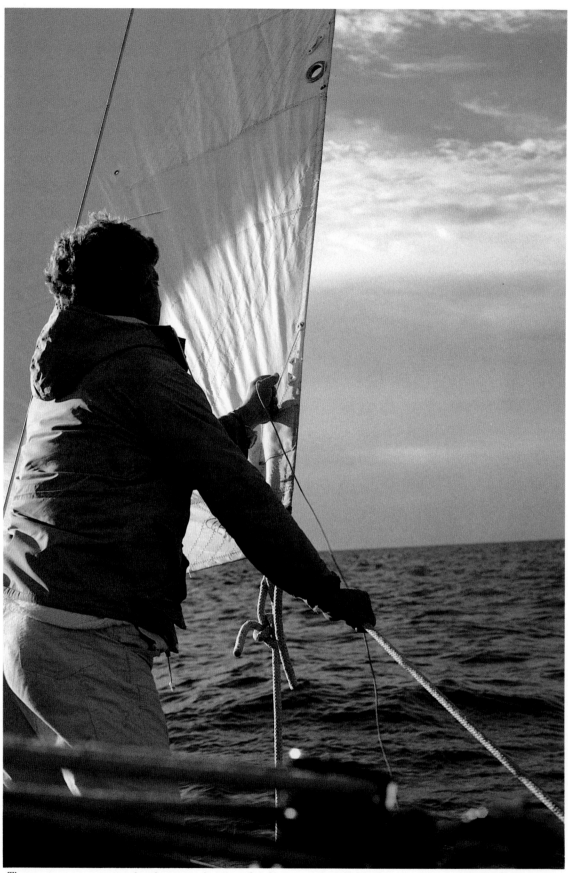

There are numerous trades that cover boating. On the recreational side there are magazines for boat dealers, marina owners, and suppliers of goods. And there are commercial journals for charter boats, fishing and ocean-going craft. All need a monthly supply of good photos.

tecture, *Landscape and Turf Industry*, and *Weeds, Trees, and Turf*. Once you delve into the trade publication market you'll be amazed at the previously hidden markets you'll discover.

If you decide to go after the trades, choose a subject first because it interests you, and second because it's accessible. Mainly, take on areas in which you might take pictures anyway. If making pictures of formal gardens gives you joy, then pursue that field—if the sight of an oil rig in the sunset is the type of photograph you'd go out of your way to

make, then try out those trades. Remember, the idea is to sell images that you already have in your files, as well as continuing to shoot pictures that you enjoy. This becomes even more important because of the low pay scale in this market. Speculative shots should be kept to a minimum.

But if you have the pictures already, or want to put yourself in picture-taking situations you enjoy, then become aware of these hidden markets and exploit them. First, you'll be increasing your stock file for other markets; second, this is a market where making

steady stock sales often leads to assignments. Become a steady source of supply, deliver consistently high-quality work, and there's a good chance you'll be asked to become a stringer or story-board photographer.

For example, Mark Zacaria is the editor of *Studio Photography*, a trade magazine for studio and professional photographers with a circulation of approximately 65,000. It is part of a larger concern, PTN Publishing, which issues ten other monthly journals in the photographic and security fields. Submitting

freelance work for consideration is "no problem at all," says Zacaria. Cover shots are usually drawn from inside material, though the magazine often uses covers based on seasonal or magazine-theme issues. "We very rarely accept covers that aren't tied to editorial." Photographers interested in getting work into *Studio* should send samples of work tied to a story idea, which means to submit theme projects rather than making a general-interest or broad-spectrum submission. If work is sent without accompanying text, and it applies to *studio*'s area of

Supplying stock to these markets is a natural for us, since we live near the water and close to a number of marinas and commercial fishing docks. Choose a specialization based on access and interest.

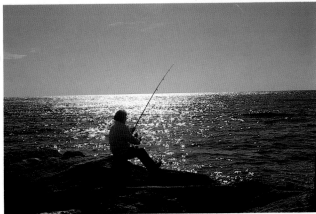

As with other editorial markets, trade magazines often use detail shots to add a spark of visual interest to their layouts. This found still life is part of the wheelhouse on a lobsterman's boat moored in a nearby harbor.

One afternoon we were shooting details of this motor yacht when a sudden storm darkened the sky and sent a shaft of blazing light onto our subject. Rather than pack it in, we shot more intently than before. I now see this shot as more suitable for a photo book than for our Boating trade file. These outgrowths of purpose are what make stock work so interesting.

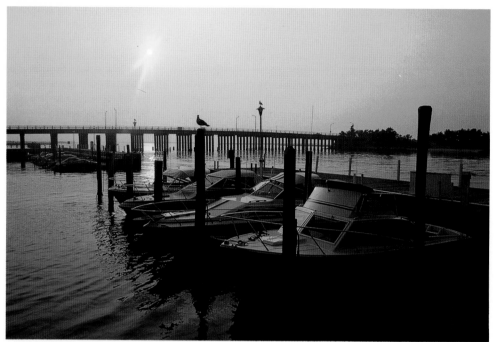

I rarely shoot with special-effects filters, but I'll occasionally use color-correcting filters for an extra, moody touch. Photos made with natural light, or with skillful use of artificial light, are the most pleasing to me. Most art directors seem to agree and shun super-special-effects-filter shots like the plague. This photo was originally made for our Boating-Marinas file, but became part of a submission to a filter-manufacturing company for use in one of their brochures. The only two filters I always keep in my gadget bag are a UV and a Polarizer, both essential for color-slide photography.

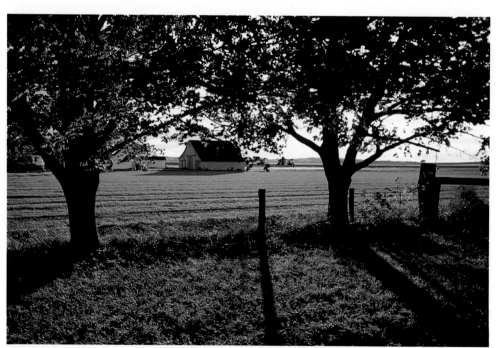

The agricultural industry has many trade journals, each one dealing with a specific level of the business. There are magazines for dairy farmers, wheat growers and small family farms, and there are magazines that feature stories on heavy-duty farming equipment. Those of you who live and work in farming regions should familiarize yourself with these trades because they represent a good market for regional stock. This photo was used as an illustration in an article on the East End of Long Island, where the traditional potato-farming industry is slowly being replaced by a growing group of vineyards. Needless to say, this is having a big effect on the lifestyle of the people who live in the area. This is a bit of a nostalgic shot, showing the afternoon sun streaking over a potato field, soon to become a planting field for vines.

coverage, Zacaria often proposes an interview or visit with the photographer to develop a story idea. If a text is submitted and it doesn't meet the magazine's writing guidelines, the editor may work with you on a rewrite. The magazine regularly issues editorial calendars.

A Talk with Jim Fullilove of *National Fisherman*

Jim Fullilove is Editor of *National Fisherman*, a trade that deals with the commercial fishing and boat industry. The publication uses *both* freelance and assignment work, and though it usually doesn't work with unsolicited material, Fullilove is always looking for good cover shots. The trade has a stable of regular writers, and they often try to link up writers and photographers in different parts of the country.

"One of the problems in dealing with freelancers," says Fullilove, "is that they are not familiar with the publication." Other times, he feels that "their eyes need a tune-up. Commercial fishing is something that's out of view to most people. A photographer covering this beat must be familiar with the industry, and know the angles that tell a story and would be of interest to our knowledgeable readers. If the photographer is familiar with the industry and knows how to handle a camera, then we can talk. For covers, we look for lots of action, with elements of importance to the industry."

Specialty Magazines

Another class of magazines with which you might not be familiar are those targeted to such special interest groups as doctors, teachers, lawyers, retired people, and consumer and environmental activists. Though some of these have a very narrow

focus, others are more in the class of general interest and feature "books." The latter group concerns us here, as publications in this genre are most open to accepting freelance photography, and they pay the best. Some are mere bulletins with news of note to their members, and although they might have large circulations they don't necessarily buy from stock.

One place you won't find these magazines is on a newsstand, and unless you are a member of a group or have a friend who receives the specific magazine, you might never see the titles. Resources for locating these publications are the same as for the trades.

A good way to focus on specialty magazines is to use a "breakdown" listing of periodicals from a comprehensive reference guide. Look for circulation, advertising rates, and, most important, the publisher's statement. Circulation figures can be deceptive—a small circulation book may be an excellent market for you. It is best, however, to have a cutoff point—say, 15,000 or 20,000—below which you can figure it won't be worth your efforts to apply and submit. Use low advertising rates to reinforce your culling operation; when they combine with low circulation you might as well pass up that publication. You can assume that it's a very narrowly focused book that leaves little opportunity for you to grow and prosper. There may be exceptions to this, but I haven't found any.

For each magazine listed, the reference publisher's statement outlines the aims of the magazine, the market served, and the overall approach to the creative product that's being offered. A statement might read: *Retirement Age Magazine* publishes articles of general interest to retired members and pensioners of the American Steel Union. Editorial items include such leisure time activities as travel, arts and crafts, hobbies, home maintenance, health-related issues and diet, as well as including personality profiles of members engaged in an interesting activity. Departments include union news, travel updates, pension news, and theme issues related to those in the forty-five-years-and-up age bracket."

This kind of statement will give you an idea whether or not to pursue the matter further. At that point, a phone call or letter should be enough to get the ball rolling. As with all magazine work, it's a good idea to request a few issues before you begin to submit work and ideas. A constant complaint form editors is that freelancers send work "blind." Doing that not only wastes your time and postage, it might also lower your standing in the eyes of buyers who feel (rightly so) that you won't even take the time to familiarize yourself with their product before you send work. Because the staffs of these magazines are usually small, that would jeopardize getting work accepted in the future. Once you do get an issue of a specialty book, you might be pleasantly surprised at the "sleeper" markets these publications represent.

A Talk with Amy Schiffman at *Diversion*

Diversion, billed as a leisure magazine for doctors, serves a well-to-do readership in the age bracket of forty-five to sixty-five years. Situated among the ads for pharmaceutical companies are columns and articles on travel, food, clothing, and other "upscale" life-style interests.

Amy Schiffman, an editor at *Diversion*, says they're happy to get work from freelancers, but emphasizes the need for picture entrepreneurs to "get organized. Most of the work we use is on travel, and on rare occasions we have budget for other things."

The art director at *Diversion* does the picture selection, and Ms. Schiffman recommends that freelancers drop off their books to show the style and range of their work. After they show their work, presenting a stock list—one that is occasionally updated with computer printouts or mailings—is a must. From these lists, the art director calls freelancers to match needs to picture files. Portfolios can also be sent by mail for perusal, accompanied by a "crisp letter"; and it is emphasized that duplicates, not originals, be sent in on initial submissions. Like most other magazines, *Diversion* seeks a one-to-one relationship, built up over time, with photographers. "We look for a businesslike approach from our picture sources," Ms. Schiffman states.

The rapt attention of this young fan was captured at Shea Stadium during the 1986 New York Mets pennant drive. Whenever you make people candids for stock, keep in mind that the picture should show a strong sense of involvement.

This photo of caged songbirds was made in a crowded street bazaar in Bangkok, and sold to a student-oriented specialty magazine. This is a case where an extended caption helped make the sale.

CONSUMER MAGAZINES

The Golden Age

IN A RECENT INTERVIEW, PHOTOGRAPHER Harry Benson said that he considered the present time to be the "golden age of photojournalism." How could he think that way, considering the demise of such giants as *Life*, *Look*, and *The Saturday Evening Post* (although two of them have been revived, to somewhat mixed reviews)? The reason for Benson's exuberance over the possibilities offered a photographer today is the incredible number and diversity of the magazines on the market.

"*Life* and *Look* were for a select few," said Benson, "and now we have a much wider market offering opportunities to many more photographers." Those opportunities are in a genre of publication called the consumer magazine.

I define consumer magazines as those available on newsstands—they range from defined-audience books, like *Skiing*, to block-buster general interest books, like *People* and *Fortune*. Whether a magazine has a narrow scope or a broad one, each aims at a certain level of readership (upscale, middle class, blue-collar) and entices advertisers to spend money by promising to deliver that particular group as an audience for their goods and services. Although marketing strategies to these diverse magazines can be similar, you should be aware that each one has its idiosyncrasies, its own approach to contributors, and a unique picture-acceptance policy.

Fan Books for Hobbyists and Activities

One of the largest categories of consumer magazines, and the one most open to the freelance stock photographer, is the "fan book." Fan books are magazines that appeal to hobbyists, collectors, aficionados, or those who *wish* they could be involved with what the articles describe, such as "Trekking Through the Great White North" in an adventure magazine. Think of an activity, and there's probably a magazine (or ten) for it. Computers, video recording, photography, sailboarding, kite flying, pigeon racing—you name it and there's a magazine with regional or national distribution for it.

Most of these books are always looking for photo/text stories that fit their readership profile. A magazine devoted to wine and food, or that has a wine and food column, may be ripe for a story like "Touring the Bordeaux Vineyards," whereas a magazine on travel, boats, or Florida would go for a title like "Motor-Cruising Down the Intracoastal Waterway."

Covers, Photo Essays, and Story Ideas

In terms of selling stock photographs without text to these magazines, you have a number of avenues: covers, photo essays, and story ideas that wrap around a series of photos. Cover shots were discussed in the preceding "Trades" section. Here I want to stress that competition in the higher-paying *consumer* cover market (in which rates can be as low as $400, or as high as $3,000 for a cover) is quite intense. Quality and "eye-catchability" are a must.

Many of these magazines bring out theme issues based on a seasonal, main-topic, or other select editorial focus. Often the main feature story will determine the cover. In the case of seasonals, remember that most books work a minimum of three months in advance, so adjust your submission calendar accordingly. For theme, focus, or main-story issues, having

The diversity of subject matter for the consumer editorial market is as wide-ranging as the number of magazines on the stands. Build your stock files according to your interests, then find a market. This shot is part of our Antiques file.

There are hundreds of magazines that use editorial stock, and there are an equal number of art directories and editors making the buying decisions. That's why it's important to try many different approaches to your favorite themes and to constantly update even your strongest, or major, picture files. Art directors are always asking, "What have you done for me lately?"

One reason we shoot at flea markets is the opportunity for pictures presented by the odd juxtaposition of objects arrayed on the sellers' tables. Once we accumulate a sheet or two of strong images, we develop themes and captions and begin our submissions procedure to various markets.

This is another "found still life," a section of an antique shop's window display photographed in the back streets of Halifax, Nova Scotia. Though initially placed in the Nova Scotia file, this photo has been moved to the Antiques, Green, Still Life, and Collectibles topic files. Once you begin to move pictures from file to file, you'll begin to see the many ways a picture can be marketed. Flexibility, familiarity with your material, and a coherant system of cross-referencing are all important factors in making the most efficient use of your work. Whenever a submission goes out, you may find yourself pulling shots from various file folders. For example, a submission to a collectors' magazine may draw upon shots from the Antiques file, the file of the city in which the shot was made, or a specific location file, such as one holding interior shots of a restored mansion. You never can tell what kind of picture call you'll receive next, so devise a search method that permits easy scanning of your material.

close contact with the editor or art director will give you a clue as to what will be needed three or even six months down the road.

Only your best, punchiest work should be entered in the cover derby—these magazines depend on newsstand sales as well as subscriptions for their market shares, and they keep close tabs on covers that garnered the highest free-booting sales. Should you get chummy with the picture editor, ask to see the "winning" covers of the last few years, and dissect their graphic layouts, compositions, colors, concepts, and subjects. Add your own vision to the stew, and you'll probably score a few covers with the recipe.

Photo-essay submissions should consist of a sheet (or three) of slides with intense coverage of one topic. They could be meant to illustrate a technique piece for *Skiing* through coverage of a downhill champion with winning form. They could be a profile shoot for *Golf*, recording an insider's day at Augusta, or a film story for *Popular Photography*, showing examples of work made with infrared film.

Choice of photo-essay topics should come from familiarity with the magazine's subject, plus research on what's been published over the last two or three years. Many magazines assume that they have a two-year turnover rate (the time in which they pick up and drop readers). You can research the articles already done through a magazine's index (issued annually) or by checking your ideas against those listed in the *Reader's Guide to Periodical Literature*.

I believe it was Plato who had the right idea about ideas—he believed that every idea has a time and

that it floats around the collective human consciousness until someone reaches up and plucks it out of the air. This seems to work with magazine articles—just as you have an essay half completed, you open up your favorite magazine and the same idea, or a slight variation of it, hits you in the face. So when you come upon a theme that strikes your eye and mind, pursue it vigorously—don't procrastinate!

When submitting stock to these major magazines, you'll often run up against competition from staff or "insider" photographers, from those who've submitted photo/text packages, and from major stock agencies that have an inside track with the art director. At first, it may seem that getting into these books is next to impossible.

My best advice is: Don't despair. With persistence, quality, and targeted submissions, you'll eventually find a small niche (such as a column or filler shot) through which you can enter the publication. With follow-up, and repeated ideas, you'll gain a name with the staff and be called upon for more work. This takes time and patience, but every photographer who has pictures published in major magazines today started at about the same place you are now. We're all born naked and take it from there.

Picture Policies at *Popular Photography*

One consumer book with which I've had considerable experience is *Popular Photography*. Although not every magazine will operate the same, there are many parallels to other large magazines in the way this book works. Except for news and reviews of equipment, "Pop Photo" is filled entirely with

This detail of a still life highlights two facets of shooting for the stock market. The first is to use compositional bracketing, which means to take a number of views of the same subject. This gives you the most mileage from every photo session. The second is to be aware of a picture's many potential uses. Originally made for a layout in an antique-oriented spread, this "sectional" became part of a submission to a music magazine for an article on lutes and mandolins. Once you begin to see how various pictures can be marketed, your method of making photographs may change.

The combination of light and texture in this still life attracted my eye to this shop window in New York's Lower East Side. Cities are like great open-air studios where a photographer can let his or her imagination roam free. Frankly, I've never had the patience for the rigorous disciplines required in studio photography, and more often than not rely on city streets and country lanes for my setups. This attitude seems to fit in well with the style of work that sells in the editorial stock market. However, I know that carefully planned studio shots do equally well. I just wanted to let you know that you don't need a full blown studio or lots of fancy equipment to prosper in this field. Often, a good camera and set of lenses, plus a roving eye, will do.

work from freelance photographers. A few years ago, *Pop Photo* had a reputation for mixing equipment stories with art photography—recently, it has shifted more towards technique articles, though excellent pictures are still sought for illustrations.

This shift in editorial makeup is noteworthy, because it gave certain picture submissions more of a chance and diminished the chances of others. For at least a year after the internal decision to change, the picture department kept receiving personal art submissions, which were summarily returned. The photographers sending such work could have saved time, and postage, by keeping up with the drift of the book. This example highlights the importance of keeping tabs on what type of work any magazine will take.

The editors at *Pop Photo* always have an eye open for potential picture stories because they publish twelve issues a year, averaging three to five freelance-supplied stories per issue. Like most consumer books, each editor has responsibility for a certain field of interest, such as darkroom, film, video, or lenses. Similarly, other magazines have editors for main features, travel stories, and special departments, among others. Getting your story pitch to the right editor can do a lot to keep your ideas afloat in the office maze. A phone call to the general switchboard, or a very defined query letter addressed to a masthead-identified department head, will lead you to the person most crucial to helping you get the sale.

Queries that are brief and to the point, and very defined in their scope, get the most attention. Suggesting a story or spread (a two-page "how-to") on, for example, "Fill Flash for Outdoor Portraiture" will get more interest from an editor than one on "Flash Photography," a subject more suited to a book-length treatment. The same goes for other magazines. A title like "Touring the Mississippi" will be too broad for most magazines, whereas "Paddle Wheelers on Minnesota's Mississippi" will get some play.

Because *Pop Photo* is "picture-driven" (the photos tell and sell the story), any ideas should be accompanied by a sheet or two of slides or a few black-and-white prints. Its editors, and those at all consumer books, have the experience to know on the basis of a few pictures if a photographer and a story idea "have it."

To overwhelm editors with your life's work on a subject won't be helpful, and in fact may harm your chances by giving the editors too much to look at and too much choice. It also shows that you haven't taken the time to focus on your subject.

Even if you can't or won't

Ripped and layered posters are a favorite subject, and the words and pictures create a kind of cultural collage.

This fun shot was made in Venice, Italy, where a tattered billboard reveals that there's no end to "wall" shots.

write the text that accompanies the picture submission, you should submit a brief outline of your idea—let the editor know what you have in mind. Many times, editors follow up evocative submissions with a phone call to the photographer to develop appropriate captions or even a full-fledged story. That is their job, and even if you can't put a noun and a verb together on paper, they will walk you through what they need to know to make a story out of a set of pictures.

Technical data (which film, *f*-stop, lens, were used) are important to *Pop Photo* readers, but needn't be sent with pictures. These details are rarely if ever called for in other consumer books, yet

This fading wall painting was photographed in the town of Bisbee, Arizona, as part of an essay on this once-booming mining town.

This photo was made while wandering the back streets of Rome, and it has proven to be one of the most popular in my "wall" series. Such street art can range from the masterpieces of the Mexican muralists to the grafitti of New York's spray- *can "writers." This free and public art is rarely sanctioned by the powers that be, but I feel that these splashes of color and design do a lot to enliven the gray cities and my coverage of them.*

Though shot on a side street in Boston, this photograph of a newsstand wall probably won't ever be used in an article about the city in a travel or general interest magazine. This detail picture is too unlike the character of the city to make the point. This is one of those "orphan" abstracts that generally finds its way into our catchall topic file of "Color and Design" pictures. Such shots are useful as part of a graphic series showing photo technique—for example, to illustrate an article in a photo magazine explaining how to expose for highlights to saturate colors. Abstracts can also be used as bright, splashy backgrounds in color spreads. Though the number of photo magazines has dropped somewhat in the United States, there are still many international photo journals that are constantly looking for pictures. Check the magazine racks in major cities for outlets, and be sure to send a query letter before shipping any work. When you look at the mastheads of these magazines, you'll see that many of them have representatives in the States.

this data is crucial to a story in a photo book, something to keep in mind when doing your general captioning.

As with other large-circulation magazines, many story commitments at *Pop Photo* are made by committee, so you shouldn't be surprised if a once-enthusiastic editor calls you back a week later with bad news. The way you take occasional disappointments in this business can often determine how you'll be received later. Understand the editor's predicament and you'll have his or her full support on future story proposals.

The span of time from your initial submission of work to its appearance on the page can take up to a year, depending on the timeliness of the story, the number of stories in inventory, the number of advertisements sold (which expands or contracts the pages in the book), and the arrival of "news" stories that bump other editorial plans down the calendar. This can be a frustrating experience for a photographer, especially if the pictures could be earning fees elsewhere. Most magazines will want first rights on pictures, at least regarding their competition. Selling a cover to one photography magazine, for example, and then having the same shot show up on an inside spread of another, is a good way not to have any more work published in either book in the future. Be patient—waiting is part of the trade.

Cover shots are usually tied to inside feature stories, but strong seasonals always do well at *Pop Photo.* Because the cover shot is one of the first pictures to be shipped to the printer, many times before photo/text stories are fully in-house, covers have been chosen from a file in the picture de-

partment or from a recently arrived portfolio of pictures. Very strong shots, regardless of theme or season, are always considered for covers.

We mentioned earlier that sometimes a "hole" develops in the magazine, a situation in which a promised story fails to appear, or more pages of editorial space become available due to increased color advertising. Although this situation is not broadcast to the general public, it's an excellent time for your submission to arrive. Panic takes place just at the close of an issue, usually the last few days of the month.

More than once, a story has been whipped into shape in miraculous time. Recently, a picture essay arrived one Tuesday afternoon, the photographer was called the next day, and layout and text was shipped to the printer by the weekend. Record time and a rare occurrence—it does happen.

Keeping Abreast of Change

Not every consumer book works the same as *Pop Photo*—some are looser, some are tighter. It all depends on the nature of the magazine, the flow of editorial copy, and the amount of timely stories the book can handle. Many magazines demonstrate a mix of approaches, depending on the editor, the department heads, and the workings of the art department. Count on the fact that structure and pace will be different at every magazine, as are the ways pictures are received and story ideas accepted and rejected.

Editors change, and so does policy, so what might be true one month could be radically different six months later. Learning about what changes and what remains the same is part of the research needed to make it in the consumer-magazine field. It takes phone calls, letters, and a certain persistence to keep it all together. Research each book, get to know the rhythm of a magazine, develop rapport with its editors and art directors, and you'll discover how to cut through red tape and make more magazine picture sales.

This painted wall outside a restaurant in the Bahamas provided another free graphic. You can use such signs to build an inventory of colorful words and phrases. These details often sell as part of overall essays on travel destinations.

In my opinion, street artists are among the best graphic stylists working today, and their creations are as stunning as they are temporary. Isolating these designs by putting a frame around their boundless energy is part of the fun of photography. I found this palm tree, which was probably spray-painted through a stencil, on a chipped wall near South Station in Boston. Roaming the streets in search of such images is a bit of a compulsion for me, but it has paid off handsomely in a library of found graphic designs.

Shadows create their own space and form, and they can be used as strong design elements in a scene. This photo of the outside wall of a Polynesian restaurant was made in Boston's Chinatown (note Tiki in upper left-hand corner) and is part of a continuing series on shadows.

PHOTO/TEXT PACKAGES
Enticing the Editor

EDITORS ARE ALWAYS ON THE LOOKOUT for photo/text submissions. These packages save them work, money, and time. Your chance of selling stock photography to editorial markets increases when you can deliver a whole package of pictures and words, rather than offer merely photos that have to wait for a "word vehicle" to carry them into print. The text part of the package can be anything from a set of extended captions to a full-blown, 5,000-word feature story. The former can be thought of as an *extended-caption photo essay*, the latter a *feature photo story*.

Photo essays require no extra research and writing beyond developing a theme, writing long (or at least thorough) captions aimed to that theme *and* to the magazine's style and point of view. For example, for the last few months I've been working on a series of pictures of details on pre-1955 American cars. The sweep of chrome and use of paint makes for some great cultural landmarks, is graphically dynamic, hits the nostalgia trend, and shows the design elements of a period as modified by garage artists. In short, this developing photo essay can appeal to a wide variety of markets.

Each market approach that I take will be different, and the theme and captions that I offer with each will be geared to individual outlets. For example, my submissions to car-buff magazines will include captions that name the make and model of every automobile, the name of the restorer, the car club (if any), and some research on the "right" names for some of the car's modifications (skirts, baseball caps, tuck 'n roll upholstery). A photography magazine will get an over-

view theme piece with a short header on cars as cultural monuments, along with tips on the film, lenses, highlight control, and filters, used to make the pictures. An in-flight magazine will get a longer introduction, a cultural overview, with captions limited to either the modification or the model of car in each shot.

With this approach, one series of photographs can be sold to a number of markets merely by altering the style and organization of the package. When you provide such a package, you help editors and art directors convince others that your work should appear in their publication. A bald submission of photographs, without a clue as to how the pictures could be used, might not instill as much energy in an editor as one that comes with an idea already tagged on. At least you give people something to begin with, a thought to get their wheels turning.

A tight theme is essential—don't come in with a grand idea and expect to fulfill expectations with only a few pictures. Focus your energy on one statement that is simultaneously universal and individual. Edit a series of pictures thinking of three possible outlets for the same shots and how different captions can alter their appeal to different markets. All this approach requires is a way of looking at photographs, and gearing one set of pictures toward a number of directions.

Freeing Yourself from Writer's Block
Before discussing more arduous forms of writing, let's talk about the photographer's supposed "writer's block." If you believe that you, as a photographer and a visual person, are incapable of developing the side of the brain that concerns

itself with writing, then you'll never be able to write. This myth carries about as much validity as the one that says an artist must starve. Writing is a craft as much as any other, and requires a certain amount of work and practice to be done well or at least competently. To be sure, some people have an easier time writing than others.

My purpose here is not to shame the blocked writer into spending hours agonizing with pen in hand, but to help photographers let go of their prejudices against writing. If you are hesitant, start by working with extended captions, then try some paragraphs that de-velop a theme, then try your hand at short picture-word stories.

Budgeting Your Time and Efforts

Admittedly, the full-fledged photo/text package can be demanding, even for the most seasoned magazine writer. Although it is finan-cially rewarding to handle both ends of the stick, it will also take up a lot more of your time. If you feel in-clined to attack the market in this double-barreled fash-ion, start with the trades, or smaller publications, and work your way up through the ranks.

Those who've taken writ-ing courses or practical composition when studying English in college are ad-vised to follow the same route. Magazines, like col-leges, have their own rarefied air, and each atmo-sphere is composed of a slightly different mixture of gases. Today's magazine world is heavily influenced by *style*, and knowing the tone and message of the book for which you're writ-ing is very imporant.

It's possible that a simple submission of a thematic photo essay will trigger an editor to commission a fea-ture article built around the pictures. Many times, a staffer or freelance writer will be assigned such a piece, and will then work closely with you in develop-ing the final story. Observing and taking part in the way a story is developed is a learn-ing experience that can be invaluable to your subse-quent writing efforts.

If you want to submit a full story idea, outline it in a brief, pointed letter to the appropriate editor, and ex-plain that as a writer/pho-tographer you have pictures available to support the text. Don't go into a major exposi-tion of the story—if the idea is good the editor will follow-up and get more details from you. Pouring on too much initial information never helps light an editor's fire—a teaser is best, as it stimulates the imagination.

There is no end to the subject matter that can serve as potential photo essays, or to the long list of magazines that buy them. This front plate, and the pictures on the next two pages, are representative of a tight, forty-shot set on classic cars. These pictures were made at car rallies—gatherings of buffs and restoration clubs—where the finest cars are at their shiniest. Finding places where your subject matter is laid out in a large, free, outdoor studio makes shooting photo essays so much easier. Check your local paper for special events that might accommodate a highly focused shoot.

Collaborating with a Freelance Writer

If you feel less than confident about writing, you might try linking up with a freelance writer who has trouble making pictures. Freelancers can be contacted through the magazines in which their articles appear (most magazines will forward mail to contributing freelancers), or by posting notices in libraries or at the English department of a local college.

Freelance writer/photographer teams can be successful if each member of the team recognizes the other's competence, and if both members work to a common level. One-upmanship and bulldozing ideas will quickly spoil a working relationship. Team writing can also work. For a number of years, Fred Rosen, a colleague, and I did the photography column for the Sunday Arts and Leisure section of the *New York Times*. Once a month we'd sit down over a Chinese dinner and hammer out story ideas. Some were technical, others aesthetic, but all were topics we agreed were of interest to both of us.

Working around a central theme, we'd do independent research and break down the points we wanted to get across in the piece. The resultant outline would be partitioned, and Fred and I would "write in" the text. We alternated doing the final revision from column to column. The text and photos would then be delivered to the *Times* editor, who would do his copy-to-fit revisions. This methodical approach worked for us; we propped up each other's weaknesses as we went along.

Finding a working partner, whether it be a friend, a spouse, or a freelancer, can lead to another entire area of freelance magazine sales. Consider it as an expansion of your efforts, one that can open up new markets and opportunities. But start conservatively, submitting thematic essays with extended captions. You'll begin to see your pictures, and your photo files, in a completely different light. Moreover, you'll also show editors something special.

This detail shot shows one of the most important aspects of cars in the fifties—their massive use of chrome in bumpers, grills, and striping. As plastic replaced metal in car construction, much of this charm was lost.

This photo of the translucent Chief Pontiac on a field of red metal and chrome is the kind of detail shot that sells really well as cover material or inside as full-pages. It was a pleasure to record the workmanship and pride shown in these cars. Though they don't make cars like they used to, these owners keep the old beauties alive, and the photographs document the car buffs' love and applied energy.

Though I'm more into shooting street cars from the mid-fifties and early-sixties, I do get seduced by the sportier models. Exposing slightly below my meter's reading for the hottest highlight helped preserve the silver gleam in the chrome and the fender.

One can't help but be attracted to the classic lines of this old Lincoln. Working with such material is a photographer's dream. Slide film adds to the effect with its over-saturated colors, and it enables you to "black-out" extraneous detail when you expose for the highlights. Shooting on an overcast day can make the handling of reflections easier, but it cuts down on potential color play.

Many of the design elements in these cars are so outrageous that they don't need distortion to spark visual interest. But I couldn't help myself—I made a number of shots using a 20mm lens. I usually include one exaggerated shot in any photo essay I make, since I feel it offers an alternative view for a layout. Some of the shots were also made with a 300mm lens to flatten the details.

The subject matter you choose for an intensive essay should be something that interests you, something that sets off a photographic "fire" in your eye, and that has a potential for sales in a number of markets. My first shoot of classic cars happened by chance. When I got back the results of the first half-roll, I knew I was hooked.

A polarizing filter is an absolute must for this type of work, and it offers many possible ways of seeing. When you move a circular polarizer through its paces, you can see details jump out or recede, reflections fade or blaze, and tonal relationships go through an infinite dance. This detail of a Buick grill was made on an extremely bright day.

TRAVEL STOCK

A Boom Market

TRAVEL-RELATED EDITORIAL STOCK represents one of the biggest markets for freelance photographers and stock agencies. Beginners in this market have the great romantic image of being whisked around the world on assignment, with fabulous day rates and porters to lug their fourteen cases of camera equipment. Whatever the dream, there are certain realities that must be considered before it can be realized.

Because most people photograph when they travel, and almost everyone thinks his or her pictures should have a spread in *National Geographic*, the competition in the travel market is fierce, if only in the sheer volume of travel pictures produced. Of course, not all photographers have the persistence or knowledge to market their photographs, but there are still a lot of amateurs who try.

The demand for quality travel stock has been expanding in the last few years, and there's no end in sight. Much of this increased demand comes from the economics of the market, rather than from any exponential leap in need. Magazines no longer have the budget to fund extended trips, so most have come to rely almost exclusively on stock picture sources.

Let's say a magazine is doing a spread on Bali. Sending a photographer to get the final dozen or so shots the art director requires could cost them over $15,000. Buyers have come to realize that they can pick up the phone and call agencies or freelancers and have more pictures of the location than they know what to do with—and they don't have to worry about bad weather or malfunctioning equipment (or a malfunctioning photographer) ruining the shoot and blowing their budget.

Many buyers also get free pictures of destinations from national and regional tourist boards. Over the years, they've developed contacts with airlines, chambers of commerce, and trade commissions that have picture libraries of their own and that freely supply magazines with shots, in hoping that the articles will promote tourism or trade. Like many other industries, the travel trade relies heavily on public relations, and a good part of PR is photography that entices the consumer to buy the "product."

All this is to say that competing in the travel photography market is no piece of cake. But don't be discouraged—many freelancers still do a good business in the market, get free trips or go on press junkets, and finance fascinating trips through their photography.

Where to Shoot for Travel Pictures

Building an initial picture file with which to approach the market takes some investment and resourcefulness. You can't merely go in with a few shots of only a dozen locales—buyers want to work only with photographers who can offer them a broad and deep range of coverage. Even if you have a small file and fill a specific need, the sale will represent a one-shot deal and will finance neither your continued travel photography nor your career as a freelance stock photographer. For repeat sales, you'll need to be able to offer a wide destination list and a continual expansion of your files.

Most beginning travel photographers start by shooting on speculation with self-assigned stories or essays and self-

financed journeys. Many a file is built on vacation time, on breaks during business travel, or on long weekend journeys. Few of us can afford month-long trips to exotic locales, but we can begin first by making pictures that are geared to the stock market, and second, by not making pictures that everyone else has already done.

Unfortunately, photo enthusiasts who aspire to sell to the travel market go to the same locations as everyone else—Paris, New York, London, Mexico City—and make pictures of subjects that already glut the market. Also, beginners often suffer from a lack of knowledge about the need to provide caption information to the extent we describe that task in our "captioning" section.

The remedy is not merely to go to exotic locales (though that can't hurt!) but to cover an area in depth. For example, everyone has photographs of the Eiffel Tower under every type of light and in every possible weather condition. But few people have a file of all the bridges over the Seine, with captions identifying each, or shots of intimate wine bars, or a sampling of bookstalls throughout the city. Yes, make pictures of the "Seven Most Popular Sites," but also find a niche, or specialty, within a city or country that separates your coverage from all the rest.

Not every travel article deals with a major tourist area. Many magazines have "regionals," or special short pieces that cover everyday places in special ways. These short snips are a good source of stock sales. Many of our own sales over the last few years have come from this type of coverage—the North Fork of Long Island, the Delaware shore, the small Upstate

The Southwest, particularly southern Utah and northern New Mexico, is one of our favorite shooting locations, and we do all we can to get there on business and/or pleasure trips. This photo, made in red-rock country northwest of Sante Fe, first sold as an illustration for a travel article on the area, then as a shot in a camera company's product brochure. Though the shot wasn't made on a specific assignment, it was marketed quickly to help pay for part of a vacation trip. In fact, almost 75 percent of our travel-oriented stock is made on a speculative basis.

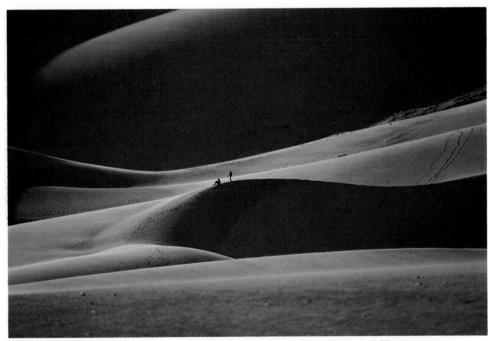

We had a two-week break between shooting assignments in Las Vegas and Houston, so we decided to take our time and criss-cross the states inbetween on a shooting safari. This photo was made in southern Colorado at the Great Sand Dunes National Monument. Notice how the scale of these massive hills of sand is accentuated by the figures included in the scene. We both love location photography, so much of our free time is used shooting "for the file." Though some people may consider marketing their pictures a burden, we consider it a necessary part of earning stipends for all those trips we've yet to make.

Finding a theme for your travel shots can lead to a salable block of pictures and to some fascinating explorations. If you ever happen to be walking around the temple grounds in the city of Bangkok, you might notice the beautiful patterns of the roofing tiles. Some have clashing blues and reds, while others feature a soft, earthen tan.

While a shot made at ground level may tell a story, I soon found that the most revealing view of patterns, or the way designs fit into the landscape, was from above. So at each temple I explored, I found a way to climb a tower or shrine to get an overhead shot. I carried both telephoto and wide-angle lenses.

Repair work is in constant progress on these roofs, and this shot includes some of the scaffolding. Although I felt it interfered with the sense of line I sought in the essay, an art director chose this scene for the cover of a magazine in which the whole essay appeared. This taught me to never make assumptions about what buyers will or won't choose.

The tower on the right side of this frame is typical of the towers I climbed, and you can bet that I made detail shots as I went. With this type of architecture it's easy to see why Bangkok is a photographer's paradise, which means a lot of competition for picture sales. That's why it's important to choose a theme and a vantage point that make your coverage unique.

New York town of Saugerties, and Atlantic City were all local trips from which we made good sales. Yes, we've sold pictures from the "major" sites, such as Rome and Paris, but those "minor" side trips still represent a real bread-and-butter segment of our travel stock business.

Travel Can Lead to Great Photo Essays

Keep an eye out for potential photo essays when traveling. On a self-assigned trip to Bangkok, I became attracted to the beautiful designs of the tiles that made up the pitched temple roofs. At each stop on my ramble, I'd find the highest vantage point, put a telephoto lens on the camera, and take pictures of the colorful patterns. When I returned home and edited the series down, I formulated an essay that subsequently sold to a photography magazine. While this had little to do with the "traditional" travel picture approach, I felt that I had come up with a telling cultural portrait that communicated a real sense of place. Happily, an editor agreed.

Good sources for travel stock are local festivals, parades, and special events. If you're at all shy about approaching and taking close-up pictures of people when you travel, these occasions are great times to get your feet wet. The "natives" are usually in a good mood and don't mind having a camera pointed at them—in fact, they'll often pose for you. So when you travel, pick up the local papers, or write the chamber of commerce or tourist board before you go, and check out the calendar of events.

On a cross-country shooting trip, we pulled off the endless Interstate and made a camping stopover in Iowa. Along with our groceries we picked up a local weekly newspaper at a small market and saw that a centennial celebration was taking place in a nearby village. We postponed our planned morning departure and arrived early for the parade and festivities.

To our delight, the townspeople were decked out in historic dress, and rode in the parade in everything from stagecoaches to tractors to horsedrawn buggies to Harleys. They posed gladly, moved into the best light, and generally mugged for the camera. One entire group of frontiersmen went through a drill of loading and shooting muskets for us—they proved to be genuinely friendly, and we got a chance to become acquainted with some good people. The resultant pictures sold not only to travel markets but to textbook publishers and general interest magazines as well.

What was important to us was the experience of meeting these people and sharing some of our time with them—the fact that good pictures resulted is the gravy of life.

This patriotic, dyed chicken (with companion) gave us a humorous sidebar shot of the Centennial parade.

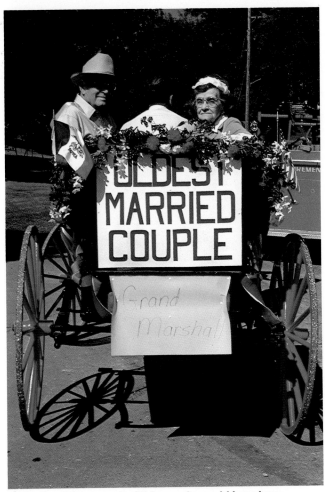

Though a tight portrait of this couple would have been effective, giving them a context added meaning to the shot.

Meeting people in all their diversity is one of the best parts of doing travel photography.

Though some critics feel that a camera intrudes upon the travel experience, I've always found that it has led me down alleys I might not have walked and introduced me to people I might never have met. Perhaps all this could happen without the camera, but I'm neither perfect nor totally socialized, so the camera added to my experience and made me see more of life.

General Guidelines for Travel Pictures

There's no set formula for successful travel sales—each publication's art direc-tor or picture buyer has his or her own likes and dislikes. Aside from studying the publication you're aiming for, here are some general guidelines to consider:

1. Include people in their daily lives. One of the major complaints of art directors is that freelancers submit pictures of locations that look as if they were made the day after a general evacuation. When readers see people in a location they are able to empathize, or place themselves in that place. If you make a picture of an outdoor café, show people eating, drinking, reading a book of poetry, or whatever. If you're illustrating a story on the Appalachian Trail, don't simply show a dirt track through the woods.

Model releases can help make a sale, although under certain situations it might be impossible to get one. If you do a close-up of a person engaged in an activity (such as photographing a lobsterman on the Maine coast extending a five-pounder towards the lens) ask him to sign a release and explain why you need one. If you ask politely, chances are most folks won't refuse. Some will be suspicious, or won't want to commit their signatures to a stranger, so don't force the issue. If, on the other hand, you're pho-tographing a crowd at Paris' La Cupole café, you needn't get any releases for general editorial usage. The same goes for places where the language barrier, or the dis-cretion of the moment, would prevent it. Use your judgment.

Active participation is a key word to keep in mind when making travel shots. Pictures of people standing around with their hands in their pockets, even if they're surrounded by beautiful

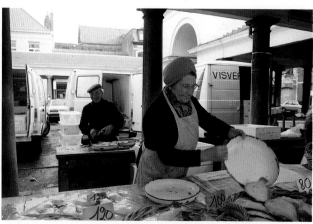

Marketplaces are always prime locations for shooting stock portraits, especially when the folks who sell the fish or produce are those who catch or grow it. This shot was made in an open-air market in Bruges, Belgium.

This well-ventilated study hall in a Bangkok temple turned out to be an English class for Buddhist monks, many of whom were thrilled to find an American to practice conversation. You never know what situations your photo explorations will involve you in, and that's part of the fun.

Whenever we travel to Europe, I try to spend at least a part of every day relaxing in a café, so I can relate to a picture that communicates a sense of quiet time spent at ease. This shot was made in Bouillon, Belgium, and it reminds me, and hopefully travel editors, of many pleasant hours.

scenery, won't help sell a location. Make pictures of people engaged in the activities of the area, whether it be hiking, sailing, or just relaxing in the warming sun.

2. Present an upbeat view. Every country or city has its "other side," the world usually not recognized in the travel market. Photographs of poverty, abuse, or decay are valuable for photojournalistic reasons, and anyone who's traveled more than a few miles from home knows that the world is full of such scenes. Photographs of these world problems are important in their own right, but they simply will not sell in the travel market.

3. Focus on details, too. Many art directors like to include architectural details or cultural still lifes in their layouts. These might be reproduced smaller than the "locale" shots, but they do afford a nice balance in the spread. Shots could include a gargoyle on a cathedral in Paris, a wood carving on a doorway in Germany, or a bright flower against a pastel wall in the Bahamas. These shots add flavor to your photographic coverage.

4. Find a unique vantage point. Not every shot need be taken from eye-level with a 90mm lens. Use your creative arsenal of lenses, filters, and films to create a special way of seeing, while avoiding preposterous tricks. For example, a shot that features a starburst filter dispersing light from the bow of a ship in the sunset will make many art directors cringe.

Use some initiative and legwork to capture angles of view that separate your coverage from the more "grounded" approach and from those pictures that could have been taken from the window of a tourbus. If you can, climb the 1,000 steps to the top of the castle turret, get off the trail to get a new view of the waterfall, or walk down that alley to find a new view of the city.

5. Immerse yourself in your environment. Whenever possible, spend that extra day in a place to find the offbeat happening, the local festival, or that favorite café of the natives. This will add to your traveling fun and to your inventory of unique pictures. One of my favorite techniques of travel shooting is to set out without a map. Getting "lost" can help you find that special shot.

This detail shot of hats, made in the straw market in Nassau, Bahamas, is a product of pure photographic technique—this scene never actually existed. Exposing for the highlights, then closing down another half stop, created this picture. The travel photo market is quite competitive, as almost everyone shoots pictures when they travel, and many make a stab at selling their work. Although a casual approach to this market is rarely successful (at least in the long run), the weekend warrior does make an occasional sale, which makes it even more difficult for photographers dedicated to making a living from their travel work. In addition, dozens of stock agencies specialize in intense coverage of nearly every location under the sun. Therefore, you should try to make your own coverage special and maintain good, close contacts with editors and art directors. Supplying top regional coverage and being on call for out-of-the-way location shots are good ways to get started.

6. **Shoot food and transportation for their ambience.** More than one meal has gone cold while a travel photographer makes shots of the table setup or the restaurant's ambience—this type of picture sells well enough to pay for more meals later. If you take a train or a bus, make a few shots of these transitional places. A photographic diary isn't merely about a place—"getting there" shots can also serve you well. Record people at work, in shops, and on the streets; these might not be strictly for travel stock, but they can help fill your files in other areas.

7. **Take copious notes.** Maps and brochures are essential for later captioning. If you hit upon a great restaurant, or a hidden-away mountain inn, ask to keep its menu or make a picture of it for later reference. Making pictures of historic markers, signposts, etc., can be a great help when you sort out your rolls after you arrive home. You may be covering a lot of ground in a short period of time, and it's easy to forget the important details that result in captions that can make or break a sale.

A trip to the newsstand, or a browse through a periodical guide, will reveal the wide range of editorial travel markets. Don't simply go by the titles that have the word travel in them—keep in mind that most newspapers have a travel section or Sunday supplement, and that general interest magazines always have a travel piece or two sprinkled throughout their various editorial features.

Updating Travel Stock Buyers

Once you've targeted potential markets, prepare a stock list specifically for "Travel" (see the section on Master Lists). Add to it a sample portfolio of duplicates and an introductory letter, and begin hitting the bricks (or the mailbox.) Make buyers aware of your existence and what you have to offer. Update your listing and inform clients whenever you make a significant addition to your files, and keep in touch with contacts for their future needs. As is true for other editorial features, travel feature and filler articles are prepared months in advance of publication; knowing what's coming six months in advance can help you organize your submissions and, sometimes, might suggest your travel plans.

Posting your itinerary on planned trips with travel editors can often lead to sales. We were planning a short trip to visit friends in Upstate New York, and just happened to mention it in passing to an editor. He asked where we were going, and it turned out he needed a shot of a particular monument in the vicinity for a

This shot of an offering at a Buddhist shrine was made on a self-assigned photo journey to Thailand. Detail shots are great for showing the varied and wondrous foods of an exotic region, while highlighting the cultural differences or similarities between societies. In the west, we burn candles in memory of departed souls; overseas, people offer food with the same feelings and motivations. As a travel photographer, you shouldn't go to a location with a preconceived notion about a people or place. Instead, think of yourself as a reporter/ anthropologist/tourist, and keep an upbeat attitude in mind.

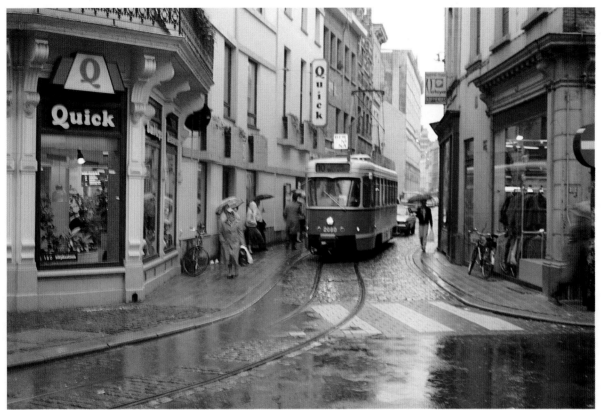

Modes of transportation are always good subject matter for standard travel stock. This shot, made in Antwerp, Belgium, shows that in this business, you often end up shooting in the rain.

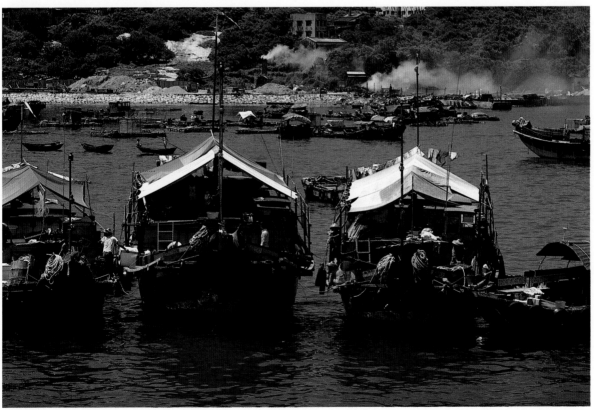

Hong Kong is one of the most fascinating travel destinations on earth. This photo was made in Aberdeen, where hundreds of boats form the world's biggest floating apartment house.

short-deadline story. It was an obscure location, and he'd run into a brick wall with agencies and all his other freelance sources. We took an hour off from our visit, made the shots, shipped the film, and returned home to find we'd made a sale. All this from a casual mention!

A Talk with Paul Prince at *Travel/Holiday*

Paul Prince is an editor at *Travel/Holiday*, a magazine that's been serving the traveling public for many years.

Working through a picture editor, the staff goes on monthly searches for pictures from a very wide variety of locations.

"Ninety-five percent of our material is from stock," says Prince, "and most of that is from individual photographers. We do get shots from tour operators and travel bureaus, but there's a limit to how much of that we use. Of the 95 percent stock figure, about 20 percent does come from stock-picture agencies."

Making contact with the

editors is a matter of submitting a stock list of destinations along with publishing credits or duplicate samples. "We do have photographers all over the country," Prince says, "but we always are looking for new sources. We usually call for work from the stock lists—this gives us a way to become introduced to new photographers. If new photographers have unusual destinations on their lists there's a good chance we'll try them out."

What does *Travel/Holi-*

day look for in a photograph? "When we get a submission, our first impressions guide us. The pictures must be technically excellent, with an interesting point of view, and good color saturation. If the submission is faulty in any of those areas, that would be the end of it. We know a good travel shot when we see it," says Prince. "It should have a striking composition. We like people in the shots, and we're not looking for strictly posed shots. People should be active and integrated in

This photo detail, showing the bow of an off-loaded freighter, was made in the commercial section of the harbor in Nassau, Bahamas. Though this photograph tells the viewer about the particulars of a place (with help from a caption), I consider it mainly an abstraction because it has more to do with the way I see. Ideally, travel shooting allows photographers the freedom to indulge their eyes or, if you will, exercise their photographic style. This may serve photographers well, but the travel industry has been somewhat reluctant to let stylizations and

personal photo interpretations through the door. Personally, I don't mind making stock records of a place, then mixing in a more personal approach with the entire submission. If a few abstractions make it onto the printed page, it's great, but I never count on them to pay the bills. The point is always to shoot in the special way that you see while recognizing the needs and the tastes of the market you hope to serve. Don't compromise yourself or your work, but try to recognize what type of product will keep your photos in demand.

the scene. We tend to look at pictures in the same subjective sense as when the photographers take them. Their eyes and instincts tell them when to shoot, and it somehow falls together. That's how we judge a picture, too.

"We do get a lot of unsolicited stock lists and pictures. We sometimes get beautiful shots with specific effects, such as an airplane racing across the moon over the Taj Mahal, but we rarely use them. Also, we don't have a need for news-oriented pictures. We do have a small staff, and we tend to work closely with contributing photographers.

A Talk with Adrian Taylor at *Travel & Leisure*

Another major travel magazine is *Travel & Leisure*. Art Director Adrian Taylor, in talking about the magazine's approach to working with photographers, advises: "The best thing you as a photographer can do is make an appointment or send in work to our picture editor. This way, we'll get to know you and your work. We're looking for individuals with extensive traveling experience and the work that shows it."

Unlike some other travel books, *Travel & Leisure* still works "about 85 percent from assigned work. Stock comes into play," says Taylor, "for the front of the book, the columns, and for departments. We keep a mental note of stock lists and call photographers when the need arises. When an idea is hatched, we put out a limited all-points bulletin to individuals and stock houses. An enormous submission follows, and we look for the best photos. Also, if we send a photographer on assignment, we don't like to dilute the take unless the work we get is incomplete."

This interior view of a chapel in the Vatican was made with high-speed film at a low shutter speed. I steadied the camera by leaning it against a column. Many churches and museums forbid the use of electronic flash, mainly because constant exposure to bright light fades fabrics and paintings. There is also fear that the heat or spark caused by an exploding flashbulb or cube might start a fire. (A more cynical view holds that allowing flash would yield better pictures for tourists, thus cutting into a concession stand's sales.) For interiors I always carry a moderate stock of high-speed tungsten-balanced and daylight slide film, knowing that I can push-process for even higher effective speeds. Most of these places also forbid use of a tripod, so its a good idea to develop techniques to insure a shake-free exposure. This shot was flipped (reversed) for use on the cover of a photo magazine.

TEXTBOOKS
The Diverse Market

IF YOU'VE BEEN OUT OF SCHOOL FOR AWHILE, you may not be aware of the changes in the look of textbooks. Photography is now the illustrative medium of choice, much of that is in color, and a lot of it is spread throughout the texts. Whether the books are published for the elementary or secondary levels, whether they deal with social studies or science, all use photographs to tell the story. And even though college texts tend to be more specialized in their content and rely on illustrations less often than in the lower grades, they still use pictures for aids in numerous fields. All this adds up to a huge market for freelance stock photographers, one that calls for a diverse range of subject matter.

A number of large publishing houses have very active textbook divisions, and a number of companies specialize in publishing only school texts. A listing of these companies may be found in publishers trade lists and directories, including those available from R. R. Bowker, Inc., 205 East 42nd Street, New York, New York 10017. Research sections in larger libraries also have directories listing textbook companies. You can also get the names from books that your children, or your friends' children, bring home from school.

Call Lists for Textbooks

Textbook companies work from "call lists," sheets that are periodically sent to a select group of photographers and agencies. These list book projects in progress and the specific photographs needed to illustrate the text. A call list can be quite extraordinary in its diversity of subject matter.

For example, a recent list for an American Government textbook called for: a horizontal photograph of a flag-waving demonstration during a national political convention; a vertical photograph of people admiring a national monument; government rescue workers aiding victims during a major disaster, such as a flood or a tornado; people doing charitable work; a naturalization ceremony depicting people from diverse ethnic backgrounds; and an overall shot of the Statue of Liberty.

A text on public speaking called for the following sample of shots: a person talking to himself or herself; a small group of people in a business meeting; people doing research in a library; a political rally; a group of female business executives; a college-age person looking into a mirror as if evaluating his or her own character; and two people involved in an interview, with one person using a tape recorder.

These lists go on and on, and they call for shots for everything from geology (a horizontal shot of striations in sandstone) to civics (children holding flags in a playground assembly) to mathematics (a photograph of circular tools).

Some photographers panic when they receive a call list; the subject matter is usually so diverse that they know they can't possibly fill the entire request. Don't worry, many photographers and agencies receive the list at the same time, and no editor expects to receive all the shots from one source.

However, you should make an effort to fulfill at least a good portion of the requests. Editors will soon tire of you if you fail to respond to at least some of their needs, and will eventually drop your name from their lists. As in all editorial markets, updates and promotional mailings keep you in the buyers' minds, so stay in touch with them.

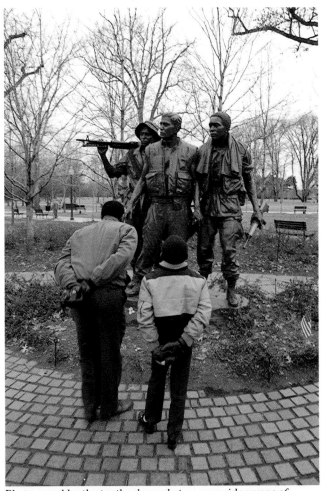

Photos used by the textbook market cove a wide range of subject matter, and you may be called upon to provide illustrations for math, history, or science books. This shot was made for a civics textbook at the Vietnam Veteran's Memorial in Washington, D.C.

Portraying concepts is one of the challenges posed by the textbook market, especially when you get calls for subjects such as gravity, speed, or convergence. This is one of a series of shots for a math book showing ratios, wherein objects of similar shape but different size are depicted.

Geology textbooks often call for illustrations of natural phenomena, such as this rock formation in Zion National Park in southern Utah. Once you delve into textbooks, you'll discover outlets that you never dreamed existed for photographs, and you'll expand your marketing horizons.

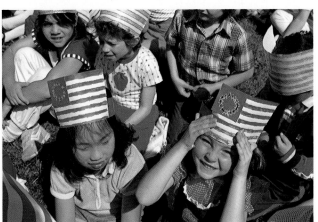

These children were photographed during a celebration of Flag Day. There's a whole series of civics, government, social studies, and citizenship textbooks geared to the grade-school level, and constant revisions and new editions create a continuous demand for pictures.

Breaking into the Textbook Picture Market

Contact with these markets is made through the picture editor or research department of the publisher. In many cases, a firm that does these books is so large and its projects are so diverse that one editor will work on only one or two of the twenty books being produced at one time. Smaller companies put out call lists covering all the books being produced in a season, while larger firms have individual editors putting out their own call sheets.

Just because you have contact with one editor in a firm don't think you've reached them all. Don't rely on an editor to "pass you around"; make an effort to contact as many editors as you can within one firm.

When making initial contact, send along a Master Stock List, samples of work and publishing credits, and any specific, directed lists you feel will aid an editor in determining that you're a photographer with whom he or she can work.

Over all, coverage of people, activities, and concepts is more important than travel destinations in this field, although a foreign language or geography text will certainly draw from your travel-oriented list. In fact, you never know what you'll get a request for, and this is part of the fun of working with textbook companies.

In some cases, the chief editor might ask you to send an initial sampling for a tryout. He or she might request 100 of your best shots in, say, the social studies field, or just a mix of black and white and color that you feel is appropriate to the market. When going through such a tryout, pay special attention to the quality of the work, show a diversity of subject matter, and study a number of textbooks before you send any portfolios. This tryout may determine whether you get on the publisher's stock-photo mailing list, an essential first step.

Once you get on the list and begin receiving requests, you must follow up. You should maintain contact with editors by calling in at least every two months, and it's a good idea to inform them of any travel plans you may have. Editors in these companies are very busy, and it's your responsibility to maintain contact and help them fill their needs. They can't make hundreds of calls for every project.

Black and White Sells, Too

This is one field where black and white is in as much de-

This rather odd shot of a map was made inside the large globe at the Christian Science Center in Boston. Expending a few rolls of film at such a location can pay off in textbook sales.

This ceremonial bunting added a touch of color to this statue of Washington in downtown New York City, which was just what I wanted.

mand as color, though the balance in the grade school and high school-level books is definitely swinging towards color. My experience has been about 75 percent color to 25 percent black and white, even though the textbook market remains a prime source of black-and-white sales. Some companies are willing to make black-and-white conversions from color transparencies, but this rarely results in the same quality as from a black-and-white negative, and is usually done only in a pinch.

Black-and-white submissions, or black-and-white samples with queries, should be on 8 × 10 glossy stock. RC paper is fine as long as the tonal scale is long and the print will be "readable" in reproduction. Dark and moody prints simply won't do. The format of choice for color work is the 35mm transparency.

How Textbook Picture Buyers Operate

The process of producing a book is necessarily longer than that of a magazine, so be prepared for some fairly long holding times. It's all part of the "hurry up and wait" syndrome of this business. Submission deadlines can be tight, but once material is in an editor's hands it can take weeks, even months for final selections to be made. Pictures often go through three or four editing steps. An image that makes it through stage one may be returned unsold at stage three of the process.

Normally, editors try to get the first cut back to you within two weeks to a month—these are experienced people who know the value of an image and will do everything in their power to get rejects back to you quickly. Be patient, and you'll soon see how professional the picture researchers and editors from the textbook companies really are. They deal with hundreds of thousands of images a year, and they want to get their desks cleared as much as you want to know the disposition of your submission.

Generally, the textbook market is lower paying than the consumer magazine editorial market, but prices are decent, and you can certainly make up for it in volume. Also, reputable companies will pay revised edition fees, usually 50 percent of the first sale. Check your final sales invoice for "edition" clauses.

Repeat sales to different books on a publisher's list can greatly increase the revenue from one image. In one

This shot of the United Nations General Assembly Hall was made from the vantage point of the press room. I was covering a story on the photo-lab operations at the United Nations, and when the job was finished, I requested a brief "insider's" tour.

Though this is basically a record-of-place type of picture, it's a good addition to my New York City and United Nations files. These bread-and-butter shots do quite well in the textbook market.

Illustrating concepts and clichés is one of the most challenging aspects of stock photography. This one, called "Bailing Out," is a very literal interpretation of an oft-coined phrase. Textbook stock lists are peppered with calls for such pictures, and you may get sheets requesting depictions of "Thinking," "Self-Evaluation," or "Lending a Hand." Although you can go out shooting with an eye for this type of material, you probably have many such pictures in your files already. For example, a shot of a group of people standing in line for a bus in Philadelphia may initially be placed in that city's file, but could just as well fit in a file entitled "Waiting." In fact, you'll probably get more calls for a shot showing "waiting" than you will for one of "people in a bus line in Philly." Knowledge of a market's needs, and keeping an eye out in editing, captioning, and cross-referencing photos can really pay off.

case, a picture of a group of children at a patriotic rally sold for a unit opener of a civics textbook: It was then used as a cover for a social studies book, as a half page for a history book, and as an illustration for an elementary-level reader. Finally, it was used as an advertising illustration for an entire line of social studies texts. All this happened within the same publishing house, and the result was that one "hot shot" brought in over $2,000.

Here's a short description of a textbook-market picture sale. First, the book's editor draws up a list of pictures needed for illustration. The editor taps likely picture sources through phoning or mailing call lists to freelancers and the agencies on their resource list. Photographers and agencies respond to the requests, and the photo researcher and layout department conduct an initial edit. They send the first cuts back to the photographers and agencies, and then make second and third cuts, returning the culls from that edit. At this time, they send notices to photographers that some pictures are being held for further consideration. Once the final cut is made, they send a notice of acceptance to the photographers and request an invoice.

The photographer then sends an invoice specifying rights sold and price quoted (usually agreed upon previously in a letter or phone call). Some publishers pay an invoice on acceptance, others on publication. The book goes to the printer, the quality of the pages is okayed, and the pictures are returned to the photographer.

All this may take a year from first submission to payment and return of the picture.

A Talk with Cheryl Kucharzak at Scott, Foresman and Company

Cheryl Kucharzak is an editor in the picture research department at Scott, Foresman and Company, a leading publisher of textbooks for elementary, high school, and college markets. The company draws upon many different sources for its pictures, with a general breakdown of 50 percent from stock agencies and the other half from freelancers.

"Our picture needs vary greatly from project to project," Kucharzak reports, "and we look for very specific images to fit the text.

This is where we may differ from other buyers of pictures, in that we always look to match an image to a specific text.

"One of the important things we look for is ethnic balance in the pictures. We can't have any logos or ads in the images, or anything that could be considered offensive."

What about the composition—are there any specific style considerations? "Many times, we choose pictures on the basis of how they fit the layout. We may need a picture that can take overlay printing, or that allows for vertical or horizontal

cropping. Obviously, photographers can't anticipate this when submitting pictures, but if they're shooting for stock they should keep this in mind and shoot a vertical, a horizontal, and a variety of poses and angles of view of the same subject.

How much does technical excellence count in acceptance or rejection of work? "A soft image is immediately rejected, as is any picture with a technical problem. For the most part, the quality of work we get is up to par because photographers know our needs."

Should a photographer going after the textbook

market shoot color or black and white? "In elementary and high school books," responds Kucharzak, "there's more use of color—in college it's more black and white, though color use is on the rise. Many photographers shoot *only* color—they think it isn't cost-effective to do black and white. We can convert, but at times it just doesn't reproduce well. A photographer doing black and white can do well in textbooks. We will look at color duplicates in the initial selection process, but when it comes to printing the final work we ask for the original transparency.

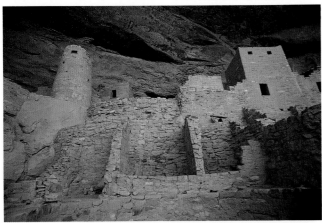

This photo of the cliff dwellings in Mesa Verde National Park can serve as an illustration for an American history or Indian culture textbook. Factual depictions of a scene are always in demand and can be placed in any number of texts.

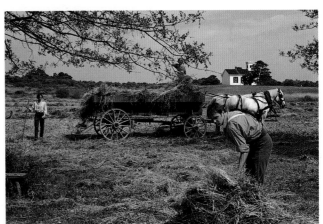

Historical village restorations, or reenactments of events, can serve as great picture opportunities for the textbook market. This photo was made at the Old Bethpage Village in Long Island.

This photo shows the clothing, tools, and calm repose of a temple sweeper in Bangkok, and is prime material for a "People of the World" text. Making cultural portraits of an area and its people serves both the travel and textbook market.

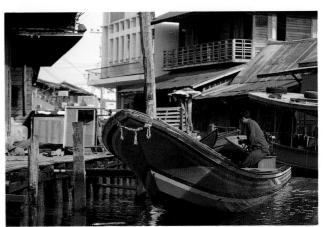

Part of a cultural portrait is showing how different people handle similar tasks. This photo was made on the canals in Bangkok's "Floating Market," and shows a grocer as he goes from house to house plying his wares.

GREETING CARDS
More than Sunsets and Roses

IN THE PAST, MOST GREETING CARD DESIGNS were made by freelance illustrators and in-house creative teams. These cards often had a clichéd, cut-and-paste quality to them, with the inevitable red valentines for Valentine's Day and misty roses for Mother's Day. Although these designs still exist, the multimillion-dollar greeting card business has of late gone through some changes that are beneficial to the freelance stock photographer. The initial incursions of photography into this often conservative market were predictable—photographic versions of the same clichés once provided by illustrators. Gaudy sunsets, misty roses, and "dead-pheasant" still lifes (photographic re-creations of nineteenth century paintings) were the norm. But as advanced scanning techniques came into the printing trades and, perhaps more important, as a more sophisticated card-buying public came to card-buying age, the "look" of photograph greeting and note cards changed.

Although your basic sunset scene still shows up on card racks in stationery stores, more and more of the "artsy" or personal photographic statements are beginning to make their presence known. Almost any subject is open game for the modern card—from highly stylized shots of ballet dancers to bucolic, rustic scenes made with filters and super–wide-angle lenses to slick depictions of sexuality.

Distribution is the Key to Success

There are many levels of producers in the card industry, from giants like Hallmark, where most of the work is done by in-house artists and photographers, to independent firms such as Paper Moon and California Dreamers, where less-conservative greeting cards are produced by both in-house and freelance photographer-designers. Many small design firms have cropped up, composed of one-person or three-person groups who create cards for "lines" to sell to larger distributors, or who produce and distribute cards themselves.

Distribution—that's the real key to this market. Any of us with about twenty great images, a concept, and about $50,000 can produce and publish a line of cards. The problem comes when you try to place the cards in stores. Most retailers buy from firmly established channels—few want to get involved with an independent whose supply, and promotional ability, is limited. Billing and collections can also become a problem, and cash-flow problems have driven many a small card company out of the business. There are cases of photographers who went out on a limb and made a go of it, but it took all their time and energy to *run the business* and make it a success.

For those with limited capital, and who don't want to devote all their time to running a photography-greeting-card production and distribution company, working through an established firm is best.

Understanding Reproduction Rights Is Important

Before exploring ways to approach this market, a few words about rights are in order. The greeting-card photography buyer looks for one of two sets of rights—one-time rights or exclusive worldwide rights *within the greeting card market*. With one-time rights, the company makes a single edition, or print run, and then rights return to the photographer.

Exclusive-to-market rights means that you promise that

the image hasn't been used by, and won't be sold again to, any other company engaged in the manufacture of greeting cards. This agreement may be qualified to a number of years, say five or so, to protect the company from competing against another company using the same image on a card. This may sound unreasonable, but it's understandable—no one wants to spend money on fees, layout, printing, and distribution, only to find that a competitor is selling the very same image.

One way to protect yourself against conflicts in this area, or any other market where exclusive rights are sold, is to use a red flag system for marking slides. I flag the categories of rights on particular images with colored dots, which are available in office supply stores. Let a certain color dot stand for a particular right sold (such as red for greeting card, green for first-time, etc.), affix it to the slide mount, and write in the expiration date, if any, of the sales restriction. (Coding systems are described in greater detail in the "Captions, Codes, and Copyright Information" section of this book.)

Researching the Market

Breaking into the greeting card market requires a good deal of research. The best way to see what's out there is to take trips to as many large stationery stores as you can find. Pick through the racks and note the cards that attract you and match your point of view. Turn them over to find the publisher's name. Eventually you'll begin to see patterns among companies.

If you can spare the time, attend the stationery or gift trade shows that visit major cities (New York, Washington, D.C., Miami, Los An-

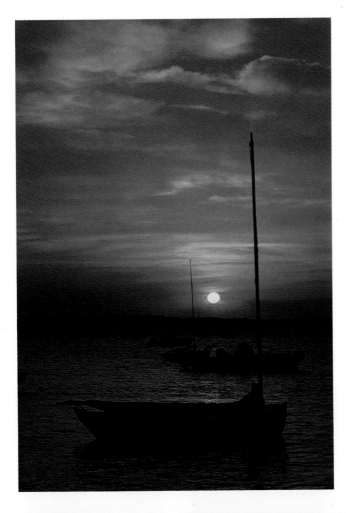

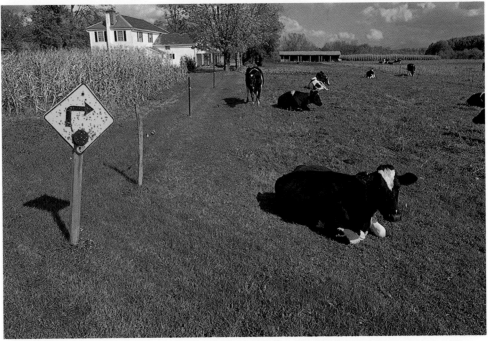

Photos for the greeting card market can cover a wide variety of styles and subject matter. They can range from the classic sunset, to specific locations, to pictorial landscapes, and include some odd humor as well. Blanks—greeting cards that allow the sender to fill in their own message—and more stylized postcards are becoming increasingly popular.

geles) once each year. These shows are buyer conventions attended by retailers, and they bring together the entire greeting card family—designers, art directors, photographers, publishers, and distributors.

Card companies both major and minor show their full lines at these extravaganzas, and you'll get a preview of the styles that will be hitting the market in the months ahead. You can obtain a show schedule from trade journals that serve the industry, such as: *Giftware Business*, Gralla Publications, 1515 Broadway, New York, NY 10036; and *Greetings Magazine*, MacKay Publishing Corp., 309 57th Street, New York, NY 10016.

Once you plan to visit a show, call the organizers and find out how you can gain admission. Usually, a business card showing yourself as part of a studio, or even as a freelance photographer, will do the trick. Just don't show up at the door without business ID and expect to gain admission. These are *business* meetings, and they don't want sightseers.

These shows are good places to make contacts and to show work, but don't burst into a booth and expect to make a full presentation of your photography. It might be better to scan the lines, make notes, initiate contact with the art director or buyer, move along, and follow up later. These shows

are usually the main selling event for card companies, and few workers at a booth have the time or the disposition to look at new work.

Buyers see so many people at these shows that when they return to the home office they spend the next week sorting through business cards, trying to figure out who said what to whom. That's why a follow-up call or letter is so important—it refocuses their minds on you and your work.

Query Letters for Greeting-Card Picture Buyers

When you get together all the information you gathered at the show (or from the racks of a stationery

store), plug in your typewriter and start mailing out query letters. Do not send work—if you must, send only a few sample duplicates. Each card company has set specific times of the year to look at certain kinds of pictures. Companies also have submission requirements and terms of sales you should be familiar with before you send any material. Submitting a mass of work prior to query and receipt of guidelines will only result in delays and waste postage.

In your query letter, state who you are, what subjects you have available, and any publishing credits you may have. You needn't go into a long-winded dissertation;

Adding a touch of mist with a diffusion filter gave this floral shot a little extra glow. Special-effects filters and tricks can be used in this market, but don't overdo it.

Those who enjoy macro floral photography will find a market "home" in the greeting card field. There are as many types of cards as there are species of flowers.

many card companies will return a guidelines form in answer to even the simplest query.

Once you receive a reply, read the submission requirements *carefully* and prepare your work. For example, you may get a note saying, "We are currently looking at submissions for Mother's Day cards until July 1, and for Thanksgiving cards until February 1." These guidelines ask you to be an in-house art director, to be familiar with their style, and to choose from your inventory those images you feel are appropriate to the occasion.

You may also get: "Our card line emphasizes the spiritual in life, and our latest lines feature rainbows and sacred places." The latter specification can be interpreted narrowly or broadly—is a sacred place a church or a temple, or is it a quiet, sun-graced glade in a redwood forest? Familiarity with the line, and a phone call, will save time and give a strong sense of direction to your picture search.

Editing and Submitting Your Work

Aside from appropriateness to a specific occasion, and keeping within the spirit of a company's line, technical excellence of each image submitted is of the utmost importance. Edit with a very critical eye. No company will even consider work that is flawed in focus, exposure, or composition.

Because of the final format of most cards, verticals are preferred, although many note cards are cut horizontally. In recent years, 35mm has become the format of choice, but larger transparencies yielding more detail are certainly not beyond consideration.

Editing also means "putting on a greeting-card set of eyes." According to more than one buyer, pictures for cards are chosen on the basis of the "ooh and aah" principle. An ooh card is one that evokes an emotional response because of the beauty of its colors, tones, mood, subject matter, and composition. An aah card is one that appeals to a clever eye, where the irony or humor of the captured moment comes through. The picture must tell a simple story, or evoke a simple response, without the need for a caption. Sometimes, emotional and intellectual responses are combined in cards with stunning graphics and colors.

Buyers choose cards in a very subjective manner. They work on an "I know it when I see it" level. Their buying decisions usually come from experience, knowledge of the latest trends (what's "really hot," in the parlance of the trade), and their disposition at the time of selection. Some buyers are so conservative

Religious and inspirational cards are very popular, and you have a ready-made studio for these shots that's as near as your closest church. Use the light and setting to their best advantage.

This shot was made in Rome, and is one of a series for Confirmation or Communion cards. This photo can also serve as "location" travel stock of Rome.

they make you want to scream, others look only for the bizarre. It's all a matter of finding a buyer who matches your vision—no easy matter, but one worth exploring.

Scanning the trade show and stationery store racks makes one wonder how some of the shallow work that's displayed ever made it past the front door. Other lines can be delightful from a creative and graphic point of view. It's a subjective field, one that can be alternately fun and frustrating.

When you make a submission, put your copyright-notice-coded slides in twenty-to-a-page sleeves, xerox the page for your records or list the slides submitted by number code, pack them carefully, and send them via return-receipt mail. I usually send duplicates the first time, with a note that originals are available on request. Include an SASE for quick return of your material.

You can send as many slides as you deem necessary for each subject, but don't overload the company with pictures. I feel that twenty to forty slides per subject is more than enough. Label each sleeve with the intent of the series (such as Father's Day). If they want to see more, send more, but don't show your full hand the first time around. I've found that some pictures rejected during the first edit were accepted later, so rotate your submissions and keep showing them new work.

Picture Policies at Greeting Card Companies

Generally, slides with people shown in anything but silhouette should not be sent, and any shot with a recognizable face should be automatically deleted from your submission. Consum-

This photo of an amusement park ride in Coney Island was made nearly twenty years ago, way before I had any intention of, or had even thought about, marketing my photography. But while going through my files one day, a picture buyer from a greeting card company plucked it out, and it was subsequently used for a childrens' birthday card. That's the way it goes in stock photography—you never know when a shot made casually in years past will help pay today's bills. One photographer I know laments his procrastination in getting his files organized and ready for sales. "I feel like I'm losing money every day I don't have my photographs circulating in the market and in front of buyers," he said. This is especially true in a market like greeting cards, where there are so many topic categories and needs to fill. This photo would probably have languished in a box or a slide tray, or faded away over the years, but having it in an organized file, and in the hands of a buyer, gave it life.

ers want to empathize with the cards they send and receive, and any face other than their own causes confusion.

Concept cards (those used as note cards and that have no holiday or specific occasion associated with them) are becoming more popular. Known in the trade as "blanks," the cards are produced by companies such as Chroma Line and Sierra Club Cards, and they've brought a sensitive style of pictorialism to the greeting card market. In addition, experimental work, special effects, and series that explore a photographer's "compulsions" (such as graffiti on walls, pink bicycles, flashy cars, etc.) are all possibilities for blank lines. This is an area where your personal work can be given a go. However, remember that this market is essentially a conservative one, and even the special effects that squeak through are of a tried-and-true nature.

Breaking the ice in the greeting card market means that you'll have to make many speculative submissions. Keep a number of sets of slides in constant circulation, and make sure you know who has what and when it's due to return. You might have to wait anywhere from six weeks to six months for a final decision, so don't count on memory to keep your in-out files for you. If possible, get a firm commitment of the holding time needed by the client, date all delivery memos, and follow up promptly when a return shipment is overdue.

Photos for juvenile birthday cards use lots of bright colors and happy, upbeat designs. This shot of a bunch of balloons was made at a street festival in New York.

Sending Duplicates is Best

Because of the speculative nature of submissions, and the great volume of work card companies receive, many companies will not make specific guarantees on the safe return of materials. Most companies are trustworthy and do their best to safeguard work in their pos-

Keep in mind that cards are made for all age brackets. This photo is geared toward a very specific group (no, not teenagers, but men in their forties and fifties) and is a bit of nostalgia that could be sent either as a Father's Day or a birthday card.

As younger design firms begin to make their mark, photos such as this will find their way into more postcard and blank greeting card lines. Though misty roses and soft sunsets still have their place, don't think the greeting card market has no room for other types of works as well.

session, but accidents do happen. Also, cards may be printed out of the country, and in the course of all the shipping and printing operations damages can occur. It's for all these reasons that I strongly suggest that you submit duplicates on speculation, and, if the company insists, originals after selection. Once they've chosen one of your images for a card, you're in a better position to demand that some value be placed on the original, and that compensation be made for damage or loss.

Duplicating all your slides can be a costly proposition, so edit down to, say, your top 200 greeting card shots, and have a quality set of dupli-

cates made. Depending on the lab, and the deal you make, this might run you between $200 and $500. Use this selection as your circulating-proof set that goes back and forth to potential customers. The feeling of security this gives you will more than offset the initial price.

Pictures for greeting cards sell in the range of $100 to $250 or more, depending on the press run and auxiliary usage. Some companies spin off greeting card images to posters, note cards, place mats, packaging, etc. You may get an offer for a low up-front payment and a royalty deal of 2 percent to 7 percent over and

above a certain sales figure, say, 10,000 sold. If given a choice, I go for a higher front-end figure and give up on royalties, because press runs tend to be limited and accurate sales figures are hard to pin down. The fact that styles turn over so quickly in this market is another reason for going for a larger flat fee. However, some markets, such as posters, use the royalty deal as standard. If you go for a royalty deal, make sure you have access to their books.

Not all of the more than 500 companies engaged in publishing, printing, and distributing greeting and note cards use photography in their lines, but the use of

photos on cards is expanding, and many companies are always looking for ways to modernize and expand their lines.

A partial list of the types of greeting cards sold includes: anniversary (wedding and general), April Fool's Day, baby announcement, baby congratulations, bar (and bas) mitzvah, birthday (all ages, sexes, and relationships), bon voyage, christening, Christmas, college, confirmation, general congratulations, Easter, engagement, friendship, get well, good luck, graduation, Halloween, . . . Mother's Day, New Year's Day, retirement, St. Patrick's Day, Valentine's Day. . . . The list goes on.

Animals are popular subject matter in this field, and you have a complete outdoor studio ready for you at the zoo. This relaxed fellow was photographed in San Diego.

Found graphics and art, such as this wall mural on a temple building in Bangkok, can be used as an illustration in the greeting card, calendar, and associated paper goods markets.

A Talk with Melanie Howard of the Greeting Card Association

According to the Greeting Card Association (GCA) more than 7 *billion* cards were purchased by Americans, with over half being seasonals, and the remaining being "everyday" cards. Sales of this latter group, such as note and blank "non occasion" cards, are on the rise. Lots of people send cards just to say "Hi."

The Association has analyzed and described the types of cards people buy, and this may be of interest to you in your editing selection. According to the GCA report, "those polled sent out at least one of the following types of greeting cards: humorous (83 percent); sentimental/flowery (68 percent); romantic (66 percent); religious (53 percent); novelty (45 percent); blank (34 percent); and sexy (32 percent)." Crossovers, such as a humorous sexy card, are not included in these figures.

Other responses are equally interesting: "Twenty-nine percent of the respondents have been moved to tears by a greeting card," and "twenty-eight percent ... contend that greeting cards have played a significant role in their romantic lives. There have been reported cases of greeting cards rekindling the fading passions of lovers."

According to Melanie Howard of the GCA, "Photography is a very popular medium right now, though freelancing is a tough business. Every company has its own standard and way of paying." She advises freelancers to "be very careful with original work—send duplicates at first, well-packaged, with an SASE. Inquire first about a company's policies, then send work."

Getting to know the market is essential. "My best advice," says Ms. Howard, "is to go out and case the card shops. Look to see who's using what. Companies don't like getting what they don't use. Try the younger, new companies, because the giants have large, in-house art departments or solicit work they're interested in."

How open is the market to freelancers? "There's a market for quality photography, professionally handled and submitted," assures Howard. "The companies are always looking for work by experienced photographers who carefully research the market. Styles and photographs used are always being turned over, and there's no set yearly, or even seasonal, change—it's constant change."

What styles are currently in vogue? "The sunset photos are still used, but what we're seeing more of is photography as an art form—very artistic, sophisticated work. In some cases, traditional companies are becoming more artsy, and the up-and-coming companies are going more traditional."

To help freelancers research the market, the GCA publishes two booklets: "The Artists and Writers Market List" ($1 plus postage) includes those companies that take freelance submissions. A more comprehensive "Greeting Card Industry Directory" ($25 plus $1.50 handling) lists Association members and breaks down companies by product and department heads, although it doesn't tell whether or not companies use photography in their lines. The GCA can be contacted at 1350 New York Avenue NW, Suite 615, Washington, D.C. 20005. The phone number is 202-393-1778.

Greeting Card Companies That Use Photographs

Here is a partial list of greeting card companies that use photography in their lines, with some of my subjective comments on the type of work they presently use. You might add to it your own list made from visiting stationery stores and writing to companies for their submissions guidelines.

Creative Graphics
P.O. Box 2626
Eugene, OR. 97402

Nature, autumn, lighthouses, florals

Windsong Designs
1805 Shallcross Ave.
Wilmington, DE 19806

Nature scenics, romantic nature

Pomegranate Publications
P.O. Box 980
Corte Madera, CA 94925

Special florals, still lifes, colorful boats, travel locations, car details

California Dreamers
3505 N. Kimball
Chicago, IL 60618

Studio setups, humorous, people in funny circumstances, graphic, punchy

Argus Communications
P.O. Box 5000
Allen, TX 75002

Scenics, cute animals, florals, natural beauty, spin-offs to posters, other paper goods

Sunrise Publications
P.O. Box 2699
Bloomington, IN 47402

Still lifes, florals, reflections in water, nature

Silver Visions
Publishing Co.
P.O. Box 49
Newton Highlands, MA 02161

Pets, travel destinations, dancers, graphic vegetables

Palm Press
1422A Walnut St.
Berkeley, CA 94709

Clever setups, style, minimalism, "found stylizations," ironic humor

Golden Turtle Press
1619 Shattuck Ave.
Berkeley, CA 94709

Rainbows, high adventure, mountain climbing, bouquets, florals, leaves, sacred places, spiritual nature scenics

Chroma Line
Roserich Designs
P.O. Box 1030
Carpinteria, CA 93013

"Found stylizations," subtle nature scenics, close-ups, walls, travel destinations

Carolyn Bean
Publishing Ltd.
120 Second St.
San Francisco, CA 94105

Sierra Club cards, strong nature scenics, wilderness

AUDIOVISUAL
Stock or Assignment?

WHENEVER YOU ATTEND A PRESS conference, sales meeting, trade show, or even a state fair these days, you are inundated with multimedia shows. Although I may be wrong about their history, it seems to me that these multiprojector extravaganzas are an outgrowth of the light shows of the sixties, when massed images and swirling lights danced to a rock 'n roll beat. Today, that attempt at mind expansion has been subverted to the purpose of raising brand awareness. So it goes.

What might have begun as two projector shows for boardroom meetings has turned into twenty-projector events complete with lasers, smoke bursts, and the rapid-fire projection of hundreds, even thousands, of images. Independent and in-house audiovisual production firms serve clients as diverse as soft-drink bottlers, heavy-equipment makers, state and city governments, and national tourist boards. These days, every city has its "Experience," and every world's fair has its pavilions with lavishly produced slide/sound shows.

These productions can be months in the making. Successful shows are often spun-off to videotape or duplicated in the original format, for distribution to regional sales meetings or smaller traveling events. Whatever the venue, it's a multi-million-dollar business that utilizes hundreds of thousands of images a year—and it's growing.

Some of the market is being gobbled up by computer-generated imagery, in which bits of pictures are incorporated with others, inserted into graphs, or mutated beyond recogni-tion. For example, a simple picture of a candle may become part of a more elaborate graphic with sunsets, power lines, faces, and a graph showing the annual growth of utility stocks. With the current technology, the possibilities for manipulation are endless.

Work-for-Hire Photography

This creative dream may turn out to be a bit of a nightmare for freelance and even stock agency photographers. Audiovisual houses are currently building their own picture libraries composed of work-for-hire and all-rights-granted images. Work-for-hire means that a photographer contracts to assign all pictures from a take to the employer. It's becoming a controversial matter in stock photography, one that keeps lawyers busy and has many photographers concerned. Most of the markets we've covered are touched only peripherally by this situation (chiefly because of the high cost of producing these images), but it's a phenomenon all of us will be confronted with in the years ahead.

Audiovisual production houses work mainly with very specific images for their shows. This comes about because of format, storyboard scripting, and layout considerations. If part of a show calls for a single-image–three-screen panorama, each shot must be perfectly butted, all with exactly the same density. If a multiscreen show has some slides underexposed and others with a slight magenta cast, it will look pretty shabby.

Continuity of style is also important to the "look" of these shows. The images' point of view must be consistent, unless, of course, the photographs are meant to give a short course in

different ways of seeing the world. This is rare, as most shows work from a specific (narrow, if you will) frame of reference.

Submitting Work and Negotiating Its Use

Most audiovisual houses work with photographers that shoot from a definite script. This gives the producers creative and technical control of the pictures being made. They use stock when needed, although they are very picky about the images they choose.

As in the textbook market, offering many angles of view of one image (vertical, horizontal, long- and wide-angle views) promotes a better chance for a sale. This gives producers both subject and layout freedom. Once the producers have chosen an image, they may further crop it, change its density, or duplicate it with various color shifts. An image may be split in three for a panorama or reversed to match others in the script. But offering a choice always enhances your possibility of making a sale.

Audiovisual houses may have ancillary uses for your pictures. Be ready to negotiate a fee for any subsequent "re-formatting" or distribution. If pictures are initially used for a show, such as "Boating on the Great Lakes," at a state fair, and then are converted to videotape for the tourist board, you should get payment for use in a different medium.

Look at subsequent uses as you would the edition rights in the book trade or spinoffs in the paper goods market. Remember, always sell your images on a *per-use basis*—this is how you'll survive and prosper in the stock photography market. Everyone involved in postproduction is paid for

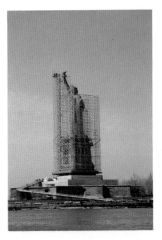

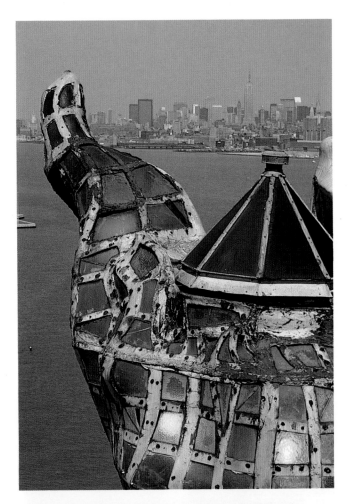

The slides used in AV shows are highly focused groups of pictures that come together to depict a product, place, or event. Multi-screen extravaganzas are now commonplace at trade shows, sales meetings, state fairs, and various city "Experiences"—visual cross-sections that show fleeting highlights of a town.

his or her work, and you should be no exception.

Approaching Audiovisual Production Firms

Audiovisual production houses are listed in the Yellow Pages of major-city phone directories, in education filmstrip catalogs, and in various industry trade publications such as *Audio Visual Communications*, Media Horizons, 50 West 23rd St., New York, NY 10010. A comprehensive listing of the marketplace is the annual directory *Audio Video Market Place*, published by R. R. Bowker, 205 East 42nd St., New York, NY 10017. These sourcebooks can be found in most public libraries, as well.

A major obstacle to selling work in this field is that production houses often use staff photographers or pictures supplied by their clients. Some small design firms, freelancers themselves, contract out to research pictures and even put together the whole show. Unfortunately, most of these firms rely on major stock houses for their picture sources. Many production houses that I've talked with believe that a single freelancer rarely has the depth and volume of coverage required for their very specific picture requests. All this leaves little room for the independent freelancer. The same goes for in-house producers. They count on the staffs of major agencies to do their research for them, even though they are charged a research fee.

Your best bet in this market is to find a small, young design firm with which you can grow. Although you might not have all the images they need, you can use your stock portfolio as a way of getting specific assignments. You may be able to fill some of their requests from stock, but chances are you'll be getting comments such as: "We like the shot of the man fishing under the bridge, but do you have one of him wearing a *red* shirt?"

If you do have strong coverage in one area, such as a travel destination, you may be able to sell shots to a firm producing a filmstrip or show on that location. Getting a Master List into the hands of as many firms as you can will aid you in getting calls for your images. As in all areas of stock sales, personal calls and contacts are important—make firms aware of your existence and what you have to offer.

A Talk with Dan Davenport at Minolta Corporation

Dan Davenport is in charge of producing, directing, and organizing multimedia shows for Minolta Corporation. His observations on this market point out the dilemma facing freelancers.

"Essentially," says Davenport, "we produce two types of shows. The first is product specific, and is linked to a public product announcement or sales meeting. These require very specific

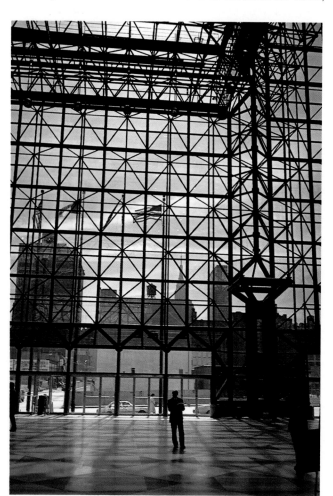

A location shot is a mixture of many moods and settings, all geared to give the flavor of a place.

Here, flags and leading lines were used to frame the skyline. This photo was made in Liberty State Park.

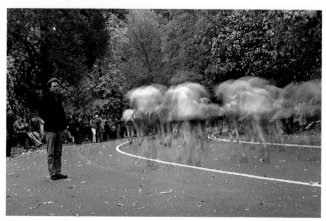

A big event in the city's life is the Marathon. Here, a time exposure was used to emphasize the pace.

illustrations that are done on an assignment basis—all 'supervised' shots—which we then incorporate into our scripts.

"The second type we do is a single-projector show—a countertop sales aid that deals in very specific camera functions highlighting the features of a camera. Here, generic shots are sometimes used, but they must be released photographs. We've found that using assigned work makes our life easier—first, because of the model-release guarantee, and second, because we can use the shots in any other way (brochures, point-of-purchase pictures, etc.) without extra permissions."

Davenport speaks to the topic of use of freelance photographs: "One of the problems I have with freelancers' work is that I always see the 'good' picture. By that I mean: Many shows call for illustrations of camera features, and that requires the before-and-after shot, bracketed exposures, and many alternative points of view of the same scene.

"These shows tend to be very pragmatic, and although we use pretty pictures we can't build a show around them. That's a dream show. Also, we look for a coherence of style throughout a show, and more often than not we get that from assigned, work-for-hire photography. And, when we get that type of work, we're not limited to a single use of a picture."

Does all this mean that a freelancer should bypass the lucrative audiovisual market? No, but be aware of the needs of the market, and be prepared to use your stock as an entree to assignments, or find firms that can use your very specific, in-depth coverage of a subject.

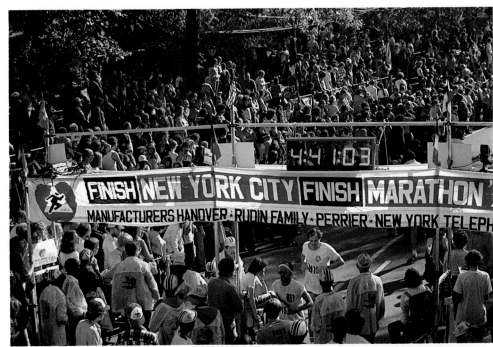

An AV show is both an intellectual and visceral experience. Viewers go through a series of associations as diverse images are brought together, and build up emotional responses to these linkings as the showing gathers momentum and thrust. Given scripting and a certain budgetary freedom, AV producers can create startling visual events. As a photographer in this situation, it's your job to give producers as many different views of the same event as you can, and thus expand their inventory of visual opportunities. AV shows aren't just still-frame movies—each has their flow, rhythm, and vision of an event.

This detail, showing an exhausted marathoner with medal, is the kind of still that allows a producer to explore an event, to sprinkle close-ups in with contextual shots, and make the presentation a sort of "inside-out" visual experience. One AV producer describes his productions as one where satellite images work around a main thematic "planet" (in this case, the NYC Marathon), and all spin in concert in the visual universe of the projection screen. Though this may be a bit too poetic for its own good, there's no denying that sophisticated AV shows are a visual world unto their own, and in most cases producers look for very specific images to fulfill the illustrations called for by the story boards.

PUBLIC RELATIONS

Spreading the Word

THE JOB OF A PUBLIC RELATIONS FIRM IS to bring a product to the attention of consumers and to foster good will for a person or a place without directly paying for advertising. Everything from a candidate to a country to a camera can be represented by a PR firm, and the "word" is broadcast over every possible medium.

Public relations and paid advertising go hand in hand. In large concerns, the budgets for the two are split, with advertising getting the lion's share. But even though PR tends to be a bit more of a subtle sell, it is still a very active market for the selling stock photographer.

Finding out which firm represents what product is a matter of consulting such directories as the *Red Book*, which can be found in most reference libraries, or you can buy one from National Register Publishing Co., 3004 Glenview Rd., Wilmette, IL 60091. You can also research the business pages of newspapers and trade journals such as *Ad Week*. Public relations contracts are usually negotiated on a yearly basis, and it's not uncommon for an account to jump from firm to firm over the course of the years, so keep tabs by using only current directories. Account executives move around quite a bit, too, and when they go they often take their pet accounts with them. In this business you definitely need a scorecard.

Presenting Your Portfolio

All but the smallest PR firms or in-house PR departments represent a number of different clients, and you may find agencies that handle a sports car, a French perfume, the promotional interests of a small country, a camera line, and a fast food franchise all under one roof.

Each account within a large umbrella organization has its own account executive, art director, and creative team. Some may piggyback on the resources of others, but it's important for you to make the right contacts for your specific pictures within a large agency. Don't count on creative teams to "pass you down the hall." Although you can save carfare by paying a number of calls within one set of offices, even though you will have to make separate pitches to each account.

Preparing for a visit or a mail query to a PR firm requires you to hone your portfolio to each account. Let's say you're making a pitch to a film manufacturer's agency, and you want to show examples of the great pictures you made on their new high-speed film. Naturally, you'll be limited to showing photographs made on that film only. Similarly, visiting a camera company's PR firm will mean that all the shots must be made with that camera. You can show pictures used in the film company presentation, but you'll probably want to expand the presentation to include many types of film used in that particular camera.

The point is that you should be flexible in your portfolio presentations. Pictures made of someone riding a particular brand of bicycle along the paths in Holland, which you can pitch to a bicycle company's PR firm, can also be used in a presentation to the Netherlands Board of Tourism. A farm scene with an identifiable brand of tractor can be used in a pitch to, say, a farm equipment's PR firm, but also may be usable for sale to a farmer's lobbying organization. Keep the client in mind as you mix and match your portfolio.

Variety Pays Off in PR

Public relations firms make wide use of photographs in any number of media. Multimedia slide shows, press conference blowups, in-house brochures, and pre-packaged articles for trade books often consist of freelance-produced, PR-firm-purchased photographs. Here are some recent sales to PR firms with descriptions of how the pictures were used: None of the photographs were ever used in direct advertising, but all were chosen to promote a product, place, or event.

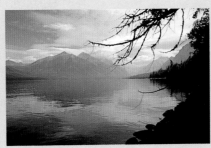

A wide-angle shot of a gnarled tree on the edge of a cliff in Glacier National Park in Montana. Use: Illustrate the quality of an independent wide-angle lens for an in-house-produced point-of-purchase brochure.

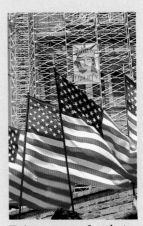

Close-up of a silver dollar. Use: Demonstrate via a dealer-sponsored traveling multi-projector show a camera's macro-photography system.

A choir on the steps of a church in the Bahamas. Use: A Bahamian Tourist Board slide show.

Enlargement of a photograph of the Statue of Liberty undergoing reconstruction. Use: At a press conference on a product with the name "Freedom" attached to it.

Tile-roofed houses off the Spanish steps in Rome. Use: Travel photography article for a camera company's consumer bulletin.

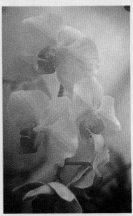

Nighttime shots of neon light-filled street in Hong Kong. Use: Show uses of high-speed film for a film company's brochure on making successful travel photos.

Sea gull on a light pole, shot through an orange filter. Use: A print in a filter company's brochure.

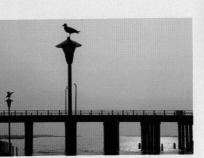

A high-grain close-up of a flower. Use: A sample in a traveling exhibit proclaiming the virtues of a particular high-speed film.

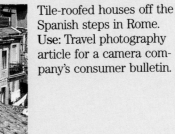

Focusing in on one industry, or on one aspect of a wide-ranging trade, is a good way to build solid public-relations picture stock. As we see a good many airports in a year, we've decided to make a project out of creating a file on the travel and airlines industries. These pictures serve a wide market, and making them fills up some otherwise boring time.

I'm always tempted to photograph through a plane's window, especially when flying through billowing clouds. This shot of an engine was made because of the special color and light that played over the metal and because of the unique filtration provided by the aircraft's window. It's an odd abstract, but one that is a regular part of the airlines "book."

The quality of the photographs in your portfolio must be high, and strict and rigorous editing of PR-directed shots is an absolute must. The art directors at these agencies see hundreds of photographs a week, and, to say the least, they have a jaundiced eye.

Usage Rights and Payments

Many times, a PR agency will want to keep your photographs on file for future use—the firm may have a number of projects cooking and can't give an immediate slot for your shots. Don't allow the firm to hold your originals. Have it make a duplicate for its files, or you make it and bill the firm, and then negotiate a fee for each time the agency calls for the original.

The pay scale is determined by usage. A photograph used in print should bring in more than one for a multimedia show; one used as part of a packaged article will probably earn less than one for a major brochure. Usage should be negotiated on a case-by-case basis.

There may be times when an agency will want to make a "group buy" of a set of pictures—the agency may want them for its files but can't yet pin down a specific place for them. This often comes up when tourist boards want to use the photographs in a wide range of brochures, slide sets, and freebie shots for trade and consumer travel books. In a sense, these boards, chambers of commerce, or whatever, want to use your photographs to create their own "stock library."

Negotiate as best you can in these instances, but don't do what in essence would be to turn your pictures over to someone with all rights for a small fee. Follow your instincts and your needs, but keep in mind that your best

financial return will come from selling separate rights rather than from giving in to an all-rights buyout.

Also, PR firms use stock photographs for the production of prepackaged articles, which they turn over to trade magazines "free of charge" in exchange for the free publicity the article (actually an informational commercial) gives them. In this case, you're leasing the image to the PR firm, not the magazine, so don't expect to do too much double-dipping. Rights and payments can get sticky in the PR world, so be sure your invoice or contract spells out the full deal and you and the PR firm know the boundaries that can and cannot be crossed.

Public relations stock usually pays less than advertising, although a picture that goes through multiple usage can be a moneymaker. Hit the right accounts and you'll be providing yourself with a good income and building your stock files for other uses in the bargain. The great thing about PR stock is that the same pictures can be used for many "crossover" purposes—they can serve many markets at the same time.

If your desire is to mix both stock and assignment work as part of your plan, contact with PR firms can lead to assigned work in your area of specialty. Show art directors and account executives the right stuff, and you'll find yourself busy photographing for this expanding field.

A Talk with Joel Samberg at Olympus Corporation

Joel Samberg is part of the public relations team at Olympus Corporation, a leading camera manufacturer. The PR arm of the company makes use of pho-

tography in a wide range of publications and brochures, including *Vision Age* and *Pursuit*, magazines for "Olympus people." These publications, according to Samberg, give full information on photography and photographers.

"Though we don't actively solicit material," Samberg says, "we do have reasons to look at freelance work. We get a lot of material from photographers all over the country, though there is a worldwide competition to do the work that goes into our publications."

Samberg describes the stock his team accepts: "Nine out of ten photographers call before they send in work, and we do spend time looking at the photography sent in. We're looking for work that illustrates the technical features of the Olympus system, such as multispot metering. The photos should show how the cameras help photographers get pictures that they can't get with other systems.

"We also look for 'special events' that include the use of an Olympus, such as someone who climbed the highest mountain in the world and used an Olympus to take the photographs. For example, we recently got a series of pictures from a man who survived a plane crash in Alaska—all his Olympus equipment was spread out all over the ground but still functioned.

We're considering that series for use in some of our publications."

What are some of the problems with work sent in? "Fortunately for us, people who take the time to submit work usually send pictures worth seeing. Occasionally, we do get submissions from people who don't seem to know how and why we might use their photographs—they fail to provide full and detailed information on the pictures.

"If we okay submission over the phone, some people seem to be in so much of a hurry that they don't include a letter outlining the reason for the pictures, the central idea or theme behind them all. Even if we get

the initial information over the phone, people should include all the information in an accompanying letter or fact sheet. We're usually working on ten projects at a time, so it's difficult to keep up with submissions.

"We try to give a yes-or-no response as quickly as possible, usually within two weeks. If we like the work, we usually send it over to Japan with a note (the publications are printed in Japan), where it goes through another selection process. We don't pass work we like along to our advertising firm, but we sometimes do recommend that photographers contact the firm directly. From there, it's up to them."

Handling cargo is a big part of any airline's business, and this shot is an "inventory" of the equipment on the tarmac.

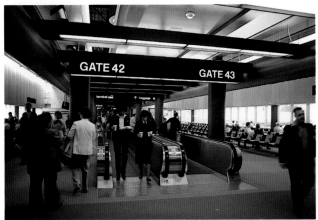

Showing people using the products and services of an industry is an important part of public relations photography.

This view of a waiting area shows how a play of light and a few figures can make a functional shot of a terminal more interesting.

After walking down this corridor while heading toward our gate, we turned and waited for some figures to come under one of the "spots" in this high-tech hall.

ADVERTISING AND ANNUAL REPORTS

Competition for the Big Dollar

BY FAR THE BIGGEST REVENUE PRO-
ducer for stock photographers is the advertis-
ing market—it's also the most competitive.
Everyone wants a piece of the pie in a field
where a single image has the potential to earn
thousands of dollars, often multiplied by fees
for repeat uses and subsidiary rights. Players
in this field include top-rated, strictly-busi-
ness professional photographers, worldwide
stock agencies, and creative graphics houses with picture-
crunching computers.

Although a lot of advertising work is still done on an
assignment basis, stock photography has gained an increas-
ing share of the market. A number of factors have contributed
to stock's growing strength, including escalating day rates
and location fees of assignment photographers, the advent of
computers as a source of images, and the high quality and
sophistication of the stock photo itself.

This wasn't always the case. Not very long ago, very few ad
agencies would deign to use stock—they considered it a
lowbrow operation more appropriate for encyclopedias and
greeting cards than for advertising. Economics, in part, has
done much to change that thinking. As advertising budgets
escalated, photographers caught on to the idea that their
creative work should be recompensed proportionately. Many
photographers protested the fact that they'd get $250 for a
picture that went on a full-page ad that was billed out for
$25,000. Some nerve! In any case, day rates went up, as did
the cost of doing business.

Over the last few years, the creation of computer-gener-
ated images for advertising has become a multimillion-dollar
business. Bits and pieces of different photographs are
crunched and reassembled to create everything from special
effects to different color washes on the same fabric.

For example, a red automobile is shot for an ad, but when
the art director places the shot on the layout he or she
decides that a blue car would look better. Rather than rehire a
photographer to do an expensive reshoot, with models, loca-
tion fees, etc., the art director ships the chrome to a computer
shop where the image is digitized and recoded, and voilà! a
blue car.

From there, the car can be placed on an estate lawn, on a
mountain top, or, if need be, on a deserted island. All this is
done by electronically melding pictures of locations with
product; all is done right on the computer bench. Once you've
seen the capabilities of such a system, you have to wonder
about the future prospects of advertising photographers.

The high quality of stock photography has also made a big
difference in the acceptability of inventory shots in the adver-
tising market. With more and more pros shooting a portion of
their work exclusively for stock, and with some of them
devoting themselves entirely to the field, the idea that stock
comes from culls, or "seconds," has long been refuted. Some
of the top names in the photography business have come to
recognize stock for advertising as a viable source of steady
and substantial income. Little wonder that there's so much
competition for this high-end aspect of the stock photogra-
phy market.

Where does this leave the independent stock photogra-
pher? Before you start knocking on doors you should be well

prepared. Have ready a client-directed stock list, a well-honed portfolio, and a mental set that is prepared to go through a labyrinth of art directors, account executives, and assistants.

Finding an Advertising Agency That Needs You

Take heart. Not every agency is of the high-powered Madison Avenue type, and not every client can afford the often prohibitive cost of working with top pros or computer-generated imagery. Many smaller agencies in all parts of the country serve a wide diversity of clients with varied picture needs. You can start by doing a steady stream of business with agencies that create modest brochures for the tourist trade, or with one that right now may be planning a print campaign for, say, a local winery.

The first step, regardless of what level of the advertising market you intend to explore, is to find out who represents what. As in public relations, a number of source books can help you find these client-agency linkups. These can change from year to year, so get your hands on the most updated version available. *The Standard Directory of Advertising Agencies*, published by the National Register Publishing Company, 3004 Glenview Rd., Wilmette, IL 60091, lists the major United States advertising agencies, their clients, art directors, etc. This book can be found in most major libraries. Smaller, perhaps younger agencies can be found in the Yellow Pages of cities. A phone call to these firms will usually get you the information you need, such as the clients they represent, their procedures for portfolio review, and how to get an appointment with the picture buyer or art director.

Once you have matched an accessible agency to a client, match your picture inventory strengths to what you feel the client can use. For example, if you have an exceptionally strong floral and garden file, seek out agencies that represent seed companies, gardening implement manufacturers, and similar clients. If your forte is industrial sites, factories, or oil rigs, a client serving those industries should be the target of your efforts.

Creating the Right Portfolio

Common sense, with a little stretching, will dictate your coordination of client and portfolio. Keep in mind that your stock shots may be used as part of a product montage, such as a bottle of the client's wine superimposed over your picture of vineyards stretching over

Photos used by advertising agencies needn't always include products—a mood or thought-provoking image can do just as well. In fact, many ad campaigns would be dead in the water without the possibilities offered by stock.

Photos initially made for the travel stock file often do very well in the advertising market.

Find the agencies that represent airlines, resorts, and national tourist boards, and pitch your travel stock for their ads.

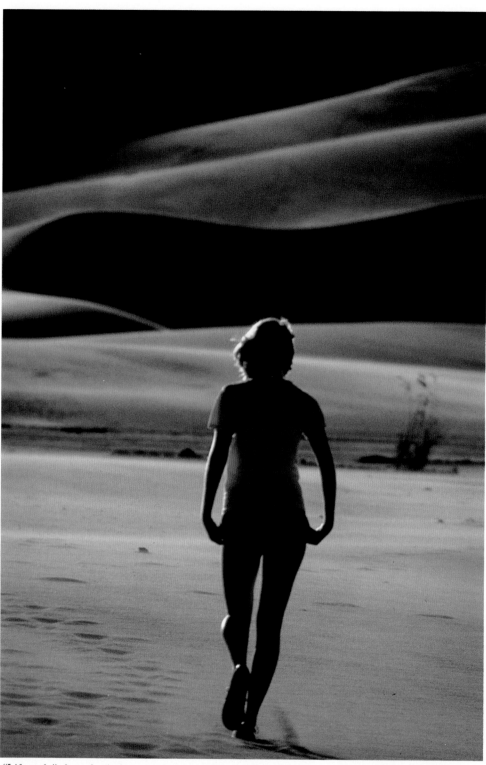

"Life-style" shots depicting people engaged in healthy, upbeat activity or struggling against physical odds do very well as advertising stock. A photo such as this one, a jogger "heading for the hills" in the Great Sand Dunes National Monument in Colorado, also leaves some room for headlines and type, and provokes a feeling through the use of light and the background design. Some photographers have done very well in the ad market with their inventories of ballooning, windsurfing, and sky diving pictures. Many of these activities may take place near your home, or you may run across them as you travel. Keep in mind that such shots can be used as location (for travel editorial) activity (general editorial), product (trades), and advertising (life-style/product association) stock. There's no question that the ad market is the biggest earner, but these other areas will add to the value of your photographic stock.

rolling hills. Your pictures might be used as a background for type, such as a shot of a woman driving a car in a torrential rain, which could be used in an advertisement for brakes.

Inspect advertisements in newspapers and magazines and you'll soon get a feel for the stock images used in advertising. Cigarette and liquor advertisements draw heavily upon stock for their imagery, as does most "life-style"-directed advertising. In these graphic representations of the consumerist myth, the product and the context are linked so that a potential buyer forms an association of mood, moment, feeling, or fear with the consumption of the product being pushed. These "quiet" sells, in which someone isn't just sticking a label in your face, are among the most common usages of stock in advertising today. Style without content is being used more and more.

After your research is complete, contact the art directors of the agencies in which you're interested, and find out if they use stock. If they do, show them you've done your homework by mentioning that you have a possible picture for the XYZ account. Arrange for a meeting, or prepare your portfolio for mailing.

At that point, you'll have to assemble a portfolio that matches your perception of the client's needs. At times picture selection will be obvious—other times the connections will be more obscure. All selections must be technically excellent, and all people in the pictures must be "released." In some areas of stock, releases aren't always necessary, but in advertising a signed model release is an *absolute must.* No agency in its right mind will go near a shot that

isn't released, so don't waste your editing time by sending any people pictures that aren't fully released.

Also, don't expect the trumpets to blare or immediate sales to occur once you show your work. Advertising campaigns are months in the making, and you may have to wait a year or two for your efforts to pay off. Perhaps you'll get lucky and slot right into a present need, but don't get your expectations too high.

Advertising Usage Rights and Fees

Rates will vary according to usage, frequency, and spin-offs of the photograph. Naturally, a small agency handling a local client pays considerably less than does a major account running a national advertisement. Whoever the client, and whatever the picture, be sure to negotiate as strongly as possible for a multiple-use contract. For example, advertisements may be used for point-of-purchase material, coupons, and billboards. Each usage beyond the first run should get you an additional fee.

A growing practice among advertising agencies is to try to purchase all rights to a picture, paying one fee regardless of other uses. Though this is more common with assignment work, and comes under work-for-hire contracts, it is becoming increasingly common in the stock photography market as well. Need-less to say, photographers and their associations are lobbying hard against this arrangement, recognizing the loss of income, both present and future, that it represents.

Do what you will, but I strongly advise against selling all rights or agreeing to a work-for-hire arrangement. Giving in to such agreements removes the image from circulation, reduces your earning potential and that of your fellow photographers, and gives agencies their own stock library for very little cost.

Shooting Life-Styles for Advertising

On inspection, you may discover that you don't have many stock shots that are applicable to the advertising market. Your first instinct is that you can't even begin to compete.

Don't worry, few of us begin in this field with an eye for advertisements. Where we all may have a "secret" advertising file is in the life-style category, one of the biggest current sellers in this field.

Life-style shots can be of anything from a trout fisherman wading in a babbling brook to people dining in an outdoor café to young, upwardly mobile types tossing a beachball around in the sand.

Whatever the scenario, the people and places depicted must be upbeat—no dour expressions, no stress (unless of course its for an

Though you may find great location sets populated by active, energetic people, you'll never be able to use such shots for advertising stock unless you obtain a model release from all recognizable people in the picture. And if there are kids in the scene, you must have a parent or guardian sign the form. Always carry releases with you in your camera bag.

aspirin ad), nothing to disturb the patina of pleasure the product purports to impart.

A West Coast photographer I know does a very good business in life-style stock photography. Through his contact with various agencies he discovered that there was a dearth of pictures showing healthy people having a ball in Las Vegas. Rather than scour the streets looking for scenarios, then cornering the people into posing and signing a model release, he hired some models for a day and went about making pictures of a young couple playing the slots, golfing, dining, hitting a tennis ball, and so forth. His investment of time and money has paid off.

A study of a catalog of a major stock agency specializing in advertising-oriented stock shows "yuppie" joggers coming over a hill, a white-cuffed hand writing a check with an expensive gold pen, a female executive poring through a file cabinet, a silhouette of a young couple at a marina, and a horse grazing in what looks to be the bluegrass of Kentucky. Such catalogs can be very helpful sources for picture types and approaches. Request one from a major agency, and compare its work with what you have in your files.

Selling Pictures to Annual Reports

All of the above advice applies to annual report stock sales. In field the approach is heavily oriented towards locations and occupations. Many of the pictures for this market are made on an assignment basis—executive portraits, factory scenes, and product-in-use shots are all part of the package.

But don't let this assignment-heavy aspect of annual reports discourage you. An annual report is much more than a product and executive catalog—it has come to be a book representing the "corporate culture" of a company.

For example, a paper and pulp company will want to show the wide expanse of forests and abundant wildlife of its wooded preserves—No skid trails, stripped mountainsides, or erosion caused by overcut-

Background or ambiance photos such as this one are often used a part of an assemblage in making up an advertising layout. Many ad agencies now make use of the "image-crunching" capabilities of computers, and they feed a number of pictures, or parts of pictures, into programs that act as painters and montagists. Others still use the art of airbrush and cut-and-paste montage to create a scene.

Annual report photography isn't just a matter of making a catalog of executives and factories—it's becoming more and more a part of an expression of what's called "corporate culture." Part public relations, part facts and figures, these slick productions use a selection of photos that show how the company's presence "impacts" on society. This photo was made on a utility company's land in Massachusetts.

ting, thank you. An oil company will want to project an image of the unpolluted ocean around its rigs, perhaps with underwater shots of teeming schools of fish. Beached and leaking supertankers need not apply. These generic shots don't represent the majority of those used for annual reports, but they do represent a share of the business.

Photographs of products in use, and workers in the field, are also big in the annual-report area. The same paper company mentioned above may use a shot of a brawny logger in a red flannel shirt chainsawing his way through some timber. A farm machinery manufacturer might use an elevated shot of irrigation wheels spraying water over greening fields.

Many of these photographs will be purchased from stock and be reproduced on high-quality, heavy-weight paper. In fact, annual reports often rival expensive art books in their look and feel. For that reason, only the highest quality images will be considered. Economics, however, often determine where annual-report pictures are obtained. Budgets for producing these reports can be very high, but the in-house and agency production teams are never adverse to saving money.

Whether it's for advertising or annual reports, some of the biggest competitors you'll have in this field are major stock photograph agencies. Rather than work with independents, many advertising agencies and annual-report production firms (often one and the same company, or a sub-contractor of same), rely on the extensive, in-depth files of agencies' huge picture libraries.

You can take an "if you can't beat 'em, join 'em" approach, place your pictures of this genre with an agency, and hope they sell. Or you can start small, build in-depth files in selective areas, and submit a list or a sampling to a handful of carefully researched clients. You have to start somewhere; so gear your approach well, do your homework, and try your hand in this lucrative area of stock photography.

This photo was made in some wetlands near a utility company's plant. As more corporations become aware of their environmental responsibilities, their awareness of their public image grows.

Annual report work allows for a bit more creativity in making industrial photos of plants and factories. Luckily, this company had an inside artist who made every photographer's job easier.

This is more a "meat-and-potatoes" inside shot that shows the area of creation of products and ideas. Though this sort of photo is usually created on assignment, it can later serve as stock for trades and annual reports.

Though I much prefer photographing in the woods, I must admit to being drawn to the graphic charms of industrial areas, I use and these elements whenever I can in my "business" shots.

PARTING SHOT

THROUGHOUT THIS BOOK, I'VE TRIED TO instill an understanding of what makes the stock photography market click, and how you can make a go of it. My purpose was not to peddle illusions, or make promises of instant riches from a few rolls of film and months of shooting. As you read through the text, I hope you've come to see the hard work, time, research, occasional aggravation, and tediousness this business can involve. I also hope you've been able to see the potential rewards of all your work.

Like any business, what you put into shooting and selling stock is what you'll get out of it. One of the first things you'll run up against, and what stops most people from progressing, is that you'll spend a disproportionate amount of time editing, filing, researching, and tracking down leads. Most people, myself included, go into this business because they love taking pictures, traveling, meeting new people, and expressing themselves through the art of photography.

But this business requires that you combine all that with what seems to be endless sorting and resorting of pictures and a nonstop shuffling of paper. It's not an easy task. It takes determination, and the drive to have your work appear in print, coupled with an incidental desire to make a living, or at least extra income, from what you love to do.

Part of my motivation comes from an idea I planted in my head a few years back. In order to progress in my photography, I decided that whatever I shot would serve a purpose, that only after a particular project was completed would I move on to another series of pictures. My concept of comple-

tion would include, for example, organizing an essay that I could present to a publisher, putting a series of pictures to a story idea, or selling at least one shot from a group. In other words, only after I successfully marketed a picture, or pictures, from a take would I allow myself to shoot similar types of pictures.

Needless to say, this didn't always work out, but at least it gave a structure to my work. It also focused my mind on taking pictures that were marketable.

Although some people work through grants, I've always believed in creating my own scholarships to continue work in photography. Taking pictures is an expensive habit, and somebody has to pay for film, equipment, and getting to and from locations. Shooting and marketing stock has turned out to be such a scholarship. It made sense for me to focus my energy this way, because one thing reinforced the other.

One of the dangers inherent in this approach, and to which I occasionally fall prey, is that you can begin a voracious accumulation of pictures *only* for the market. Your personal vision can become clouded by making pictures for only one end—sales. This corruption can become a problem in the stock photography market, and it's one you should guard against.

Even though I realize that the failure to "produce" may result in a loss of income, I highly recommend that you take as many busman's holidays as possible and shoot for your own pleasure. Occasionally I'll do this by carrying two camera bodies, one for work and one for play. I realize that it's difficult to turn off one switch and activate another, but, frankly, it's something you'll need to learn to do if you don't want to be

consumed by commercially oriented photography.

Also, guard against the temptation to continually clone successful pictures. As I've tried to emphasize, making a go of this business is a matter of combining the elements that go into a salable picture with your own personal vision. That adds a good deal of satisfaction to what at times can be a busy gathering of photographs. This combination also yields images with a unique point of view, a vantage point that makes your pictures stand out from the crowd. Besides, if you can't make pictures with your personal touch, photographs that give a part of you to the world, what's the point of the whole photography exercise?

The ideal objective is to be able to market pictures that are a true and honest reflection of your vision. This takes a lot of time, effort, and determination, but it would be wonderful if it could work out that way for you. The real world demands a certain amount of compromise, and I hope it will demand less of you as you advance in the field. Good luck, and I'll look for your pictures in print.

One of the great things about making and marketing your own stock photography is that the world is your studio, and you can work from anyplace that has a telephone, a mail link to the outer world, and enough peace to allow you to get organized. Though it will take you time to get going and a strong will to keep at it, it's the type of work that's nearly ideal for anyone who loves a sense of freedom and photography. It's a great vehicle to ride through this wide world.

INDEX